SKETCHBOOK

A Memoir of the 1930s and the Northwest School

Sketchbook

A Memoir of the 1930s
and the Northwest School

WILLIAM CUMMING

University of Washington Press

SEATTLE & LONDON

1984

Library of Congress Cataloging-in-Publication Data

Cumming, William.
 Sketchbook: a memoir of the 1930's and the Northwest School.

 1. Cumming, William. 2. Artists—Washington (State)—
Biography. 3. Northwest school of artists. I. Title.
N6537.C794A2 1984 759.13 84-40324
ISBN 0-295-96156-2

Contents

The Thirties

Contents

The People

Contents

Illustrations

Following page *116*

William Cumming, 1937 *Ernst Kassowitz*
Morris Graves, 1938 *Ernst Kassowitz*
Morris Graves and *Moor Swan* *Seattle Times*
Margaret Callahan *Private Collection*
Kenneth and Margaret Callahan *Private Collection*
Guy Anderson and Leo Kenney *Frank Murphy*
Faye Chong and the Model A *Priscilla Chong Jue*
Mark Tobey, 1938 *Ernst Kassowitz*
Mark and the Market *Seattle Times*
Mark Tobey and Betty Bowen
Lubin Petric *Don Lockman*
Ginger Dare
William Cumming and Lubin Petric *Don Lockman*
Richard Gilkey
Guy Anderson, 1964 *Mary Randlett*
Richard Gilkey *Paul Macapia*
The Blue Moon *Mary Randlett*
Federal Art Project artists
Portrait of Bill Cumming, 1940

Following page *148*

Faye Chong and Julius Twohy, 1938
Robert Bruce Inverarity
Denise Farwell *Hollis Farwell*
Emma Stimson *Dorothy Conway*

Illustrations

Betty Willis, 1948 *Mary Randlett*
George Mantor
Malcolm Roberts
Ted Abrams
Kenneth Callahan, 1950 *Private Collection*
Betty MacDonald *Seattle Post-Intelligencer*
Drawing
Ambrose and Viola Patterson, 1964 *Mary Randlett*
Johnny Davis *Idaho State University*
William Cumming and Eustace Zeigler *Mary Randlett*
Dr. Richard E. Fuller *Seattle Art Museum*
Two Paintings by William Cumming
Betty Bowen, 1965-66 *Mary Randlett*
My Gramma
My parents, Melvin and Joseph
Myself in my studio, 1964 *Mary Randlett*

Many thanks to the following people who helped find the photographs for this book:
Bill Basnight, Tom Bayley, Warren Bybee, Paul Dorpat, Richard Engeman, Hollis
Farwell, Richard Gilkey, Eve Green, Katherine Hacker, Lamar Harrington, Janet
Huttunan, Karen Irwin, Barbara James, Priscilla Chong Jue, Leo Kenney, Jo Lewis, Don
Lockman, Charlotte MacMillan, Dottie Malone, Murray Morgan, Linda Neumaier, Gwen
Putnam, Esther & Eli Rashkov, Virginia Roberts, Steve Small, Jan Thompson, Paula
Thurman, Pat Tyler, Elizabeth Bayley Willis, Jim Wilson, Karyl Winn

Acknowledgement

This book languaged itself over seventeen years of lying fallow, followed by two-and-one-half years of writing. For a long time I actively worked at not-writing. Then I spent some time not-wanting-to-write. Then I worked up to wanting-to-write.

Then I wrote it, between June 1981 and January 1984.

These are the special people who supported and helped.

Betty Bowen, out of whose vision the book appeared.

Margaret Callahan, who was my sensei. WIFE OF KENNETH CALLAHAN

Sue Cumming, who supported me in making my life work.

Rita Jacques, who helped out of nothing but friendship.

Karen Cumming, who picked away at the scar-tissue on the chakras of paternity.

Martha Russo, who unstuck me after sixty-six years.

Polly Friedlander, who gave me thirty whacks.

Bill Henry, who gave me hard enlightenments.

Art Hupy, who created a space in La Conner where the universe could appear.

Jess Cauthorn, who created a space at Broadway and East Pine where art could show up as a sharing between professionals and seekers.

Tom Robbins, who friended me.

Don Ellegood, who edited me.

Anne Whiting, who created a mirror of earth in which I could see who I was and be appropriate to myself.

Werner Erhard, who supported me in taking responsibility for creation, in languaging it and imaging it, in getting it and using it.

Dr. Rox, who pushed and pushed and finally got what she wanted—a book out of me.

Mary Randlett, who appeared all sorts of neat photos to image my words.

William Cumming

The Thirties

I Call on an Old Friend

Sometime in an autumn in the late fifties I called on an Old Friend. I was living in a disintegrating house on Thirtieth and Yesler, painting again after a fifteen-year exile occasioned by tuberculosis and a mad desire to change the world for the better, and I felt an ancient hunger to see and hear a friend twenty years out of the past who, more than anyone, had formed and shaped me out of the raw sewage of small-town youth.

So, enveloped in the meager warmth of a lemon-yellow October sun, I walked leafy streets up to the ridge overlooking Lake Washington, the mushy warmth of the Madrona district, down shaded streets to a pleasant house with colonial overtones where I rang the bell and was greeted out of the tenebrous cave of the open doorway by a voice trilling fondly, "Oh my God! It's Bill!"

Gray eyes I loved beside the Shalimar spilled their delight across time and space sprawled between us, recollected affection eddied in pools around me as I stood uncertain as ever on the tiny porch.

Then I was dragged in, my coat gently wrenched from me, a chair forced beneath me, and once more I sat as twenty years gone, a cup of coffee steaming neglected on the table, shabby before the softly growling fireplace, readmitted to a lost landscape of certainty where I would always be loved whatever my follies. Across the esoteric patternings of the rug (knotted fantasies of village women of the Anatolian hills), laid back in easy nonchalance in a wing chair, sat the friend of all friends, Margaret Callahan, her lilting drawl couched in perpetual amused disbelief just as I had first heard it on another October evening more than two decades lost out of memory, when it shone with the soft glow of spun gold in the dark-packed chiaroscuro of Morris Graves' living room on a night when I had walked through a different door into a life spun out of the astonished and astonishing visions of a small-town adolescent.

For once in my life I had heeded the promptings of memory before it was too late. Jogged by remembrance I had roused myself, put away the apprehensions of alienated years and had made that most sharp-edged of pilgrimages, the Call On An Old Friend.

Old friends pile up in fence corners, they drift into hollows, they eddy in whirlpools and flow gently sweet afton past fading woodlots. Their voices gather like moss around rotting stumps in logged-over clearings of disbelief. We conjure them up in vagrant moments of our lives, recall their voices when an ancient song leaks out of the car radio, grasp despairingly at their fading image in ambiguous snapshots.

"I saw an old friend today."

The words tip carelessly off the tongue, rattle across the linoleum floor into dusky corners of the kitchen, obscured in steam and the rattle of the bluely-luminescent evening news, only to ricochet back into our consciousness long enough to be batted away like an obstreperous housefly in the split second it takes for us to recognize that to have an Old Friend is to be, oneself, a certain degree of Old.

So we cherish them in memory at one moment, only to forswear them in the next.

Remembering them over lunch on a steamy summer day we forget the companion seated across from us, go unconscious for two-and-a half seconds as a cracked and grainy film unwinds across the patched screen of our flea-hop brain. Our heart constricts with a faint tinkle of pain. Memory congeals into affection, affection commences to harden into commitment, and in another moment we will be pledged beyond possibility of retreat to a visit, a phone call, a letter. Two-and-a-half seconds. Then the film breaks, commitment melts away, dribbles down the drain into irresolution, faltering hesitations and treason. We return to our filet of sole, the steaming coffee, the molten warmth of the day, the palimpsest chatter of conversation. All that is left is a faint tracery of fading voices and faces beneath the aimless drift of present smalltalk.

Until one day an acquaintance hails us on the street, calls us on the phone, scribbles a note. Dissolve commitment, erase intention, burn the film, darken the theater brain. You'll never have to make

the visit, pick up the phone, write the letter. One more Old Friend has been transformed into one more Late Friend.

And yet for once, I had heeded memory in time. I had acted. I had walked the autumn streets, had stood once more on a porch waiting in suspense for a door to open, jiggling in painful apprehension outside that door which concealed the meanings of my life, and the door had opened and life did indeed wait there, and I was greeted by the gray eyes of Margaret, pulled in, uncoated, settled into a chair, coffeed and cookied, loved unreservedly, my only pain the chagrin of estrangement from Kenneth.

Her drawl loped lazily across the floor, snaring my fugitive ear. "Well, Bill Cumming! Are you still as conceited as ever?"

And I laughed, joyful again to merit her gentle scolding. And heard my snickering reply, "You'd better believe it, kid!"

While in the back of my skull a voice hooted and jeered. How did you come to this place and this time? How stagger out of a depression-gutted town to sit here in the warmth and light of books and paintings and deep rugs, with Cascades spilled through the east-seeking windows and the gray eyes and the drawl of the best friend you had ever known?

Like Bilbo Baggins I had come by the only road that was any good.

I Remember an Earlier Day

Perhaps the road could be said to have started on a September day in 1937 in a sunlit loft in the Maritime Building on the Seattle waterfront, where a tall young man stood stoop-shouldered over a drawing board, working on a large charcoal drawing of a bird.

A stocky man walked briskly in followed by a congeries of

thin, bad-complected adolescents who promptly set up a tripod on which they fastened an old Speed Graphic. The stocky man took photographs of the room, of its furniture and of the young man, working quickly with the glum efficiency of the professional working at a job beneath his potential.

The tall young man continued to draw, paying little attention to the intruders outside a raised´eyebrow of good-natured resignation.

When the last plate had been withdrawn from the camera, labeled and stuck into its case, the stocky man and his youthful crew packed up their equipment and prepared to leave. Their job was finished. As they passed through the doorway one spectacularly thin youth stopped short. A nervous lurch rattled his bones and he stood in desperate indecision. As his companions clattered off through the big warehouse rooms toward the elevator, this one hesitated, then walked gingerly back to the tall young man at the drawing desk, peered shyly up and asked, "Aren't you Morris Graves?"

The reply was a cautious and speculative, "Yes," drawn out in a soft guarded voice. In the face of the youth's intensity, the man might well have retreated even further behind a watchful diffidence.

Heedless of danger, the youth plunged ahead.

"I'm Bill Cumming."

Surprisingly, the young man brightened.

"Oh! You're the one who . . ."

"Yes! Did you . . . ?"

"Of course! And thanks for . . ."

And that's sort of how it began, although what it was and where it would lead would have been hard to say.

And Still Earlier

In 1936 I was living at home, which was in Foster, a rural town in the valley south of Seattle. I worked in town, riding in each day on the interurban bus, eventually diving down a stairway into the basement of the Second and Marion Building. A suite of small rooms in this basement were occupied by the Photographic Project of the National Youth Administration.

The NYA was one of the forgotten New Deal attempts to ameliorate the impact of the Depression on the swarming hordes of unemployed youth. The principal activity of the Photographic Project was to take, develop, print and file documentary photographs of government work-relief programs. These glossy print images of a nation's clumsy reaction to economic disaster piled up by the thousands in our cabinets, tended by about twenty young people, uniformly thin and poorly nourished, who were in turn tended by a decaying professional whose talents, whatever they might have been, had lapsed into numbed mediocrity.

The Photo Project was not the Farm Security Administration Photo Section where Walker Evans and his commandos would shortly blaze a trail by their merciless documentation of the face of tenant-farming in the South and Midwest. Our work was literal documentation of the activities of the Works Progress Administration and National Youth Administration. In our files you could find countless images of day laborers wielding shovels or picks or wheelbarrows, youthful seamstresses sitting stiffly at sewing machines, crop-haired youths building log bridges in parks, dazed writers seated at typewriters, artists working on murals for libraries, actors on the stages of the Federal Theater's Living Newspaper.

We foot soldiers of the project learned to operate cameras, develop film, enlarge, print, number and file, and all of this without the slightest trace of enthusiasm. But perhaps I speak for no one but myself. For all I know someone in that company caught fire, fell in love with lenses and light meters, went onward and upward into the

stratospheric regions of *Life Magazine.* But for most of us our dreams were elsewhere. Our biggest common dream was to escape starvation. A few of us dreamed vaguely of fame.

In the end most of us outwitted starvation, and some of us achieved a minimal sort of fame. At least I'm disposed to think so although this disposition is tempered by the vagrant thought that fame in 1936 meant something radically different and more modest than today. Perhaps not really fame at all.

For me the parameters of fame were to be oddly modest. While the painters with whom I became associated went on to varying degrees of national and international repute I found myself contented with small notice in a single town of a single provincial region. And if this possibly reflected more modest artistic merits it also reflected a hopelessly provincial sense of values which could not conceive of operating beyond the boundaries of the home terrain. (For in spite of my youthful arrogance in wanting to be of my own time, the blood of my parents and their parents and their parents had cased me in a tough peripheral integument which bound my perspectives to the near and the tangible, a heritage of generations of yeomanry stretching back to the crofts of the Highlands or to timorous clearings ripped out of the dark forest by lean desperados lurching through Cumberland Gap with old Boone.)

We were all so shabby and thin and unformed and anonymous!

Surely each of us did something noble or ignoble, notable or unimportant, lasting or transient. Quite possibly one or two names live on in the carved marble immortality of Victory Plaza where the names of those who gave it all up in the Second World War or Korea or 'Nam live on in imperishable glory, dazzling the eyes and hearts of their grateful countrymen as they feed the indifferent pigeons. But at that time we were indistinguishable in our shabbiness, our thinness, our shapeless unformed anonymity. A frightened nation was paying us a pittance to keep us off the streets. Wrapped in our private dreams we scarcely noticed each other.

Indian Summer, 1937

Indian Summer in 1937 was hot and indolent. One day after lunch the project manager delegated three of us to pack up cameras and equipment for a patrol over to the Federal Art Project in the Maritime Building. Laughing and joking, we packed up, welcoming the opportunity to get out of the fetid cling of the dingy little rooms and stroll lazily the few blocks to the Art Project in the hot sunshine.

But here a question arises.

Who knows today what was the Federal Art Project?

Studs Terkel recently pointed out that the New Deal arts programs have virtually disappeared from the national memory. Their repercussions and reverberations remain in ever-widening circles. Indeed the whole course of the so-called cultural explosion of post-war America was blueprinted in coarse outline in the programs of the New Deal. Still only a few sociologists and historians remember them as part of the social history of the thirties. The hyped-up biographies of the trendy stars of fifties- and sixties-isms coyly mention that their subjects started their careers painting embarrassing social-conscious schlock as members of the Federal Art Project, leaving the impression that this was a youthful vice on the order of adolescent masturbation.

Was the art of the Federal Art Project so hopeless?

Who cares? What matters is that millions of people were hungry, that they suffered not only from hunger but disease, dislocation from their roots, from political oppression and vagrancy laws. Among these millions were thousands who had adopted the identity "artist." To their amazement these thousands discovered that before they exist as artists, they exist as people, that they were starving in the company of millions of nobodies who had never painted a picture in their lives. The resulting art of the Federal Art Project was a part of this massive pilgrimage and needs no apologies nor defense against the jeers of those who have never bled.

Contemporariness has become so engulfed in trendy waves of fad and fashion and hype, trumpeted in the shrill jingle of media jargon, that art before 1948 has become pretty much terra incognita unless it can be mortised into the modern fast-sell.

True, there is a continual exploration and search of these very areas in a frantic search for raw material with which to revive the jaded appetites of the Contemporary. Severely limited areas of the past are explored, invaded and settled by armed coveys of marauders in the guise of art historians, cultists, tribal gurus, and ingenuous seekers for Truth. Having settled in for a stay, say, in the regions of Catalan Renaxence or Patagonian Primitif, the new settlers, comfortably ensconced on the gravemounds of the vanished aboriginals, begin producing a New Contemporary Art Product, using the artifacts and effluvia of the graves for raw material. New Contemporary becomes all the rage for awhile, after which it is displaced by Newer Contemporary. The settlers lapse into surly defense of their entrenched position protesting the excesses of the Newer and Contemporarier. The history of art like the history of everything else is served up in little slices of chic with no sense of continuity or development.

And the results of this are not all that bad. We get new waves of fashion, new accessories, new styles of hair or eyeshadow, or greeting cards or posters or jewelry or god-knows-what. And our lives are made more colorful and more exciting and so forth.

Except, it's all taken so seriously.

One thing has to be validated by invalidating something else, preferably something in the immediate past.

So pre-1948 painting has pretty much been invalidated, which raises the disturbing possibility that one of these days it will be validated and will become New Contemporary.

What Was It?

So what was the Federal Art Project?

It was one of many New Deal work-relief programs, one of a number devoted to the various arts. Its existence was motivated by its supporters for many laudable reasons. The United States at the time trailed the entire civilized world (whatever that might be) in government support of the arts. Even Lichtenstein (the Duchy, not the painter) outspent us per capita. A Federal program of aid to the arts would mark us significantly higher in the scale of civilization.

There were a number of arguments for establishing such a program.

Art contains socially redeeming values (somewhat like vitamins) providing therapy for the bad dreams of the social body. This is Aristotle's theory of art-as-catharsis.

Art mobilizes men and women to struggle for a better world. This was the social consciousness thesis, and ended up being attributed to Karl Marx because his various disciples made more noise about it than anyone else.

The commonsense thesis was simply that it would keep many of us off the streets, producing art, appreciating art, and writing about art.

But there was a more cogent reason.

From 1930 to 1940 the private sector of the nation's economy collapsed, stagnated, collapsed again and stagnated again in endless cycle. Even workers in the useful trades were unable to find private employment. Farmers were driven off the land, their farms seized by the banks which held mortgages on the land. The administration of Herbert Hoover did nothing, assuring everyone that prosperity would start again in its own time, that it must start at the top (among the most worthy) and then trickle down (to the less worthy). Since there were some fifteen million unemployed and dispossessed plus their millions of dependents among the unworthy who were being exhorted to pull in their belts, help each other, and wait

Common sense — is two words

for the trickle from above, it was not surprising that 1932 saw the repudiation of the Hoover administration and the election of Franklin D. Roosevelt, who had little idea what he was going to do but was pledged to do something.

The New Deal had little idea what that something was going to be, only that mass unemployment, mass starvation and mass misery was insupportable and could not be left to the trickling down of an uncertain future prosperity. Confused and uncertain, goaded into action by the pressure of millions, it initiated a wide spectrum of reforms. One of these was a system of public-financed work-relief programs by which millions of workers and shirt-tail farmers were put to work for subsistence wages.

Artists were less useful than other workers. In the aggregate they had always been the vanguard of depression, leading even that perennial bellwether of recession, the farmer. Stagnation and collapse had been threatening the ranks of art since the French Revolution.

So the best reason for the Federal Art Project, the Federal Theater Project and the Federal Writers Project was to keep artists, writers and actors from starving to death. Five years earlier the idea would have been unthinkable. As far as the economic standing of most artists was concerned the arts programs of the thirties could have well been started in the twenties, for the arts had enjoyed only the crumbs of Coolidge prosperity. What was even more lacking than vision was fire power. If artists had asked, who would have answered? Now in the thirties, with millions of plebs knocking at the gates of power, artists rode the shirt-tails of the plebs into a works program of our own, a Federal program making use of the skills and not-so-skills of hungry artists, writers and actors. With some minimum monthly income we could descend from the garret to the storefront studio (thousands of small businesses having been forced to vacate their premises). The storefront was significant since it was nearer the street where the unemployed and the burgeoning unions were demonstrating, not to speak of the student masses arrayed against war and fascism.

That was the Federal Art Project.

Artists, 1937

The Maritime Building was (and still is) a square-block warren of high-ceilinged lofts on Western Avenue between Marion and Madison Streets. Offices and smaller storerooms were partitioned off by rickety walls of two-by-four and plasterboard. The Federal Art Project occupied a number of rooms on the fourth and fifth floors. A tiny waiting room housed a blonde typist, lately unemployed, showing it in the dingy pallor of her sagging cheeks. She perched timorously behind a desk surmounted by a typewriter which appeared better fed than its operator. Beyond her station a door led into the office of the Director. Nothing forewarned me that my stars would ever lead me into that murky little cave.

A door in the opposite wall led into storage and work areas. The big lofts had been divided into studios with flimsy partitions. The first two rooms were storage, filled with racks, bins, cabinets and boxes. Even a few people, filling, filing, removing, raising, hammering closed, tearing open, working in a euphoria of relief at doing something and actually getting paid for it.

A third room contained filing cabinets and shelves on one side of a narrow aisle separating them from four drawing-desks arranged next to the large windows. At each of the four desks sat a drab figure clutching a watercolor brush with which he was rendering a tightly painted image of some antique American artifact, handcarved wooden dolls, cast-iron banks, moustache cups and suchlike.

Looking less like artists than unemployed accountants, they each wore a threadbare suit, jacket stripped off and draped limply over the back of the chair or impaled primly on a wire coathanger and hung on the nearest protruding object. In their vests, swinging open to reveal fraying white shirts, they stored pencils, erasers, bits of gum, and phone numbers penciled on torn scraps of envelope. Two kept their ties primly and tightly knotted. One loosened his and let it drop like a dead fish between his thighs as he bent over his work. The fourth had removed his and hung it over the arm of his

instrument tray where it absorbed a series of intermittent showers of dirty paint water flipped from his brush.

Each one terminated on the vertical in a thinning layer of hair. Two parted it to the side, endeavoring to cover the bald spot. One parted his in the middle. One brushed wiry gray stubble back in a lumpy pompadour. All wore pencil-thin moustaches, trimmed to edge the upper lip tightly, influence of William Powell and Clark Gable.

Shrunken and sallow from poor diet they trooped in each day to sit stiffly, clutching their brushes and gazing at their work through giant magnifiers mounted on goosenecks. Each painting was an accumulated mass of thousands of minuscule strokes of watercolor applied short (without much water) over a base of traditional wash (color applied with lots of water). Highlights were built up by loading Chinese White (plus a tinting color) into a tiny area which would eventually rise slightly in relief. Their technique was a triumph of method, paintings as technically remarkable as the later temperas of Andrew Wyeth. But they were anonymous foot soldiers, recording with surrealist detail the vanishing trivia and everyday artifacts of an already vanished America. Eventually their efforts became part of the Index of American Design, a monumental and largely forgotten effort to record the look and color and texture of things which had once been everyday familiar to the hands and eyes of Americans.

Their leader, Fletcher, filled his armchair to overflowing, his massive bulk threatening to capsize its matchstick legs. His balding head had all the alien and remote look of a granite crag, except that clenched in his jaws at all times, a stub of evil-smelling cigar smoldered, never more than a stub and never less, held in place by the jut of his aggressive jaw. Why did the stub never burn down, why did his massive grinders never bite down on a fresh cigar? The constant wisp of haze rising from the cigar gathered in front of his eyes, trapped there by the green eyeshade which was popped on at eight every morning and torn off at five every evening. Rimless eyeglasses slid down the bridge of his nose to be held in place by the red round bulb. And through the hazed lenses of his glasses, around

the great bulb of nose, his little gray-blue eyes focused their hard glitter on the work at hand, guiding his enormous bear-paw as it stroked the tiny brush over the white paper, delineating the dainty details of some orphaned cream-pitcher out of the vanished frontier.

Alf at the second desk had lost the first phalanx of the index finger of his painting hand. His brush was securely locked against his middle finger by the truncated knob of the index. In his off hand he clutched a cigar, smoldering incessantly, like Fletcher's alight forever. Presumably, it balances to this day on his tombstone, an eternal beacon of wispy smoke by day and a feeble glow by night to mark the resting place of one more Good Soldier.

Walter, quiet and self-effacing, was an alcoholic. He sat through the day, a bemused smile on his face, working quietly, greeting acquaintances with a keen beam of his warmly brown eyes. At night he shrugged into a worn topcoat and disappeared on the instant. Alone in his little room, far removed from the roistering clangor of taverns, he downed pints of cheap muscatel, filling up the chink and crack between dinner to bed with a wadding of alcohol to submerge and eventually drown out the memories of a wife and child lost in the wreckage of the first flash-flood of disaster of the years of Depression, until, floated away on the disintegrating measures of Gus Arnheim's orchestra playing *Tiptoe Through the Tulips,* he slid away into sleep.

The fourth figure I remember only as thinning, parted hair, fraying clothes and a constantly fondled pack of Wings, one of the ten-cent packs of cigarettes which burgeoned during the Depression. His face has bloomed with the mold of time until it resembles a sort of cloudy excrescence without feature. He sits there in memory, without name or remembered image, the Fourth Horseman of my Apocalypse, a victim of my faulty memory, lost beyond hope of recovery.

In the next room stood a large canvas propped against the wall. Actually the canvas was a great sheet of sailcloth lashed through grommets to a two-by-four frame. The artist stood in navy-blue serge trousers and vest, his coat tossed over a chairback. His rump had polished the blue serge of his trousers to near mirrorlike perfec-

tion, his vest hung slack and frayed from round shoulders. His hair was dark but disappearing under the encroachments of a brow which advanced relentlessly toward the peak of his skull. What hair he had lost from his head had apparently taken refuge beneath his nose where it reappeared as a wadded black moustache. As I watched, he glared at the canvas out of watery eyes imprisoned behind spectacles. From his vest pocket he removed a tiny tube, out of which he squeezed a jelly-like grease which he rubbed on his lower lip, then licked off with his tongue.

The next room rattled with carpenters and cabinetmakers pounding, sawing, planing and chiseling at stretchers, stands, stools, cabinets, desks and carved bears.

In a rear room a buxom lady of advancing but lovely years wreathed her short ample body in the traditional sculptor's smock out of which she conducted a tireless attack on buckets of modeling clay, transforming the wet slop into figurines. The whole room seemed to boil with miniature pioneers, cowboys, Indians, farm women, kids with dogs and an occasional antiseptic nude tripping a not-so-light fantastic in the flailing veils of Isadora Duncan.

We staggered through the rooms, setting up the camera, standing by while our boss shot the activities, proving to Congress, the taxpaying public and a dubious press that somebody was doing something with their money. It was our job to keep charts correlating plates with subjects, so that a photo of the sculpture-lady would not appear over a caption identifying an aging male watercolorist painting an antique American cast-iron bank depicting a mountain-man shooting a penny off his Kentucky longrifle into the hinged mouth of a grizzly bear.

One set of photos taken, it was our job to dismantle the equipment and drag it into the next room, there to reassemble it and repeat the ritual. We worked our way in this fashion from room to room, following our impatient commander as he led our patrol on to the next stage of the perilous struggle for glory and fame and possible disaster. His own aim was modest, to get done with the job, return to our basement, put us to work developing the negatives while he retreated to his desk with a brown bottle of booze and a pulpy copy of *Breezy Stories*.

Like Wolfe and his colonials at Quebec we stormed from room to room, except that our struggle was waged along the horizontal rather than the vertical and we eventually emerged not onto the Plains of Abraham but into a high-ceilinged room where we confronted not the gallant Montcalm and his French and Indians but one tall intense young man standing at a drawing desk by the mullioned windows. Besides the drawing desk and the young man the room contained a large table covered with drawings and a pair of easels holding large rough-textured canvasses covered with pigments slashed onto a brown imprimatura.

The young man glanced briefly at us.

His eyes, dark and liquid, seemed to look through people and birds and rotting fruit at the timeless patterns engraved there by the hand of God.

I Meet Morris

Morris Graves had won the Katherine Baker Memorial Award at the 1934 Northwest Annual in the Seattle Art Museum. Subsequently, a picture of him was printed in the rotogravure section of the *Seattle Times*. Morris, thin and smoldering, wistful and folded up on one of the Art Musuem benches, languid hand propping up his winning *Moor Swan.* I clipped out the picture and pasted it into my scrapbook between a print of Rembrandt's *Portrait of His Son Titus,* some gravures of Tanagra clay figurines and a Charles Russell pen- and-ink drawing.

Since 1934 so many prize-winning paintings have trashed their way across our vision that we've become jaded. Largesse breeds indifference. Familiarity breeds contempt. Halter-champion studs with holes in their pedigree are bred to good mares and breed geldings. The postwar cultural explosion has often cheapened the indi-

vidual experience at the price of widening the collective experience.

In 1934, however, there was only the Annual, the only stage on which the artists of the Northwest could do their song and dance turns in front of a sparse and nonopulent audience which often looked but seldom bought. Buying paintings, except for the wealthy, was a habit on the other side of a mountain labeled war. Although we all could see the mountain looming up, none of us had any idea of what lay on the other side.

Winning the Annual was a major event in the life of the young artist. So Morris, the victor, sat having his picture taken, brooding and inward, exuding indifference while the Swan stood in its armor of pigment, remote, diffident, unseeing. An elegant and severe painting, one of the few winners over the years that stick in the memory, and indeed, one of the landmark paintings in the idiom that would eventually come to be called the Northwest School.

I had seen the photo in the *Times,* clipped it, and had visited the Museum and seen the Swan, fingering the ragged impasto secretly when no one was near, had stared at the rough pigment from close up, my nose to the canvas, reading the forbidding relief-map of ridges and valleys. Then had leaped back to see it from across the room, the chaotic pattern of black and umber and muted pinks merged into a coherent image of regal bird.

Up to now my acquaintance with great art was by the way of reproductions, page-sized and reduced to the dot-pattern of print-ers' ink. Now I had met a great painting in the flesh, painted by an artist not much older than I, one who breathed the same air as I. The gray, softly muted air of the Pacific Northwest.

The Town Crier

The *Town Crier* went back to 1912. Margaret Bundy, who was to become Margaret Callahan, was editor for a time in the early

thirties. At the time that I wrote for it, the editor was Lancaster Pollard and the magazine was on its last legs. I came in to the office some time in late 1937 when the magazine was being published at First and Virginia and found Pollard at his desk, buried in papers, good-naturedly explaining to Charles Hilton, who wrote literary criticism, that someone had absconded with some funds, of which there were precious few, and that publication would probably have to be suspended. The magazine did suspend publication. A year later, amazingly, one more issue came out with Hugh Gale as editor and Pollard contributing an article. This last kick of the dying rabbit's leg floored me, and I still have no idea how they managed to pull it off.

In any case, I wrote an art review in the June 23, 1937 issue, a long article on music plus a long review of the Northwest Annual in the October 13, 1937 issue, and a short article on the paintings of Alexei Jawlensky, an associate of Kandinsky, in the October 20 issue.

In the July 23, 1937 issue I found that "Callahan . . . suffers at times from his tendency toward intellectual content in his paintings. At the same time he is technically one of the finest artists in the Northwest." I find this hard to follow, but you have to remember that I was twenty years old. Kenneth's paintings were not burdened with intellectual content at the time, nor indeed was he ever an "intellectual" painter, if by that we mean a painter whose images contain extraneous material beyond the parameters of painting itself. Which doesn't mean that they didn't contain intellectually challenging material. But how they "suffered" from this is certainly unclear to me now, and sounds as if I were trying to be profound.

The October 13 issue was important. In a three-page article I reviewed a presentation over the radio of the four last Beethoven quartets, each paired in a concert with one of the four Schoenbergs. The series, presented by the Kolisch Quartet, was one of the highlights of thirties radio.

It was in a two-page review of the Northwest Annual that I burst forth as a partisan of what was the avant-garde of Northwest painting at the time, starting out by flatly declaring "the finest

paintings of the show are to be found outside the list of prize win-
ners." Disposing of the winners as safe, unexciting mediocrities, I
quickly took up the cudgels for what I titled the progressives (as
against conservatives)."One of the very finest works of the show,
Still Life by Guy Anderson, as hung suffers from the lighting . . .
but despite this problem the work impresses me as one of the finest
paintings ever to hang on the Museum walls. The color is quiet, but
deep and rich, relieved here and there with a bright spot of lumi-
nous color; composition is excellent."

A little later I complained that "in the case of some progres-
sives, the jury hung works comparatively inferior to those rejected.
Kenneth Callahan's *Old Lady On the Beach* while brilliantly executed
is nowhere so important as his *Horses on the Beach* which was re-
jected. Morris Graves is represented by a very fine painting, *Dis-
mantled Fort,* much more conservative than his *The Wolf of Rome* and
The Fountain, both rejected. *The Wolf of Rome* is particularly fine,
though not calculated to appeal to those who like pretty pictures.
Graves reminds me of El Greco, not in surface qualities but in the
extreme subjective intensity of his work. He and Callahan are to my
mind the most important painters working in this region at the
present. True, their paintings lack the facile surety of the conserva-
tives. They stammer repeatedly. They fumble towards an expression
yet more intense. They are not attractive. They are esoteric. And
when we have said all that, we remember that it is the exact line of
criticism which has been leveled at the true artists of all ages."

So it is not hard to understand the stir within the Callahan
circle caused by this stormy little article written by someone un-
known to them. And their astonishment to discover that the writer
was an undernourished youth three years out of high school must
have been acute.

The stilted style offends me and it's hard to recapture exactly
what I was trying to do outside of jump in with both feet on the side
I chose for my own. Reading it over doesn't endear me to myself as a
critic, which I never was, but it does recreate the work of my friends
as I first saw it in the midthirties. And it recreated the spirit, the
sense of art as an adventure, in which we "progressives" arrayed our-

selves in battle against the "conservatives." And this was somewhat the way things were in actuality, and my article certainly helped to crystallize matters in that sense.

The Group of Twelve

In 1937 Frank McCaffrey's Dogwood Press printed a brochure entitled *Some Work of the Group of Twelve.* I ran across it on the new-book shelf of the Art Room of the Library. It contained no overall description or statement about the group as an entity, merely twelve individual statements of purpose. None of the participants with whom I talked shared any feeling of groupness, and memories of how the brochure came to be printed were hazy.

By 1937 I was familiar with the work of most of the Twelve through the Northwest Annual and shows in the Museum and Henry Gallery as well as the Fifth Avenue Art Gallery, located on the east side of Fifth Avenue, across from the Olympic Hotel. The latter gallery acquainted me with most of the well-known painters of the area at the time—Eustace Ziegler, Edgar Forkner, Paul Gustin, Paul Immel and other pictorialists as well as the avant-garde painters represented in McCaffrey's brochure.

While the term "group" was somewhat an exaggeration, it was significant in Seattle painting of the thirties. Art in the area had scarcely exchanged diapers for training pants. Amateur pictorialism of the genteel finishing- school watercolor sort had only lately given way to professional pictorialism by people who were often commercial artists as well as painters. The unquestioned master of local pictorialism, Eustace Ziegler, dominated his field much more thoroughly than Mark Tobey was ever to dominate the insurgent avant-garde.

The key question was to eventually be "What is the nature of reality?" And from this question artists would be led on to explore

the nature of dual reality, the reality of the world and the reality of art and of all the multiple realities which proliferate around them. And if the artist was convinced of the importance of the eye as a primary agent in starting the painting process, he could begin the painting process; he could begin the tortuous experience of journeying from the eye to hand to brush to the surface of the painting.

AVANT-GARDE
A.

These were the questions addressed by the Twelve in their statements and in their work, and they were the questions agitating the dinner tables, living rooms, studios and taverns and greasy spoons where the ideas which later grew into the Northwest School were being shaped.

B

The pictorialists were seen as conservatives. Conservatives did not question the conventional assumptions of post-Renaissance art as to the nature of the three-dimensional world or the fundamental principles of translating it onto a two-dimensional surface. The progressives questioned everything.

Today it is virtually impossible to reconstruct the tone and texture of this conflict. Pictorialism and a hundred different schools coexist peacefully. No one gets exorcised about anything. Nonpictorial art in bizarre forms undreamt of in the thirties has become a part of the academy, which includes all.

But in the thirties the battle which had started in Paris was only beginning to stir up the surface of the Seattle art world. Before our advent there were a few daring quasi-impressionists, who shocked people by dividing color or using open brushwork. And in the thirties, when I first arrived, the Twelve had just made their statements, although they were intangible as people to the art world, since they existed as a group primarily in McCaffrey's brochure. It still remained for a coherent body of artists to launch a direct attack, and this would come in the form of the Callahan circle, the Northwest School, or whatever you care to call us.

The fundamental question of "How does the eye see?" remained. At that point I doubt if any of us considered its extension to "*Does* the eye see?" And the questions rising from this were going to be talked about in the Callahan living room, in Morris' arcane caves and in Tobey's sunlit studio.

1. KENNETH CALLAHAN
2. MORRIS GRAVES
3. EARL FIELDS
4. GUY ANDERSON

At the time when the Twelve gave their answers, artists had generally to depend on their own analyses, their own instincts, for answers. Peter Camfferman, who had been born in Holland in 1890, spoke in his usual brusque aggressiveness: "I am living in constant amazement at the public's insistence on realism, as if the photograph of a clock depicted the spirit of time . . ."

And this was to be the theme of all Twelve. All were concerned with an attack on the tenets of Realism, and this in 1937 which had been the theme of the war in Paris one hundred years earlier. By 1937 in Seattle, all progressive artists were in agreement that Realism was the target, Realism and the blindness of a public which had grown up with it as a virtual article of faith.

In response to the general question "How does the hand interpret visual reality?" the Twelve split into three subgroups. Three Japanese-American painters (Nomura, Tokita and Fujii) struggled to synthesize eastern and western approaches to seeing reality and painting it. All were born in Japan in the 1890s. None really solved the problem they posed, and it was eventually resolved by the Chinese-American painter, Fay Chong.

The largest subgroup were painters close to the academic scene, either the University of Washington School of Art or some high-level academy or institute. This group included Walter Isaacs, Ambrose and Viola Patterson and Elizabeth Cooper, all related to the University of Washington School of Art. It also included Peter and Margaret Camfferman, who had studied in the Minneapolis School of Fine Art.

These painters produced work that was bland, harmonious, decorative and noncontroversial. They reconstituted reality rather than reflecting it, but their reconstitutiion was selective, abstracting from the real world the experience of the pleasant, the decorative and the balanced.

The final subgroup was made up of Callahan, Graves and Earl Fields. Callahan and Graves were, of course, the stormy petrels of the group, and with Guy Anderson, represented the true avant-garde of Northwest painting at this time, all of them marked by a

stance of support toward <u>Mark Tobey</u>, who <u>was still in England.</u> Fields was the son of Finnish peasants who came to the United States in 1903 to escape from the Russians. He painted in a stolid, plebian idiom utilizing a simple pictorial technique which was capable of great power at times by virtue of its lack of technique, a way of painting which actually had at its best a sort of Zen quality of getting the suchness of things by not intervening with technical finesse. Eventually Earl lost interest in painting, worked for years at the Museum and indeed became the Museum's photographer. He is the curious loss of the period, a painter who definitely showed a potential idiom that could have grown and didn't.

Time has certainly passed since then, if we accept the illusion of time passing in a linear sense. Morris and Kenneth, along with Mark, have been explained, analyzed, interpreted and expostulated by so many writers, scholars, experts, docents, critics, enthusiasts, detractors, scholars and interviewers that it is hard to see through the dust raised by all these mandarins, hard if not impossible to see 1937, that lumpy year of depression and slow-moving lives, and Morris and Kenneth, still very young, stating their aims at the virtual beginning of their painting lives.

In a sense, it's easier for me to see them, except that I always see them as older than me, more established, more formed, more centered. But it is true that I can visualize them, presence them before my inner vision, and there it is generally 1937 or 1938 or 1939 or 1940.

Sue and I met Kenneth one afternoon in Pioneer Square a year or so ago and talked for half an hour, Kenneth still fiddling from one foot to the other, laughing his embarrassed self-deprecatory laugh, finally darting off for an appointment with Don Foster.

I stood staring at the space he had just vacated until Sue jogged my arm. After all we were hungry and it was time for lunch. But I found it hard to allow him to be gone. I could still see him. His face was a bit more rosy, reflecting the heart trouble that has troubled him in recent years, but his face always had a ruddy hue, and his presence was little different from 1937 to me. I half-expected an invitation to come to dinner, to hear how young Tobey

was doing with his first steps, that Margaret was well and in good spirits and longing to hear from me. Then Sue jogged my arm again, a puzzled smile breaking over her face, and I levitated reluctantly back to 1984.

But you can see how it is. And that's why the scholarly studies mean little to me. They contain all sorts of data that is new to me. I didn't bother to collect the data in 1937 and it doesn't really mean much now. I read my friends' words from 1937 and it's the present, either 1937 is 1984, or 1984 is 1937. Out of all the twelve statements these two speak now with the same intonation as then, I hear them with the same ear, a nerve begins to vibrate, it passes on to other nerves and soon I'm back in 1937 myself, fresh from the country, sitting at a table in the Art Room of the Library, looking over the little brochure in its stiff library covers, saying to myself as I read the words of Morris and Kenneth, "That's it!"

This is what they said back in 1937.

Morris: "I believe that the greatest value of a creative expression is current *only when available to an audience,* and that they can be reached only by overstatement. That in painting, one must convey the feeling of the subject, rather than the imperfect physical truth through photographically correct statement of the object."

Kenneth: "I do not believe the basic importance of painting is aesthetics, nor do I believe that painting is for decorative purposes. I do believe that it is a language of its own, bound by certain rules through which an individual can express his consciousness of life in its broadest sense. To this end, a complete understanding of problems peculiar to painting is necessary . . . by which the painter can make concrete *the essences of things, that eternal truthfulness and permanence that lies below the surfaces of life and objects.*"

The emphasis is mine. I'm impressed once again by the simple declarative force by which my friends cut to the core of the question, the need for an audience to whom you communicate by overstating, that is, by cutting past surfaces and appearance to essences.

At this time Kenneth was thirty, Morris was twenty-seven, I was twenty. Since that time, we've all suffered numerous and grievous wounds, most if not all self-inflicted, which is the nature of

those kinds of wounds. We've all felt the tug of the seducer at our sleeve, known the utter despair that says to you in the night, "After all, isn't it just a bit of mud smeared on a flat surface?"

All of us have felt what Walt Whitman called "the bitter hug of mortality." Oh, yes indeed!

All the same I read those words and a nerve vibrates and I'm in 1984 and 1937 simultaneously or wherever the universe pleases to have me, and my friends' words are realer than real, and I'm glad it pleased the universe to make me a painter.

To Think About It All

Our crew had finished its chores and packed up to leave. Morris had captivated me with his grace, drawing me out about my own work. He ended by inviting me to dinner the following week.

Forty-five years later I sit in our house in the Cascade foothills, writing this memoir. Depression over, war triumphantly concluded, witchhunt and blacklist come and gone, even the magical outpouring of the sixties and the Woodstock Nation dismissed as an antique and bizarre incident in an increasingly irrelevant past.

And memory hovers stubbornly over the image of that sunlit loft, retrieving crumbs of remembrance, conjuring up the tone of a voice, the glisten of an eye, the feel of rough oiled planking through thin shoe soles. Trying to see myself standing thin and hungry, raggedy-assed and shabby, realizing that what I had never seen before in that room was myself, my own very self standing there talking with Morris. I see the room, Morris, myself, and I hear the murmurous drone of our voices and the background of things and people.

To stand there and talk with an artist whose work I had admired for three years, practically one-sixth of my life. To hear his familiar talk of Kenneth and Margaret, of Guy Anderson and Mal-

colm Roberts. To speak of the great names. To hear him speak of El Greco, of the *View of Toledo,* to know that even as we spoke, El Greco's terrain was shattering under the guns of the Spanish Civil War. To listen to his detailed description of the color declensions of Joan Miro's *Dog Laughing at the Moon.*

To stand in that sunlight, to speak with that voice, to feel the surge and mutter of the future, to know that a door had opened.

To think back to that morning.

I had gulped my breakfast, Shredded Wheat with cream and sugar, sprinkled with salt.

I drank my Ghirardelli's chocolate.

My father left for his job as a foreman on a WPA project. My mother slept. Later she would rise, dress, and start out on her foot rounds as an Avon lady, trying desperately to add to our family finances, striking deep into my father's heart the desperate fear that had undermined the certainty and confidence of millions of American husbands and fathers as their earnings became more and more insufficient for their family's needs.

I hurried out the door and down the gray-misted hill.

Stumbling to my seat on the Greyhound bus, I sat bemused as it charged smokily through the autumn morning, past Quarry Hill and over the Duwamish Bridge, through Georgetown and up Second Avenue, past the Smith Tower to alight dazed at Marion Street and hurry back up the block to the photo project in the basement.

Morning was routine. The low-ceilinged rooms stank with the acrid odor of prints rotating in the big drier before they fell to the counter to be sorted and labeled.

The desultory rattle of adolescent voices. What did we talk about? We must have talked about something, made plans for lunch, spoken of girls, baseball, movies. But the words are lost, the faces are lost, the voices are silenced.

Lunch came, for most of us dry sandwiches out of paper bags, perhaps an apple, perhaps a candy bar. After lunch, the head of the project calling three of us back to his corner, pack up the cameras and the equipment, lads, and carry them over to the Federal Art Project in the Maritime Building.

Setting out up Second Avenue, then down Marion, loaded with boxes and cameras and packages of film and tripods, passing idle words with my comrades. Did I foresee any epic encounters in the hours ahead? I certainly felt curiosity. Perhaps someday I would find a place on the Art Project? Could I have visualized that as a serious possibility? And was I aware that there would of necessity be painters on the project whose work I would know?

No matter, we would take our pictures and return to the Photo Project. I would catch the Foster bus at day's end. I would eat dinner. I would draw and paint and read. And go to bed in my attic room. Dreaming.

Arriving, I was intrigued by the high-ceilinged rooms with their activities. And yet I felt a twinge of disappointment. This was the Art Project, these were artists? These sad, plodding men and women were not the great companions of bohemian legend. Here were only the same curiously gentle victims of the depression that you saw anywhere, in general work projects, at relief offices, standing on street corners, seated in their homes listening to their radios.

Today in a world lashed by ceaseless unrest, rolling in a continuity of multiple violence, it is hard to recall how gentle were the great masses of men and women in the thirties, how they stood or sat or lay down in stunned bewilderment, uncomprehending what had happened to them.

Here on the Art Project they were again working, employing their professional skills for a token wage ranging from $66.00 to $97.00 per month. Much of what they did would be used to shed some warmth on people, depending on the foresight and the fight put up by the project director and the art community where they happened to live. But as a whole, they moved and worked in a vacuum, frozen in stunned gestures, their work was not infused with the self-confident energy that even the most minor of the arts generates. Working for a wage that was grudged as a dole, subjected to a daily barrage of attacks in the press and on the radio, hearing themselves caricatured as shiftless deadbeats wasting the taxpayer's money, they passed each day with the mark of failure on their pinched apologetic faces.

To Think About It All / 29, 39

All I saw at the time was that these were not the great companions of the legend. Like my friends and our boss I looked forward to finishing the job and returning to wind up our day's work.

Consequently, I wasn't prepared for the last room.

To step through the doorway out of a loft bustling and grating with trivial activities. To step through into a great silent cave lit by the soft light of dirty windows. To see standing at a desk by the window a figure which had so far existed only in a frayed rotogravure photograph glued in a scrapbook.

To stagger inwardly under the shock of recognition.

To know in that instant that this time and this light and this space had been inevitable, prepared for you by the gods.

To know that only this figure, thin, tall and intense, bowed over his drawing board, could be standing there.

Struck dumb.

Already retreating with your companions to the pedestrian and the prosaic, wrenching yourself back into the cave, risking all, breaking through his concentration, speaking his name.

To converse, to hear his low voice talking the known names, to be admitted to that company, to sit at dinner, to bathe in glory.

To be foolish and not-foolish.

The illusion was not all illusion. For about four years we did exist as a little company of men and women who somehow stepped out of their mundane worlds into a world of some light and even a bit of glory. At the center of it all sat Margaret Callahan. Around her were grouped the painters who would someday be known as the Northwest School, and around them were grouped the friends who shared in the vision.

And I would be admitted into this circle to call these people "friend," to plunge into the surge and welter of a life bigger than my own.

In 1937 it was my happy destiny to step into a world where I would sit at tables undulating in the glow of excited voices. To visit friendly studios, look at new paintings and drawings, murmur words of encouragement. To walk the streets of the city out of afternoon into evening, across the bridges of night, emerging, sketch-

book in hand onto the banks of morning, smiling into the eyes of your best friend. To breathe salt air off the Sound, to offer your arm to a drunk teetering on the edge of disaster. To scuff a bit of graphite over the surface of a sketchbook page, conjuring up the look of a slim girl disappearing up Madison Hill. To shoulder your way through the crowds at the Market with Ken and Margaret. To stop in wordless astonishment, plucking uselessly at Margaret's sleeve. "Oh my god! You missed him!" Missed who? Old Walt Whitman? He's dead. And yet. . . .

For that is the world that opened and in youth and folly I knew that it was inevitable, that the gods which had withheld many gifts had offered me this one, had led me surely through the door where I would speak to Morris and he would answer, and we would be bonded friends, and the invitation would be offered and I would walk up Profanity Hill between the ranks of concubines and step through another door to break bread with Morris and Lubin and Kenneth and Margaret.

I Go To Dinner

A week after the meeting at the Art Project I took the evening bus into Seattle, dropping off at the Skidroad station at Second and Main, now dissolved into the bland landscape of shops and shoppers. In the cold October twilight the figures of passing pedestrians emerged, dissolved and reemerged from the translucent mist. Fragile yellow headlights traced quivering lines of pallid light in front of sputtering automobiles. The city began its descent into night. As the darkness flowed into the remotest corners a quiet hum rose from the streets, the sound of voices looking for the joys and surprises denied them during daytime. I felt my pulse quicken with the secret excitement of the city streets. Secret because it was unknown to me. Excitement because with the gullibility of the provincial I took

it for granted that what is unknown is by definition exciting.

I walked over to Second and Yesler and started up Profanity Hill. The hill was steep but I didn't care to use a dime to ride the cable car. Past Prefontaine Place, past the old jail, past the eroding store fronts, up the hill to Sixth Avenue, where I crossed down to Washington Street. The jangle of cable cars was faint now, the streets darker. Clumsy Victorian mansions in disarray lined the street, their dignity somewhat restored by the embrace of darkness. The sidewalks were cracked and broken. In places they had subsided to gravelly fragments. With sufficient care and attention you could break a leg. From the windows came the rapping of diamond rings on the glass as scented harlots in crepe-de-chine wrappers competed for the attention of passersby. My reading in the literature of the French decadents had prepared me for this initiation into the music of venery, and my nostrils flared with sickly agitation. Windows slid creakily up and Southern voices, musky and indolent, coiled out and around my ears, stroking, tweaking, entreating. The agitation unrolled through my veins, swelling my belly, weakening my knees.

Old memories of the South and slavery coil viscid in the bellies of the grandsons of Appomattox. I was in the living presence of Southern voices, Southern flesh about which my grandma had told me, her gentle border accent embracing all Southerners, white or black. My grandma had stood, a child of six, while Jayhawk militia had burned my great grandmother's house to the ground, casting adrift on the roads of misery the entire household, including those of what is coyly called color. 'Black and white, we are all children of God,' said my grandma. Somehow, without specifics, I realized somewhere along the line that black and white might literally be children of the same branch, that my grandma and my mother demanded gentility toward black and white without discrimination for the simple reason that you could not possibly know when dealing with citizens of color but what they were blood kin. And this fact of life, fitted with my grandma's religious beliefs, equipped us to reject racism simply and without ostentation because racists rejected and injured folk who were very possibly our kinfolk, and loy-

alty to kin was taken for granted. So that was that! And now, for the first time since my grandma's death I was hearing the whispered accents of South, a murmurous rustling of countless tongues abroad upon the night, addressing me not as kinfolk but as a potential customer, kinship being of no consequence whatsoever in the dash for cash, depression having rendered even venery an oftimes losing proposition.

The voices curled deep into my veins warming me with a liquor far transcending mere sex, returning me to a sense of my past, opening another door onto a present enmeshed in the past and tangled into the future. But I hurried on, thinking only of my destiny contained in the firelit rooms of Morris' place, freighted on friendly voices gathered around dish-crowded tables, not able yet to see that destiny that night was wearing a whole ensemble of faces, opening doors upon doors upon doors.

At Tenth and Washington, a half-block lit by two weakling street lamps bracketed a row of Nineties townhouses descended to tenements. They loomed high and narrow, like the superstructures of the great aircraft carriers which were even now forming in the wombs of war. Lemon light seeped from windows and muffled voices of domestic revelry or warfare limped out upon the night air. For the most part the street stood quiet. From a doorstep two thin black children stared soberly at me and I stared soberly back, wondering from what Southern roots had these branches sprung, were these children kin to me?

Halfway down the block, a porch with double stairs flanked by iron railings led to a double door in the middle of which a key protruded. (Today, we have a similar key protruding from our front door in Upper Preston. Few of our friends use it for the simple reason that this kind of doorbell is not familiar to people today.) I stood a moment, catching my breath. Under my left arm I held a clumsily wrapped bundle of drawings and small paintings, my portfolio for entry into the world now beckoning from beyond the door. Inchoate maunderings ran through my head, warnings, fears that my small-town clumsiness would mark me a fool and a clodhopper, suspicions that my intensity of feeling would lead me into catas-

lyrical writing

trophic excesses, that the evening would end in disaster, my draw-
ings lacerated and burned, my manners and clothing objects of
scorn, my abject skinniness seen as the mark and proof of failure,
my words dismissed as tedious, flatulent, pompous and silly.

Nearly fifty years later, I still stand each day before that same
door meat-hooked on the fears, the same warnings, the same suspi-
cions, pleading with God who does not deign to exist, to guide me
out of this valley of despair.

I Step Through the Door

I stood there on a porch at Tenth and Washington in the cool
mist of an early October twilight in 1937. The ripples from that
moment would spread out in ever-widening circles year after year,
but of that I was unaware. I knew only that in a moment I would
turn the key in the middle of the door, the ratchet would sound a
bell on the back of the door, and the dark hallway, undulating
through the uneven glass of the window, would be broken open by
the light of a door opening somewhere interior and someone would
come and the door before which I stood would open and life would
receive me.

And so it came to pass.

I reached out, turned the key with unexpected violence and a
garish clatter ruptured the blackness of the hallway. A heavy drape
parted briefly in the bay window to my left and an unidentifiable
fragment of face glanced out. The drape pulled closed. A long mo-
ment passed. Nothing happened. Would the unidentified face
choose to leave me standing there for eternity? A blinding flash lit
my brain. Behind the drape Morris was entertaining other more in-
teresting friends, urbane, nonrural, sophisticated. I had intruded
where I didn't belong! Or perhaps it was all a cruel joke. Morris,
recognizing the churl behind my guileless face, had invited me to

be the exhibit in a charade for his fashionable admirers, sophisticates who would smirkingly encourage me to show myself foolish. (Fortunately, I had not as yet learned how Morris was quite capable of doing such things to punish the effrontery of persons who really had violated his hospitality.)

So I stood nervously shifting from one foot to the other. I heard footsteps. A door slid open between the interior rooms and the hallway, letting escape a faint sliver of orange light. A tall figure stepped through into the diluted darkness and loomed suddenly behind the glass of the door. Leaning forward to peer through the uneven glass, Morris' face appeared white and corrugated behind the translucent barrier. The door swung back. Morris towered over me, his hand extended in greeting, murmuring, "Well, you've actually shown up! I wasn't sure you'd honor us with your presence. But you really are here . . . and I see you've even brought some of your work."

My right hand firmly clasped in his, dizzy with relief, my left arm frantically flapping to keep the clumsy parcel of my stuff from spilling all over the porch, I stammered some banality and was yanked gently into the hallway and through the sliding door into a lofty-ceilinged room crammed with furniture, drawings, paintings, bits of found-art, artifacts. I stood there overwhelmed, voiceless, awkward and ungracious. Yet within my breast there chanted a swelling egoism telling me that I had successfully stepped through the barrier door into a world to which I by right belonged, which must acknowledge me, and in which my destiny would not be ignoble.

In the pedestrian reality of the moment Morris graciously managed to untangle me from my bundle of amateurish smudges, restore me sufficiently to maneuver me into a chair without knocking over any of the assembled artifacts, and excused himself to disappear into the rear of the apartment, presumably into the kitchen from which issued a lumpy drone of stirrings, choppings, rappings and thumps. Voices, too, for in addition to the low pitched tenor of Morris, I could distinguish a deeper voice, a sort of casual growl appropriate to a friendly brown bear.

lyrical writing

I could only sit in my deep Victorian armchair, leaning forward occasionally to peer into the corners of the room at some article of furniture or some drawing perched recklessly on the edge of a stand. A fire burned in a tiny grate in the center of a tile-fronted fireplace topped by an ornate mantlepiece crowded with vases, bits of wood, drawings, photos, old books and flowers. In the bay window stood an immense library table, larger than the one at home, and over its surface was spread the same torrential clutter of things and stuff.

I settled deeper in my chair, nervously gazing around, amazed and pleased at the display. On the library table stood a framed photograph: A Yesler storefront, a window full of odds and ends, very like the jumble on the table and the mantlepiece. In the window a sign, IF You DON'T See It, ASK! Over the front door another sign, *Father Divine's son,* Bill. In front of the door a dour black man, heavy-set, presumably Bill himself. In another smaller window another sign GOD LOVES YOU. ASK AND YOU SHALL RECEIVE!

The books on the mantlepiece, scattered haphazardly, contained none of the usual titles of the literate, neither classic nor modern. Instead there were cardboard-backed pamphlets by obscure occultist gurus, leatherette-bound gems of literary trivia, books of Rosicrucian philosophy and numerous pamphlets and newspapers of the Harlem prophet Father Divine.

Father Divine was a true phenomenon of the Depression. A Harlem streetcorner preacher, he launched a widespread campaign by press, pamphlet and radio, announcing himself as God made Flesh come to lead the chosen, regardless of race, out of the chaos and misery of Jim Crow and economic disaster. To his ranks he attracted not only thousands of blacks all over the country but thousands of whites as well. And over these battered lives spread not only an idiosyncratic spiritual therapy but physical well being as well, through the ministries of missions in every city at which the poor and defeated could find fellowship, spiritual sustenance and red beans and rice. For years I dined at the Father Divine Mission on Madison where gourmet meals were served to the poor at low prices.

At this time Morris was deeply impressed by the message of Father Divine. He was not one to become a follower and propagandizer. No groupie, his conversation, as on this evening ran to obliquities. "Have you ever run across any of Father's writings?" he would query, handing you a pamphlet or newspaper.

"Well, actually . . . no!" in a nervous whine, fumbling the print into focus and running your eyes stumbling down the uneven lines of crudely set type.

"I feel that there is really something very deep here, really deep!"

"Umm . . . yes, I can see there really is something to what he's saying." A timid agreement, absurd for the simple reason that at this point I could hardly translate what he was saying from the chaotic way he was saying it, typefaces of different point sizes mixed up without any order, boldface emphases thrown liberally without regard to appropriateness.

Morris would sigh, gazing wide-eyed at you as he turned the talk abruptly to the painting of El Greco or the sumi drawings of Japanese Zen. A master of Socratic dialogue.

At this point he rose lightly, fled into the rearward recesses on feet clad in low-cut white tennis shoes. I stirred restlessly, my stomach growling. Low murmurings from the presumed kitchen. My stomach growled again. Bemused, my eyes wandered toward the ceiling, shrouded in deep shadow. Over the corner of the mantle-piece, like the lines written by the Bible's Moving Finger, WHERE THERE IS NO VISION THE PEOPLE PERISH! Scrawled in charcoal, the letters seemed ready to burst into flame.

And precisely at this moment the sliding door to the rear rooms opened and Morris reappeared, followed by a stocky Slavic gentleman built like a teddy bear. The Slavic gentleman strolled in, his face wreathed in an ursine smile supporting a heavy black moustache. Where had I seen that moustache? Of course! Newsreels of May Day on Red Square. The crudely uniformed Red Guards strut past Lenin's tomb, and on the tomb are ranked the leaders of the faithful. In the center, Moustache puffing a pipe, squinting suspi-

ciously around at his colleagues, leering in sadistic paranoia, wondering, "Who is disloyal? Who is scheming with the enemies of our socialist revolution? Who is fit for the prisoner's dock in the next exemplary Trial?"

Wrong! I had been misled by the fact of Moustache entering so soon after my startling encounter with Morris' scrawled warning to those of no vision. The Slavic soul was not Djugashvili the Georgian, but Lubin Petric the Serb, Morris' brother-in-law.

"Lubin. I'm sure you'll enjoy meeting our guest, Bill Cumming. He's the one who wrote the article about Kenneth and myself in the *Town Crier*."

And indeed Lubin did enjoy meeting me, although he suffered a crisis of confusion on seeing my bulging portfolio of drawings and small paintings. "Oh another painter! I thought you were a writer!"

Confusion was dissolved with some difficulty as I explained lengthily how I happened to write art criticism to convenience Lancaster Pollard even though I was first and always a painter and not only a painter but a serious painter who was willing to starve if necessary in order to paint.

The confusion laid, or at any rate somewhat bent over, we were enabled to troop through the middle-room (Morris' bedroom in which stood not only a large bed but a medium-sized upright piano) into the kitchen at the rear of the house, where an old-fashioned coal range glowed red hot, filling the kitchen with a thickly moist warmth laced with odors of cooking food.

Morris, Lubin and I sat at a round table. Three painters, where shortly before Lubin had laid the table for two painters and a writer! Vegetables and fish and tea cooked in the Japanese manner formed our menu. Candles on the table lit our faces, limning softly the planes of light and dark, presenting us to the indifferent gaze of God as a Rembrandt interior.

Our talk was of art and artists. It soon became apparent that there was a differentiation along three different lines. Where I admired Rembrandt, Morris preferred Kokoschka and Lubin leaned to Soutine. Where I drank indiscriminately at the taps of Degas, Renoir and Whistler, Morris was steeped in the dark suffering of El

Greco. Lubin for his part preferred Fauves and Surrealists. And in the realm of Japanese art my taste was firmly in the here and now of the Ukiyo-e printmakers, Hokusai and Utamaro in particular, while Morris was engrossed in the Zen-influenced masters of esoteric brush drawing, both Chinese and Japanese. It was apparent that my aims in painting were deeply based in the masters of French painting and with those Japanese masters of the transient print most closely aligned with the French. Morris, ten years older and already firmly launched on his personal idiom, was more strongly directed toward art like El Greco's or the Zen masters which looked on the physical world as a world of appearance. And these differences of outlook would shape our different paths in the world and in art. And they would make no difference in our friendship. We argued nothing, we discussed everything. Our words rang with pleasure and enthusiasm. Despite his greater experience Morris listened to me with respect and courtesy. I wasn't then quite as brash as I later became. As for Lubin, he was at this time Sancho Panza to Morris' Quixote, and like Sancho he observed both of us with amused detachment.

New Friends Arrive

As we were finishing the dishes in the darkly shadowed kitchen the ratchet of the front doorbell sounded and Morris flew for the hallway, exclaiming, "There's Ken and Margaret!"

Morris' footfalls hurrying down the hall, the sound of the door opening, voices, Kenneth's perpetually amused chuckle, Margaret's nasal drawl. The sliding door to the front room opened and Morris led the guests in, as Lubin and I finished the dishes and hurried through the bedroom to the parlor.

Introductions amid the usual confusion. Myself awkward, embarrassed, clumsy and grotesque. Kenneth standing about middle

height, his hair cropped in a stiff crewcut, already graying, nervously hopping from one foot to the other, encased in a youthfulness that has endured to this day. Margaret above the median height of women, graceful, beautiful without any hint of shallow prettiness, a long-bladed nose and a pointed chin, her eyes gray-blue, calm, taciturn, a natural observer with a genius for being with you.

How did they see me? I have often wondered, recreating Margaret saying to someone, "We met a young painter from the country the other day. He's thin and a bit tall and . . ." And what? All I know is that I stood clumsy and gaping, eager to throw myself into relationship with these amazing new friends who seemed to surround me. I remember how I nervously sought somewhere, anywhere, to put my hands, how I must have constantly brushed back my dark ill-cut pompadour, smiling in nervous apprehension as I felt the gaze of so many pairs of appraising eyes.

The evening passed, a haze of firelight and murmurous conversation, ideas extended friendly and generously without polemical motive, the smoke of pipe and cigarette, the bite of wine and cheese. Margaret sat somewhat stiffly uncomfortable, being well along towards the birth of her first (and only) child, who was to be named Tobey. She finally curled up in a big chair near the fire, lambent light playing across strong-chiseled planes of her face as she talked. She smiled much, almost incessantly, delighting in the conversation milling around her. Occasionally she would fall silent, listening passively as her eyes studied the flames, her face slightly closed in contemplation, a bit removed from us, and at such times, Kenneth would study her silently until she would look up, intercept his gaze, and smile, whereupon he would answer with his own pleased look of happiness and do a barrel-roll back into the conversation, enthusiastically enlarging on their stay in Europe or in Mexico, where his most vivid memories were always of painting, visiting the Louvre or the National Gallery, seeing the frescos of Orozco or the easel paintings of Rufino Tamayo. 1

After these occasional rests, Margaret would edge nonchalantly back into the conversation, often making her contribution by pushing forward, hesitantly and bashfully, some question which would

1 CALLAHAN influenced by MEXICAN MURALISTS:
SIQUEIROS - DIEGO RIVERA - OROZCO 58, 39

help you to reveal just who you were and where you were coming from. She had an instinctive ability to bring out the keenest edge of others' ideas, without compromising the intensity of her own certainties. She was a voracious reader, who devoured books whole and looked forward already to the years after her child was born and grew up and she was again released for her first love, writing. From her, I heard about Thomas Wolfe, whom I had never read, indeed had hardly heard of. Margaret burst into exuberant flights of enthusiasm in describing *Look Homeward Angel* and *Of Time and the River*. Mesmerized, I sat enthralled, pledged to look up Wolfe's books within the next day and read them. Jim Stevens and his wife, Theresa, had brought Wolfe over to Callahan's not long before, and the acquaintance had left its marks on both Ken and Margaret. Wolfe's enormous build and the volcanic rhetoric spouting from his throat were more like elemental spasms of nature than the extravagances of the human. Margaret would never forget the dichotomy of this gigantic biped sprawled in a merely normal easy chair before her fireplace, threatening at any moment to bound to his feet heedless of the threat posed to his head by the low ceiling. His conversation, which was less conversation than explosion, was a reasonable facsimile of his writing. "Oh how I wish you had been here to meet him," she cried in her joyous trill, initiating a whole series of how-I-wishes, ranging from the jazz-era twenties to various writers and painters who had passed in and out of the Callahan doorways. Somehow, listening to her panegyrics of Wolfe, I felt that I had somehow failed by not being there when one of the gods had passed. Passed on forever, dying absurdly from complications of the flu, dying of something which in a few years would have been ended with an antibiotic.

Margaret's infectious enthusiasm for books sent me two days later to hunt for Richard Hughes' *A High Wind in Jamaica* which I found, read and reread within a day. Her love for this miraculous book was endless, and on our last meeting we laughed again over it. Hughes is best remembered today as a neighbor and friend of Dylan Thomas, but his own high talents peaked in this tale of children accidentally hijacked by incompetent pirates, not the bloodthirsty

types of *Treasure Island*, but real pirates, working stiffs laboring at an unfriendly trade, unable to succeed at anything except captivating the children, winning their love to no other end than the gallows tree, suspended there by the fond testimony of the loving kids. Years later, when I wrote of this era in a memoir for *Puget Soundings* it started a run on the book, which was still in print in paperback, and one bookstore owner described in amazement the horde of Junior League matrons descending on his establishment, depleting his meager stock in a day or two.

Kenneth and Morris had widely differing approaches to painting. Kenneth had and has a single-minded love for the whole spectrum of painting craft: brushwork, impastoes and glazes, tempera, fresco, oil, watercolor, sumi, ink. What painting was to say was never a problem for Ken. He knew that there were certain things in the visual world which he could draw and paint and which would allow him to explore in depth through the use of formal values. At the time he was still under the spell of his recent visit to Mexico and the Mexican muralists, (a debt clearly seen in his mural panels for the Marine Hospital).1

Jose Clemente Orozco and Rufino Tamayo struck Kenneth as the giants of Mexican painting, and this strikes one as particularly relevant today, when Tamayo is at last acknowledged and Orozco, although pretty well forgotten in the facile memories of the trendy, looms more and more as one of the true greats of twentieth-century painting. On Ken's return to Seattle he experimented with fresco. Alas! to little avail, he confided in me. The plaster took up too much moisture from the air, no matter how he juggled the recipes.

In any case Kenneth had just installed his murals in the Marine Hospital and described them to me in terms of the architectural problem of narrow panels within a restricted space. The apparent subject matter was the life and work of merchant seamen. "By gosh, you know, I've got to go up there tomorrow and see to the last bit of installation. If you're going to stay over in town, why don't you go up with me?"

Overwhelmed at the thought of being present at the last stages of the installation of something more important to my eyes than the

1 Hospital on Beacon Hill, known as "Pacific Medical Center", "Public Health Hospital", "Marine Hospital" [formerly].

Sistine Chapel, I agreed without my usual oblique evasions. In two shakes of a dead lamb's tail, we had made all the arrangements to meet the next day and go over to the hospital on the east end of Beacon Hill.

During most of the evening, Lubin sat curled like a sleepy badger in a big chair in a corner of the room, barely reached by the flickering light of the fireplace. His face screwed up into its characteristic smile of a slavic Buddha, lighting chain-linked carcinogens (the redoubtable depression era cheap cigarette Wings), muttering unintelligibly when most amused. He cast a benign glow over the proceedings, occasionally interjecting enthusiastic approvals of something said by one or the other to the rest of us. Midway in the evening he suddenly rose, stretched, tossed his cigarette into the fire, smiled hazily on the company and pronounced a mock benediction, concluding by announcing, "Well I must tear myself away, you know Celia's probably home by now and will be expecting me." Under a low-lying cloud of farewells from the assembled company, he slid back the door to the hallway and stood for a moment suspended in the semidark. For a moment our gazes locked and he smiled a last oblique smile, dissolved into the dark hallway, and a moment later was heard opening the front door, then closing it, became a muffled clatter of footsteps descending the porch, echoed hollowly across the paved sidewalk and was gone.

Kenneth and Margaret remained a while longer. Margaret had succeeded in drawing me out and I suddenly erupted into voluble enthusiasm about art and artists, books, history, all sorts of intellectual bric-a-brac. At one point we found ourselves wading astonishingly into the quagmire of English book illustration and I broke out into a panegyric on Phil May, one of the greatest and most obscure of the *Punch* illustrators. Margaret smiled indulgently. "Good grief! Where do you learn all this? What school did you go to?"

Confused, I answered promptly and truthfully, "Oh, Foster."

"Foster?"

"Yes, Foster, Foster High School."

Perplexed, she rejoined, "But I mean what art school? Or did you go to university? Have you lived much in the Village?"

Totally in disarray I could only fall back on the truth. "Well I really didn't go to art school, at least not the usual kind. I wanted to go to the Chicago Art Institute, but after the 1929 crash that was out! But back when I was ten my aunt bought me a course in the International Correspondence Schools and then I won a scholarship to the Northwest Academy of Art but it didn't last very long . . ." and I dribbled lamely to a halt, only to brighten up and exclaim, "But I've really read almost everything in the art room of the Library."

Margaret sat in astonishment. I sat in apprehension. Had I transgressed somehow, blindly tripped over the tentacles of protocol? Was friendship only legitimately bestowed on possessors of degrees? Would I now be exposed and expelled from the golden company?

My apprehension must have shown. Margaret exchanged a glance of amused disbelief with Kenneth. Morris sat under the arch of his own brows which had so far exceeded their usual vaulted reach as to leave his eyeballs almost naked, hanging like a double moon over a smile that threatened to collapse into giggles at any moment. Margaret's laughter pealed cool and casual. "Well, Bill Cumming, you're someone! You must come to dinner at our place soon, before the baby comes. And don't forget your appointment with Kenneth tomorrow!"

The evening was over. And now the cloud-capped towers were ready to dissolve, the golden-lit room stood cold as the company rose and put on overcoats and mufflers and the fireplace stood forth dead and fireless and our insubstantial pageant faded as midnight shouldered its way into the room.

Kenneth and Margaret, overcoated and ready for the chill, disappeared into the hallway under our yawning goodnights, dropped through the door and down the front steps to become footfalls across the walk, the tinny clang of car doors banging shut. Presently the grudging cough of a Model A started up, died, restarted, died again, was transfixed by the furious buzz of the starter until, suddenly catching, it burst into hysterical tirade, settled down and

purred off toward Twelfth Avenue where it was instantly gulped down by the dark and the distance.

Morris had made up a cot for me and I fell off into bottomless darkness as soon as I lay down. Safe asleep I had only time to notice that I had made it through the door.

Breakfast With Morris

Next day dawned sun through blue mist, real Seattle October snap, crackle and pop. Through the rooms of Morris' flat the air circulated gray and languid, dribbling little echoes of last night's voices over the somnolent furniture. The kitchen stood remote and cold, aloof and unfriendly until Morris succeeded in coaxing fire in the range whereupon kitchen unbent at first slowly then more rapidly until the air vibrated pink and rosy, welcoming us to hot coffee and oatmeal laced with soft rolls.

Languidly relaxing from the excitement of last night's high converse, we talked of art and artists, of life and of the strange and bittersweet road of humanity. Morris talked of his journeys to the Orient, of a philosophical detachment alien to the impatient demon roistering in my heart.

To my astonishment, he proposed swapping paintings. I had admired a small tempera of his, which he now insisted on presenting to me, taking in return a violent red nude projected against a bilious yellow background, thinly painted in oil-glazes, color garish but without body. A thick triangle of ultramarine blue in the center of the nude's trunk formed the only impasto in a lake of glaze, giving it a horrible pornographic effect. A bad painting, and I knew it, an amateurish attempt to paint like Gauguin. But Morris swore that it had hidden virtues to which I was blind, and I did covet the tempera. So the swap was consummated and I still have the tempera, a sketch in sober blacks and browns and earth-greens of

one of the old gun emplacements at Fort Worden near Port Townsend, the straits of Juan de Fuca muttering under a guttural sky darkly glowering.

With the painting came a typical recital of the type of misadventures which dogged Morris' youth. Setting out on a solitary sketch-trip of the North Kitsap Peninsula, he discovered with elation the gaunt concrete emplacements in which coastal defense guns had stood at the turn of the century. Devoid of any frills, the severe concrete forms had stood like dinosaur skeletons since being stripped of their armaments and crews, brooding, latter-day Stonehenges, over the sullen mutter and rip of the great Straits. Lost in his vision, Morris made a series of pencil drawings as studies along with the small tempera which today rests in my studio, submitting himself more and more to the presences of the place, the aura of long-dead coast-guardsmen and loggers or of even longer-dead Indians. Time passing, the presences became stronger, until they explosively materialized as two Military Police leaping from the brush where they had been surveying the mysterious doings of my friend. Morris was seized, his drawings and tools confiscated, and he was dragged off to Fort Worden, where he was questioned by a triumphant lieutenant of Military Intelligence, delirious with certainty that he had just roped a major Japanese spy, euphoric with fantasies of fame and promotion. Morris' straightforward tale of artists' infatuation with the troglodytic remains of ancient gun-emplacements fell on barren ground, the tin ears of a bureaucrat who had too much commonsense to accept the possibility that someone might really see in the concrete monsters a living beauty that had never occurred to the men who designed or used them. After a couple of days intensive interrogation of Morris, and after the intervention of people like Dr. Richard Fuller and Emma Stimson, Morris was released by the disappointed spy hunters.

Years later, the red nude returned to me. Over the years we had all left large bits of ourselves in the form of books, paintings, drawings, easels, brushes, old boxes of worn-out color tubes, address books, divorce decrees, unused marriage licenses, ration books from the war, photo albums of unidentifiable ghosts out of our pasts

and other such impediments, these discards piling up in various attics and basements dependent on the shifting sands of our lives. Who was stable at the moment and who was in transit? Those who were stable became the natural repositories for the gypsies among us, who usually forgot where they had left what they had already forgotten. Of necessity, Kenneth and Margaret became the major depot for this stuff, their basement becoming a sort of mortuary of dead or moribund fantasies, lives which hadn't worked for their owners, who had checked them while they went off to find a life that would work, but usually didn't.

I had traded the nude to Morris, who had by the fifties existed in a number of states, none permanent, and who had shed his various skins of possession and attachment like a snake. The nude was a bad painting, though not a trivial one (bad paintings are never trivial), and I would hardly have expected it to remain in close proximity to my friend. Eventually I had a call from Lubin, who arrived with a box of various junk he had rescued from some loft or attic or basement, and which he was now engaged in finding owners for, and which must of necessity include my damned red nude, embarrassingly mine since signed with a large blue scrawl and having improved not one bit with age except to have acquired somewhere in its peregrinations a whole latrineful of graffiti, scribbled obscenities with neither imagination or style.

"When did you do this?" my Slavic friend murmured, with an amused glance which seemed to challenge me to deny painting the abomination.

"Oh Christ! That goes back to when I was a kid in Tukwila, not more than fourteen!" Lying a bit, mortified to think that at the age of nineteen or twenty I could have painted a nude with such lack of tactile experience with the female body, but convinced that there was no hope in repudiating the signature, since it would have required more than a willing suspension of disbelief for Lubin to accept even the remote possibility that anyone would have forged my signature unless it had been some dedicated enemy sworn to damage my reputation.

"Well it certainly looks like some of Morris' friends have been

using it to express their opinions of you, your painting or your subject!" and he laughingly rose, stretched, and purred, "Let's go up to the Moon for a beer!"

I burned it eventually. Burning was difficult, for I had painted it on three-quarter inch plywood, and I had eventually to borrow a power saw to cut it into pieces small enough for my freestanding fireplace.

So perished the red nude, but Morris' tempera of the Fort Worden monoliths hangs in my studio, a surety that memory hasn't betrayed me, that I did indeed go to dinner, that Morris and Lubin and Ken and Margaret and I really did sit there in Morris' living room, and we did say one thing and the other, and the time passed, the earth turned in its orbit, and we were transformed over and over into different people, and yet within each transformation lay hidden the people we were on that night, each of us buried in holographic replicate in each of the others forever.

I Look at Kenneth's Mural

At ten o'clock I was standing on the Sixth and Pine corner of Frederick and Nelson waiting for Kenneth. In about three minutes I heard the rattle and wheeze of his Model A coupe as he drew up to the curb. I hurtled across the sidewalk and into the car and we drove south, Kenneth chattering animatedly, asking questions, describing his murals and the problems associated with their installation.

We rolled across the Twelfth Avenue bridge in tinny dignity, suspended in galactic remoteness, Dearborn Street crawling light-years below us. Off the bridge up the hill and through the gates of the Marine Hospital, new at the time in its orange stolidity. Kenneth had won a competition for the murals, a major victory involving cramped spaces difficult to effectively fill, and into these spaces he had poured a vivid continuity of workmen, tools, levers, gauges,

steampipes and trivia in somber grays, umbers, ochres, earth reds, browns and greens. By present-day standards, the paintings are gauche, awkward and unsophisticated. But I was impressed then and still am today by the virile sweep of line, by the powerful gesture inherent in the forms, by the uncompromisingly straightforward integrity of a statement made directly and simply in a technique without technique. Everything to come in Kenneth's painting is present in the murals, clear to be seen, his lack of sophisticated grace and of ingratiating manner, and the powerful directness which makes him at his best the most Zen of Northwest painters in his willingness to recreate and communicate the suchness of things.

Years later the hospital murals were threatened with extinction by the General Services Administration. A fight was made to preserve them and they were subsequently installed in the lobby of the County Hall of Records, where they are probably viewed by more people than saw them in the hospital. They are paintings by a country boy[1] who had journeyed with his wife to Mexico, had absorbed the energy of painters like Jose Clemente Orozco, who had shipped out in the Merchant Marine, seen the Orient, had lived life, had come home and painted a picture out of his own experience of things. That is rare. Most painters paint out of knowledge of things, out of concepts of art. Kenneth observed life through his own eyes and created his paintings out of his own worldly experience.

I was tired, so we returned to town, had a hamburger somewhere, and ended up at the Art Museum, where Kenneth had to get back to work as curator. We stood there in the stacks, I lost and drifting in a welter of memory and hope and fantasy, wondering would my work ever grace these august halls, saying an interminable goodbye until I became aware of a sudden that Kenneth's habitual nervous dance had been transformed into a whirling-dervish tour de force, the polite smile on his face maintained there by sheer force of will, his bladder almost visibly bursting through his tweed suit, and in a panic that now I had done it for sure and the doors would never again open for me I fled madly out of the Museum,

[1] CALLAHAN born in Spokane, Washington 1905.
CALLAHAN Public Health Hospital (Pacific Medical Center) Murals — now re-located at County Hall of Records

down the steps, and down the long hill towards the Eighth and Stewart bus terminal, leaving Kenneth to bolt for the head, hoping his bladder wasn't irreversibly fractured and cursing the amiability that led him to devote valuable time to an idiot young painter.

I Meet Two Friends in the Library

My life had suddenly kaleidoscoped into a tangle of people and events overlapped, mortised, dovetailed, interfaced and montaged to the point of total confusion. Like a dance tune that begins in a sedate *andante cantabile,* only to double and double once again through *allegretto* to *allegro con brio* and yet once more into *presto furioso,* individual increments of time and people and place had blurred into a seamless streak of light. From the tedium of the NYA photographic project to the minor excitement of the assignment to photograph the Federal Art Project, things had proceeded uneventfully up to the moment when I stepped through a doorway into a lofted room where Morris stood drawing at a desk, only to accelerate into a series of quantum leaps where Lubin, Kenneth and Margaret like free-ranging vectors intersected my life, following which fate allowed thirty-six hours of calm during which I spent a whole night at home, slept in my own bed and failed utterly to convey to my folks the miracle of what was happening to me. I lay awake half the night watching a new moon disk the sky, fondling each remembered image, bombarded by steamily blurred fantasies of a future tangling together *La Vie de Boheme,* the poetry of Byron, the nudes of Rubens and Renoir, fate thundering on my door in a dozen different rhythms.

Next day I took the bus to town, lunched with George Hager and wound up in the late afternoon unwilling to retreat just yet to the country, finally slouching up the steps of the Central Library, past the flamboyantly pigeon-decorated stone lions into the dingy

lobby and on into the great General Reading Room, intending to hunt up some of the books Margaret had mentioned two nights before.

Prowling restlessly the dark aisles I headed towards the new arrivals. Arms full of books I rounded the corner of a row of shelves and lurched almost literally into Kenneth and Margaret, their arms full of books. Consternation gave way to pleased surprise and surprise melted into greetings as if I were a just returned voyager from some Jules Verne odyssey to some far galaxy. I drooped into a condition of semimute paralysis, unnerved by the warmth of their greetings, scarlet with embarrassment, contriving just about every buffoonery necessary to convince them that I was a hopeless boob. And in the same moment I got just that, that they saw me indeed as a hopeless boob and for precisely that reason they had taken me into their hearts and their affections.

My graceless nincompoopery fazed them not at all. With the innate grace that marked Margaret's confrontations with everyone, she blithely ignored my clumsiness. Cool gray eyes regarding me with fond amusement, she happily smothered me with titles and authors guaranteed to enrich my life.

Margaret in the library was an image of amazed and amazing grace. Books for her were not accumulations of chewed up wood pulp disfigured by smudges of printing ink and wedged into stiff covers. To the end of her life she threw herself into her assignations with books with a sensuous enthusiasm in which every syllable became palpably physical so that each word became a complex of sensory signs out of which sparked meanings transfiguring her face and body.

Kenneth stood to one side, smiling, his face ruddy with pleasure, interjecting himself into the conversation in amused counterpoint to Margaret. My contribution was undistinguished, yelps of youthful egoism in a shaky tenor checkerboarded with acknowledgements of my new friends' commentaries, leaving me dismayed and sweating at my own foolishness.

Margaret was this night in a state of high elation. She had walked into New Arrivals to find waiting to hand volumes of Re-

becca West and John Cowper Powys, newly published and normally to be awaited for weeks or even months on the Reserved List. How it happened that they found their way immediately onto the Open Shelf will forever remain wrapped in obtuse mystery, but they did and Margaret was ecstatic, clutching them with the passionate intensity bestowed by a housecat on its newest mouse. Her joy was infectious but I shared it only as a reflection of herself, for West and Powys represented that type of highly sophisticated, convoluted English writing with which I was least comfortable. She thrust them like rare and exotic prizes for me to examine, and I leafed gingerly through them, bemused and becalmed like a schooner out of breeze, baffled and put off by their dense thickets of closeset thorn-think. But how could I resist the sight and sound of Margaret reading out short excerpts, rolling in the dense verbiage like a bear cavorting in stickers?

One other British writer found us both receptive, and in fact sealed and bonded our friendship forever two nights before at Morris'. Rereading D. H. Lawrence recently, almost fifty years later, I found the bond unbroken by death and time. Tracing idly through his early poems, hopping from one poem to another, following underlinings scored into the books years ago, I heard again Margaret's voice flooding the air around me, feeling the soft light of her eyes searching my face for my reaction to her favorite lines. Once more I felt the arterial surge of my blood respond to Lawrence's demand that we be here now, be involved in immediate sensous experience out of which could flow spiritual renewal and transcendence. And I felt in the questioning of her eyes her curiosity as to how and why I could have gone off from that point of time onto a tangential excursion into the facile and shallow materialism of authoritarian Marxism.

My reading habits were then, and are now, extremely asymmetrical. While I had not read Thackeray or Galsworthy, certainly not Rebecca West nor John Cowper Powys, and very little Dickens, Kipling or Wells, I had read virtually everything of Lawrence in print, including most of the existent memoirs of the period. Margaret and I had both read Frieda's recent memoir *Not I But The Wind* and I had

read Jessie Chambers' book which gained added significance from the fact that its author was the original of Miriam in *Sons and Lovers*. Not only Miriam but a Miriam very different from the mild lambkin of the novel, a Miriam with blood in her eye ready to leap out and land a few knocks on the distinguished head.

Lawrence's flaws were always easy to find, indeed they were difficult to avoid. Already in the midthirties he had become the target of experts weaned on the treacle of academe. But for us, both born out of rural terrain, he stirred deep responses with his call to the subterranean rivers of racial memory and with his genius for a direct experiential interaction with nature, which in his prejudiced eyes included the human race. In particular we loved his poetry, and in later years, during my detour into the arid deserts of historical materialism, I still clung sullenly to his poetry as well as his early novels, although I conceded uncomfortably that the shrill tendentious tone of the later novels did contain unfortunate leanings towards the simplistic emotionalism of many of the fascist intelligentsia, a disastrous concession on my part since I insisted simultaneously that Lawrence himself transcended any such simple-minded categorization and simply wasn't a fascist but merely a naive wanderer who sometimes found himself unexpectedly running on parallel tracks with rightist authoritarians, who ran on tracks parallel to leftist authoritarians.

At the time, we three stood bonded in friendship under the chandeliers of the old high-ceilinged reading room. The rays of weak light struck vertically upon our heads and bodies so that one was conscious of highlights flooding the hair and brows of figures whose faces and frontal planes were veiled in half shadow. This piquant effect of chiaroscuro brought to mind the paintings of Caravaggio and the Tenebrists, and I thought of Rouault's lithograph of Verlaine, in which the falling light described in similar terms the vaulting rondure of the poet's brow.

On that evening I knew only that moment, that now, the cling of that friendship, the tipsy brew of ideas thrown off like sparks, the warmth of affectionate obliquities. My friendship with Kenneth and Margaret would prove to be the great landmark of this

part of my life. With Margaret it was based largely on her delight in finding a young painter who was as drowned as she in the voluptuous depths of books. Kenneth, not too long graduated from his own apprenticeship to forget his first clumsy staggerings, himself extended warm and generous friendship to a new painter caught in the painful and tentative gestures of the amateur, full of the hoodlum wish to strike for his own unique note, certain that it lived in him but without the interior balance or the experience to bring it to life, unable even to recognize it when he fell over it.

So the three of us stood there, each of us wrapped in the ambience of light-scalded union, each of us subdivided into separate essence, Kenneth beaming, Margaret swelling with new life, gray eyes pulsing beneath fringed blonde hair, and myself thin, jittering from foot to foot, clumsily erupting in polysyllabic bursts of opinionated trivialities.

A remarkable pair, Kenneth and Margaret. They stood there, their own lives interrupted, while they attended to me, the proverbial hayseed, the two of them bathed in treacly light, themselves exuding their own light to bathe me in a friendship born out of an unforeseen conjunction of vectors. Three weeks before they had only known a name signed to a review in a little magazine. I had only known some paintings signed with a name, and of Margaret or the child burgeoning in her belly I hadn't an inkling. And now I stood, their pensioner, receiving affection and friendship and the promise of the future and what had I to offer in return beyond the clumsy egocentrism of my years, the desperate wish to forge a foothold in the cliffside of the world? I knew without asking that their friendship was given spontaneously, without concern or calculation.

Margaret's laughter seeped into the air around me as she said, "Well, Bill Cumming, this is a providential meeting. Now we can make definite a date for you to come to dinner."

"Yes," added Kenneth, "why don't we make it next week, before the baby begins to crowd us." For Margaret was nearing her term and in the few days since we met at Morris' she seemed to me to have grown larger and more luminous.

So we parted that night, they to go home, I to climb to the Art

Room on the top floor. The faulty lighting of the old library filtered feebly down on us, modeling the powerful arch of Kenneth's forehead, cresting Margaret's blonde hair, dropping across the bony promontory of her bladed nose to fall triumphantly across her swelling belly, now able to be contained only with difficulty by the clutch of her tweed topcoat.

I sat in the Art Room, staring blindly at a book of reproductions of the drawings of Edwin Abbey. Next week I would go to dinner. Next week I would sit at table, look at Kenneth's new paintings, show my new drawings, talk books and movies and music with Margaret.

Dinner at Ken and Margaret's

Next week I left work one evening, boarded a Montlake streetcar and headed for dinner at Callahan's. In my hand I held my sketchbook with recent drawings; in my heart a multitude of fantasies. The doors had been opening so rapidly over the past three weeks that I had become dizzy with anticipation each day.

The streetcar followed the same general route followed by today's busses, leaving the downtown area by way of Pike Street, climbing east up the hill, eventually turning north off Madison onto Twenty-Third. The passage through Upper Madison was for me a new facet of Seattle's ghetto, which had previously been for me the Yesler-Jackson area. I stared with passionate intensity at the twilight-shifting figures outside the storefront cafes, pondering over the contours and planes of dark faces. The soft Southern voices woke memories of my grandma's Kentucky whisper, although the middle-frontier accent of my kinfolk helped me little in deciphering the bewildering array of accents spectrummed from deep South of Georgia and Alabama to Creole and Cajun of Louisiana to a whole variety of accents linked to varied regions of the <u>Tidewater and seaboard</u>.[1]

1 VIRGINIA, N. CAROLINA, S. CAROLINA

And all these variations could be heard in the space of three or four blocks, from Nineteenth to Twenty-Third.

Bearing north, the car rocked on down Twenty-Third, trucking with the mesmeric weave and sway of generations of streetcars, an experience in motion that has been pretty well lost in the age of the motorbus. As we drew nearer to Roy (noted on my sketchbook cover as the stop at which I must get off at risk of plunging all the way downhill to Montlake if I should forget), my excitement mounted to the level of suffocation. We were nearly there!

I jerked on the cord with unnecessary violence, drawing a glare from the motorman as we slowed. I had ensconced myself so that I could observe my fellow passengers without being observed by them. My progress to the front exit was marked by the usual flutterings, dartings and staggerings, ending in a swooping coda which threatened to catapult me through the front windows as the car decelerated precipitately to a stop. Intimidated but defiant, one more small-town immigrant to the Big City, I descended the steep old-fashioned steps and stood for a moment on the corner gathering my fragile geographical coordinates. The car lurched away from the corner, angled right then left, plunged in a sudden shower of sparks from its overhead trolley into the gloom of the long hill leading into Montlake Hollow, visible to me only as the retreating rattle and bang of its flat steel wheels. I breathed deeply, shook myself awake, and stepped off briskly towards Ward.

Ward plunges off just as sharply to the east as Twenty-Third plunges to the north. At the bottom of Ward's precipitate dive it falls into the valley which now embraces the Arboretum. One block from Twenty-Third, perched on a steep slope difficult to gracefully negotiate even in dry weather, stood a white frame house, fronted by a rockery and sided on the east by a spacious picket-fenced yard with a cherry tree in its center. I mounted the steps between the rocks and the baby breath and the shrubs and the rose bushes and god-knows-what-else and ascended the porch steps.

My breath was coming tight and shallow, less from physical exertion than from the sense that each step was one step more away from mundane adolescence into the light and glory of Art. One last

step and I stood upon the porch separated only by the glass paneled front door from warmth and friendship and fame and certitude. A white curtain stretched on rods to cover the door, reducing the hallway behind it to a blur. Staring through this obstacle I could make out a landing leading up to second-floor stairs and a first-floor hallway stretching straight back to a slightly open door leaking layers of steamy light from the kitchen. On the hallway walls I could see framed paintings and drawings. Curtained windows in the bay to my left gave veiled visions of a front room with bookshelves, big chairs, a couch, paintings and drawings scattered prodigal, some hanging on the walls, some standing against bookshelves, some lying under chairs. In one big chair sat Kenneth, engrossed in his sketchbook. Across the gap of the kitchen door Margaret flitted back and forth.

A furious roar broke out from the front room and a heavy body hurled itself through the dining room, into the kitchen, and out upon the hallway, bursting totally open the ajar kitchen door, unveiling the steaming kitchen, all green and pink-rosy, a startled Margaret standing with saucepan tilted in left hand while right hand suspiciously dangled a long cooking spoon over the pan avoiding disastrous drips on kitchen floor, her gray eyes peering down the hallway past the now frenzied heavy body which even through the front door veil had resolved itself into a medium large brown and black Airedale frozen into a two bar phrase of atrocious atonal madrigal, while Margaret calmly and quizzically called, "Kenneth!" into the living room where Kenneth, simultaneous to all this, rising from his chair, put aside his sketchbook and conte-crayon, rose, opening the sliding doors to the hallway just as Margaret, wiping her hands on a dish towel, hurried through the kitchen door, the pair of them arriving to form with the Airedale a trio of choiring angels.

The door was torn open, Margaret pulled me into the hallway by my free hand, while Kenneth all in one motion quelled the Airedale with peremptory admonitions of "Down, Mike!," closed the front door against the outside chill, and relieved me of my tattered topcoat. Mike having been temporarily silenced, I was dragged

through the sliding door into the front room and seated in a big armchair across from Kenneth while Margaret disappeared into the kitchen, from which she intermittently popped to enquire about details of taste or appetite or to intervene in some overheard scrap of shoptalk. Kenneth was ever a lover of shoptalk. Painting by its very nature lends itself to such palaver. The great range of techniques, mediums, supports, finishes, brushwork and other esoteric matters offer a virtually unlimited spectrum of subjects for working painters to jaw about.

Today's trend is for painters to become entangled in abstract philosophic speculation about the alleged meanings of art rather than in the prosaic question of how-I-mix-my-painting-medium or how do you treat the surface of your support. Materials are only worthy of talk if they are new and exotically technological. For his part, Kenneth, without losing interest in new materials and technological breakthroughs, has always been an enthusiastic student of the traditions of the craft as they pertain to him. His basic craft approach is rooted in the touch of a brush loaded with pigment, its gesture across some supporting surface, and it's safe to say that this love of the brush mark has always been the essence of his life as a painter.

That night, waiting for Margaret's call to dinner, he talked enthusiastically of his time in Mexico. In the Mexican painters he was struck most by their dedication to a painting rooted directly into the daily culture of the land and the people, and to their straightforward use of materials and techniques which could express this culture simply and with little false rhetoric. His attitude was in marked contrast to that of the political left toward the Mexican painters, an attitude of glorification of Mexican painting for its ideological symbolism, which is of negligible moment to the art as a whole, except insofar as it tends to vitiate the energy of the painting by diverting much of its weight into silly matters of daily politics. The left saw the Mexican painters as political cartoonists, and so far as this was accurate, the painters were less as painters. So far as it was untrue, which was particularly so in the case of Orozco, it was an attitude which radically underestimated the worth of the paint-

blue-collar Painter unpretenti

—BLUE-COLLAR FEELING FOR THE MASSES. UNPRETENTIOUS

ers, severing its continuity with the art of the past and reducing it to the breadth of the daily political cartoons of the left press.

Orozco was for Kenneth the giant of modern Mexican paint- —OROZ ing. For Diego Riviera he felt considerably less admiration, seeing in that one a dangerous infatuation with transient notoriety, a fatal love for the facile opportunism of the world of headlines. David Alfaro Siquieros impressed him not at all, a mediocre painter who had attached himself to the bandwagon of Stalinism because it appeared to be a winner.

Almost as highly as Orozco, he valued Rufino Tamayo. Tamayo was already under attack for his "un-Mexican" stance, for his close relationship to the School of Paris, which to the epigones of the left branded him a "bourgeois decadent." The politics of Mexi- ONC can art was strongly tied to the politics of the labor movement, and any Mexican artist who failed to make Mexican politics the source of his symbolism and imagery could expect to be crowded out of commissions and positions controlled by the government and its allies. Tamayo continued for many years to be outside the pale, and he continued to attract the admiration of Kenneth, and for that matter, of myself, for even during my period of unconsciousness when I followed the erratic star of political radicalism, I continued to admire Tamayo.

So we chatted on, counterpointed by the snap and crackle of the fire in the fireplace and the snores of Mike who had now collapsed on the hearth, worn out by the vigor of his rowdy behavior on my arrival. Sounds from the kitchen, the rattle of pots and hiss of faucets, were now being gradually supplanted by sounds of the table being set, the mutter of silverware, the sharp click of dishes. Serving dishes now appearing, thin clouds of steam hovered in the gleaming air. In another moment we were called to the table.

Margaret's smile of satisfaction as she surveyed what she had wrought spread a glow over the room. Her gray eyes twinkled as she urged on me enormous helpings to ameliorate my alarming thinness. For my part I ate in a daze, floored not only by the fact of sitting at this table as a guest, but by acute embarrassment at the fact that Margaret had refused all help from me in getting the meal

CALLAHAN DOES NOT LIKE SIQUIERDS [the best of 3] !!!
(ALIENATED by POLITICAL VIEWS OF ARTIST ?)

on the table (she refused even Kenneth's help) which had caused me to visualize my parents' disapproving faces hovering over the table, our own family routine being marked by the responsibility of males as well as females to engage in all the routine gestures by which a family receives its sustenance. *division of labor,*

Dinner over, my conscience was able to once more stand erect, as Kenneth and I were allowed to clear off the table and do the dishes, while Margaret lounged in front of the fireplace, a ruddy glow of pleasure lacquering her cheeks. Dishes done, Ken and I retired to the front room, joined Margaret and plunged into an orgy of talk about books, music, art, history, people and life. Margaret loved jazz, and she played for me her entire album of blues by Bessie Smith, Columbia having shortly before this issued Bessie's records for the first time on their general label. (Up to this time blues had been confined to the "race labels.") We sat entranced, lights turned low, the glow of the fireplace painting our faces orange and violet as we sat silent, bemused, lost in the terse flow of voice interwoven into the brassy coil of trumpet.

The hours passed swiftly, unbelievably. I had scarcely set foot on their porch and it was time to catch my bus. Kenneth bundled me out the door, down the steps and into the Model-A which indulged its customary sequence of protests and balky roars before at last it consented to catch and groan into movement. We moved off, executed a shaky u-turn on the steep hill and clambered laboriously up towards Twenty-Third, passing the white house with Margaret standing on the porch under the light, waving "Goodnight!" the pallid yellow halo cast by the electric bulb modeling her skull's rondure for my memory, where it remains to this day.

THOMAS HART BENTON - popularized U.S. MURAL PAINTINGS.
'30s Depression Federal Art Project - federal Gov't commissioned artists to paint murals in post offices + public bldgs COAST-TO-COAST. [Seattle Museum of History + In

Paris Fifteen Miles From Tukwila

Began now a life divided between my small-town home and the city. My dream of Paris didn't vanish. It simply melted into life in 1937 Seattle. I was never again able to summon up one scrap of the kind of restless and unsatisfied dreams on which young provincials have traditionally motivated their treks from Idaho or Uzbekistan to the City of Light. To my small-town sensibilities Seattle was a reasonable facsimile of all the mythic fantasies which had fattened my imagination out of the mare's nest of adolescent sampling of Gautier and Verlaine, Renoir and Manet, Debussy and Aristide Bruant. Verlaine nasally intoning *"Il pleut dans mon coeur comme il pleut sur la ville"* in a garret in Montmartre had merely written an anthem to sustain my adolescent melancholy as I looked out over First Hill soaking under the leaky sky of winter.

I was not the first rural American schoolboy to go off in search of a grail, but I may well have been the first and possibly the only one to be satisfied so easily, to find the answer to all desire in a soggy seaport town wedged into the furthest northwest corner of our United States, a cultural dustbin in the dyspeptic grump of Sir Thomas Beecham. Ezra Pound and Ernest Hemingway, Henry Miller and Stuart Davis, James Baldwin and countless thousands refused to accept a homegrown substitute for their dreams, made their way across the Atlantic, lived in attics and lofts, sat at sidewalk cafes with bohemians from Bulgaria and Reykjavik, stayed for a year or two or ten or twenty, gloried in the title 'expatriate' and came home finally to vegetate and compare unfavorably the native soil with that rich compost to which the youthful Lindbergh had leapt one day in 1927. And here was I, fifteen miles away from my childhood, hobbling down Yesler Hill beneath the tinkling windows of homegrown whores, prowling the alleys and the greasy spoons of the Skidroad, marching from Yesler to the university district, savoring the sickly-sweet aroma of female flesh at the State

SEATTLE

lyrical writing

SEATTLE IS A "SOAKING SOGGY SEAPORT TOWN"

Theater[1] or along Main Street or in stuffy Capitol Hill apartments situated conveniently near Cornish School.

And all this laughable rodomontade added up in my buzzing skull to a page straight out of Murger's *La Vie de Bohème*. And not only that, but today with the flux and flow of nearly fifty years passed, I wouldn't change a bit of it, so thoroughly convinced am I that Seattle furnished me a thousand times more of the soul of Paris than I could ever have gotten from the city on the banks of the Seine.

[Seattle was my Paris. I did indeed come to realize my dreams ⌐ of a studio with a skylight and a mistress, plus an unforeseen flood of wives and numberless friends, and I led a life of undeserved and unbelievable joy and luck within geographical parameters so narrow that they can be taken in at a single glance from a high-flying plane.

— — but he clearly loves it, like most Northwesterners.

Friends

I was now not so much plunged into a new life as hooked and wriggling like a fish as I was slowly and steadily pulled into the Graves-Callahan orbit. I still had a small circle of friends from the immediate past to whom my loyalties attached even as they reluctantly let go. Clinging to each other with a sort of desperate determination, we built illusions of a bonding that disguised the transient and provisional nature of our ties. Like a milling herd of yearlings, we nervously circled, rubbing against each other, apprehensively gazing beyond the rim of our herding at the world outside.

I remember them as a group in a single image, sitting around a candle-lit table in Morris' kitchen at year's turning between 1937 and 1938. They had heard with mounting excitement the ongoing story of my new friends and Morris had assumed near-legendary dimensions for them, so that it was with ecstatic hilarity they accepted through me his invitation to dinner in the same high-ceilinged rooms into which I had stepped so shortly before.

1 2nd Ave. burlesque house.

Into our ragged topcoats we shrugged and across First Hill we straggled, past the old cable-car barn at Broadway and James, kicking at piles of frozen slush in the gutters while our shaky voices intoned snatches of Hart Crane, Whitman and Rimbaud, counterpointed with off-key renditions of *Moonglow* and *I Didn't Know What Time It Was*. Adolescent inspiration dribbled from us like postnasal drip. Leaky shoes invited rivers of freezing water to soak our threadbare socks, a condition to which we in our euphoria were so oblivious that it would only come to our attention a day or so later when we awoke with stopped-up noses and congested bronchi.

By the time we stumbled up the steps onto Morris' porch winter night had totally closed in. The porch rumbled with the shuffle of our feet as we peered through the glass door to watch the kitchen door open at the far end of the long hallway. Morris, responding to the tinny rattle of the doorbell, loomed once again before me in the gloom, silhouetted in the gold glowing of the kitchen behind him.

He opened the door. We crowded in and he herded us through the sliding doubledoor into the front room with its photos, religious tracts and artifacts. The evening proceeded smoothly and from it I retain only one image.

The spinach soup was spooned away, the graceful Japanese bowls fondled in hot hands, tea smoked in the pot, we lay back sated, toying with rice candies. Words floated on the air, idly winding themselves into art and life. Morris presided, wrapped in his innate elegance. He baited us with Socratic questions, tempting and provoking gently, his smile wavering beneath mobile eyebrows.

We were borne up and up into a high filigree of rice wine and verbal ecstasy, so that our faces seemed to hang disembodied in the air and the candlelight like the chiaroscuroed faces in the paintings of Eugene Carriere. And in that moment Morris' voice inched out in a sibilant whisper, tempting me with one more Socratic trap. "Isn't the point of art that we are able to reach up out of our ordinary lives to an occasional plane of magnificence?"

Blind with pride I fell into the trap. "We should refuse to live for even one day on any plane less than magnificent!"

His eyes studied me as he murmured casual thanks for my of-
fering. Did he laugh or weep at my foolish bravado, at my Icarian
plunge straight into the blaze of the sun?

The faces hang there in memory. They shine in joy and cer-
tainty, for in that moment we were all caught up in the vision I had
languaged for us. All of us believed, if only for that instant. All but
Morris, who had already learned that God allows only short stays in
magnificence.

Sour Notes

In spite of my provincial naivete I had noted in myself and
others the petty emotions of envy and spite, the malicious subver-
sions of mediocrity, the pretentious claims of ego, and most of the
other tools with which humans manage to turn their lives into snake
pits of pain and sadness. But the provincial boob displayed his full
range of chromatic technicolor in a settled conviction that such
flaws were confined generally to the non- artistic masses and partic-
ularly and specifically to my own skinny self. The world of Art and
Genius (with the caps in color) was a world of pure intent, lofty
sentiment and noble endeavor. In my schoolboy enthusiasm I had
absorbed Byron's puffed-up illusions without noting the hard-edge
cynicism behind them. So I was totally prepared and prompted to
step into a real pie-in-the-face pratfall when I finally found myself
totally through the door and into an enthralling new world of art.

Within a couple of days of my initiation I received my first
intimation of something far less majestic than my fantasies of bo-
heme. Seated at the table of a Skidroad coffee-and joint with Lubin,
I babbled incessantly in an insane jumble of joyous panegyrics to my
new friends, to Kenneth and Margaret, to Morris, to Guy, to Mal-
colm Roberts. In my rosy-cheeked enthusiasm I scarcely noticed the

gradual clouding over of Lubin's Buddha-face until in the middle of one of my most effusive eruptions, a fanfare of verbal trumpets to Morris' austere spirituality, I became joltingly aware that Lubin's smile had been transformed from sweet charity to the sourest of grimacing petulance. But still smiling, oh disarming, lethal, strike-to-the-heart disillusioning words, the slavic smile still hanging there under the coal black moustache, still smiling, but smile transmuted by bilious malice into caricature of Buddha, and once more the disturbing resemblance to the moustache smiling on the tomb of Lenin, the smile of Djugashvili contemplating murder.

And the words dripped steadily onto the cheap varnished table top between us, oozing greedily around the coffee cups, staining the paper napkins, to drip and drop and leak into the lap of my consciousness, never to be erased, never to fade. A cold, ice-sharp arrow of fear sliced through my heart and stuck there, where it still sticks, overgrown with scar tissue. Until I wrote these words I never knew how deeply it was stuck, how disastrous was that shock to my foolish fantasies of a great tribe of creative souls.

For what my friend gleefully rubbed in my face was his own contribution of penny-ante gossip, of spiteful muckraking effluvia to the continual flood by which mankind cuts itself down and down and down beyond the danger of ever having to live up to its own greatness. And this was not one of my yokel friends sitting behind his father's barn, cavorting in pastures of barnyard wisdom. This was one who was destined to be one of my closest friends, a luminous and courageous spirit, a painter of power and insight and a friend of my friends.

So I sat, like D'Artagnan fresh from Provence, gaping foolishly while Lubin, slyly smiling, detailed for me in his sibilant whisper the flaws, spiritual and emotional and moral and artistic and psychological and economic, of each of my new friends. My friends had all lived before I met them. When I met them I created them in my own dream, impossibly heroic, impossibly austere, impossibly grand. And Lubin, who possessed knowledge of the past back beyond my creation of my friends, overwhelmed by a pitiful and fruitless envy, cynically and joyfully kicked my playhouse down.

In sullen discontent I sat ashen under the flood of shit. My bowels had turned to ice and my heart had slowed to a crawl. In a few minutes the tirade died of its own weight. Lubin and I sat over our dying coffee cups, tongues locking into impotence. When no words were left to issue from our mouths, and no steam rose from our cups, we rose and fumblingly left, drained and exhausted by an invisible emotional storm. In the troubled blink of Lubin's eyes I saw a filmy veil of shame denied and evaded, and, in the mirror behind the cash register my own face glimmering whitely back to me, I saw the fearful stutter of fear, like a bird caught in the net of fate.

A few days later we sat, Lubin, Morris and myself, enjoying Morris' cooking over the breakfast table in Morris' kitchen. Pancakes and syrup glutted into our bellies, coffee steaming onto our tongues. Honeyed words floating into the thin sunlight from the kitchen window. Morris, thin face severely smiling, murmuring about gods and chairs and ferns and whales. And Lubin, his smile sliding downscale from Gautama to Djugashvili, eyes suddenly lit with malice, turning to Morris after some naive platitude from me. "Morris," murmured in the soft caressing tones of Iscariot. "Bill doesn't believe that you are a homosexual," blinking brazenly into Morris' suddenly icy glare. Detailing my naive nonacceptance of corruption, fatuously and lethally failing to see that what I refused to accept in my naivete was not Morris' mortality but Lubin's cynicism. And Morris, transcending his anger in dignity and simple pride sitting silent a long minute, till, turning back to me a bit sadly and quietly resuming his description of the painting of a crow by a sixteenth-century Zen master.

Yet something had changed.

And there were times when Morris' own often-stifled enmity to Lubin flared up. Not loudly but well. He refused ever to take Lubin seriously as an artist, and in this there was a plausibility inherent in the situation. No master can ever take seriously his followers. And Lubin had assiduously played Morris' fond ape too long, so that Morris could only feel that his brother-in-law sought to deck himself out in feathers that he had dropped by the side of the path.

And more, in that sleek smile, he sensed a derisory note rising out of Lubin's relationship to Morris' sister, Celia.

Celia was deeply enamoured of Lubin, but it was a doomed love. Lubin lived a compulsively disorganized life, verbalizing his apologia in a continuous boozy hymn to bohemian free spiritedness. Celia worked as a waitress, returned home to cook Lubin's dinner, only to see him depart for the evening, sketchbook in hand, but more often than not with his mind set on women and booze.

Shortly after we met, he invited me to join him for an evening of sketching on the Skidroad. I arrived, he met me at the door, and we started off. I wondered idly why he hadn't invited me in. As we turned out the gate onto the street, he stopped, murmured, "Oh, I forgot something!" and ran back in. A few minutes later he rejoined me. Seizing my hand, he held it to his cheek which was wet. "Feel the tears!" he groaned. "She loves me so much she cries when I leave! And I love her so much that I am willing to cause her pain even though I can't stand it!" This convoluted thinking left me cold. Considering that Celia had just put in eight hours slinging hash to help pay their rent, I felt that it wasn't unreasonable for her to relish an evening at home with her love.

My evening was lost in the image of Celia sitting bent in sadness, the fragile nape of her neck exposed under the bun of soft blonde hair. She had a tiny classical head perched on a swan neck, wrote idiosyncratic poetry, kept her hair on top of her head and floated gracefully through life like a vision out of Byron. The bohemians in Puccini's opera were romantic. Lubin's bohemian irresponsibility in real life didn't seem very romantic or even very real.

This treatment of Celia contributed to Morris' arrogance towards Lubin. For his part, Lubin loved to needle Morris. Forty years later, he still enjoyed telling me a story from the period when Morris was first living in La Conner. Lubin was visiting Morris, who lived in a little shack which was kept immaculate. One morning, after Morris had taken off for a day's painting, a couple dropped by, friends of Lubin. After lunch, Lubin went out sketching. The couple had indicated by their deportment their interests in things venereal. Lubin cheerfully invited them to use Morris' bed, which they

did. In the evening Morris discovered his bed, which he left neatly made, torn up and bearing signs of amatory confrontation. Lubin in his telling of the story attributed Morris' rage to puritanism, rolling with laughter at the sight of Morris stripping the bed, hand washing the bed clothes and finally throwing Lubin out.

This story, like others in Lubin's repertoire of anti-Morris jokes, left me with a curious feeling of sad emptiness. I found myself concerned not with Morris' imagined puritanism, but with the sad picture of Lubin, boorishly and maliciously violating his friend's hospitality, only to continue the vulgar charade over the years with each repetition of the story. And I got the pain Lubin felt, who had fallen in love with Morris' painting when he first saw it, the first admirer, and the pain felt because he identified with his friend, and his painting did reflect this identification, just as his later painting would reflect his admiration for Tobey, and in each case Lubin would eventually be rejected and hurt. Until all he could do was express his hurt in petty spite, he who of nature had little spite in him.

Occasionally Morris and Lubin would act in concert to twist my tail. My serious reverence for classical musical training aroused their derisive laughter, since they had no musical training and found traditional music puzzlingly complex. In Morris' apartment he kept an old upright in an advanced state of collapse, on which he and Lubin would rhapsodize with fist, feet, open palms, elbows and foreheads to produce something which could pass as a cross of Henry Cowell and John Cage. During those moments when they tired of this juvenilia I would occasionally sit down and play Chopin and Beethoven badly. My playing was not of the highest order, and the piano was so nearly an instrument of torture to begin with that the results were not enhanced.

One evening as I struggled with the Beethoven *Appassionata* Morris and Lubin, wearing grotesque makeup, stalked in, drew themselves up and began a burlesque of Martha Graham, interspersed with thumps and thuds on the unoccupied keys, jostling me nearly off the bench, and howling like dervishes. White with rage I stalked out. The affront to my performance I could accept, but the

insult to Great Art was insufferable and it was several days before I would return.

A Portrait and What Happened to It

Lubin and Celia lived at this time in a tiny room at the very top of a winding staircase in the tower of an eroding mansion on Capitol Hill. A block away lay Volunteer Park, and in the park stood the Art Museum, shedding its gentle glow of inspiration on the friends who gathered to talk art in the minuscule studio at the top of the stairs.

The mansion had been divided into housekeeping rooms, the whole thing being run by a genteel elderly French lady who added to her income by giving French lessons, which were advertised on a swinging wooden sign jutting out from one of the pillars of the spacious porch. This lady, who attended to the greeting and over-seeing of each visitor, seems in memory to go under the name of Madame Tussaud, which is patently absurd, but such is memory.

Having been ushered onto the stairway and abjured to "rise, rise all the way up to the top!", I would trudge self-consciously up, up and up, feeling like the protagonists of *La Boheme,* tattered and poor, but touched with the glitter of an inevitable greatness which lit up our lives and made possible our jaunty acceptance of the pov-erty of those times. At the top of the stairs I would be greeted by Lubin or Celia, ushering me into their domicile as I huffed in short-winded tribute to the steep climb, tumbling me into a big armchair and forcing into my hands a cup of coffee, after which Lubin would sit on their one kitchen chair and Celia, when at home, would re-cline gracefully on the bed, and we would launch ourselves out into the thrilling space of the Impressionists, the School of Paris, the Mexican muralists, and our own friends who would eventually congeal in the minds of art lovers as the Northwest School.

One day, Celia at work in some greasy spoon, Lubin seated on the bed spun his dream of a great book, large format like the Phaidon Press artbooks, in which color reproductions would present the work of this little band of painters holed-up in the far northwest corner of the country. Somehow he had struck up a friendship with a wealthy woman, one of a number of such friendships which were to speckle his life with hopes that flowered only meagerly. And this woman was to be the source of the capital to underwrite his project of a book. The whole thing staggered me. I couldn't imagine the day when it would be possible to find the dollars necessary to publish a book with color plates. I had a hard enough time living from day to day, paying twenty dollars rent each month, eating such food as would keep my meager frame alive. But such was Lubin's confidence in his dream that his certainty infected me so that I found it impossible to seriously question it.

Enthusiastically he ticked off the names of the painters who would be featured in the book. A half dozen of Mark (who was still in England at the time), five of Morris, four of Kenneth, a couple of Malcolm Roberts, a couple by Guy Anderson (for whom Lubin always reserved a certain air of denigration based less on artistic than personal annoyance, since Guy's painting had always seemed to me to focus in some ways what Lubin himself aimed at in painting). Of Lubin, himself, an airy, "Oh one or two of mine, just a sample really!" Crestfallen I advanced some tentative queries about other representatives of our circle. "Oh yes, a few that I haven't decided on, maybe Al Banner, maybe one of the Japanese painters." Crestfallen even more, I finally suggested that perhaps there would be room for something of mine. "Oh," smiled Lubin seraphically, "you know, people really think of you as a writer!"

I sat in bitter depression for a little while more as my friend's voice flowed on, lost in its wanderings into a fantasy that would never see reality, that indeed was created purely out of his imaginings, something which he had dropped briefly into the ear of his wealthy friend who had never even registered it and would have been amazed to think that Lubin could spin any serious web around it, a fact which he shared with me years later. But at the time all I

NORTHWEST SCHOOL

Sketchbook—a Memoir /

1 MARK TOBEY
2 MORRIS GRAVES
3 KENNETH CALLAHAN
4 GUY ANDERSON
70 5 MALCOLM ROBERTS

saw was that I was out, that my friend did not include me in the band of comrades who would represent our painting to the world. A little later I left, outwardly cheerful, inwardly cast down.

Years later the scene returned often to my memory when I saw Lubin.

By the late seventies many books and articles had been published on the alleged Northwest School, and in some of them my work figured. Lubin in the meantime had wandered in stunned confusion through a life in which he always managed to steer away from anything resembling success, whatever that is. And I wondered often, as I watched my old friend's face what had been the true visage of his dream. For he had seen more clearly than anyone that the core of painters he named were indeed destined to make a mark. And, as he once stated, he knew that my destiny was secure on that first evening when he looked at my drawings at Morris'. "You know, Bill, I could never hope to draw like you, never!" And I got it, that my gentle friend had told me by his omission of my name from his Pantheon that he recognized my work as true, true exactly in that area where he most felt lacking, just as his animus towards Guy betrayed to my eyes in later years his envy of Guy's painterliness, his capacity for rich textural combinations.

My depression didn't last long, it never did. Soon I was back climbing the stairs to the diminutive room, until time had rolled over a few times and Lubin and Celia moved to a little house somewhere around the south end of Capitol Hill. Before this move, however, I sat one day for a portrait by Lubin, perched uncomfortably on the kitchen chair, and thereby hangs a tale of a later day, much later.

In the early sixties the bombing of a black church in Birmingham aroused a great upheaval of emotion across the nation. One evening Dick Gilkey came by my university district studio in an unprecedented state of distraction, declaring that he intended to renounce his white skin and dye it black. This struck both Roxanne and myself as a peculiarly ineffective manner of protest and we convinced him that it would be more effective to hold an auction of paintings and drawings by local artists. The success of our auction

exceeded all expectations. Response by artists was tremendous, only two artists refusing. Jim Washington at first turned us down, but later called up and joined us after his minister assured him that it was a legitimate gesture of support to the embattled blacks of Birmingham and not a Trojan horse sent out by subversive agents of a foreign ideology. And Phil Levine cheerfully turned me down because he felt that local artists were not doing enough to support Israel. Both responses were legitimate, and I'm sure that some of our acceptances were in the nature of getting on a bandwagon. The main thing is that no one was unaffected, and that makes the "Birmingham Auction" one of the high points of my memories. All of us, including Jim and Phil, expressed our concern for a world that would include everyone, in which there would be no losers hence no winners. And our concern worked, some $15,000 being raised in one afternoon.

But within this story I had my own personal sub-story. In addition to a dozen drawings, I donated a portrait of me which had been kicking around Ken and Margaret's basement ever since 1942 until I picked up my stuff from them in the late fifties. Over the years a number of portraits of me have been painted, at least three by Morris, and this painting was unsigned as were Morris' paintings of the thirties. But I was convinced that this was the portrait painted by Lubin in his tiny studio on Capitol Hill, and I was shocked when he looked at it briefly and said, "No! That is positively not the portrait of you which I painted in the attic room!" I was staggered, but Lubin remained firm. "The fact is," he stated categorically, "that is the little portrait which Morris painted of you down in the house at Tenth and Washington." And he went on to describe the scene in detail, the bitter winter cold of 1937, Morris painting with his hands in cotton gloves, myself wrapped in a blanket in Morris' big Sheraton armchair while Lubin sat by, smoking, drinking coffee and strumming a zither. The scene was not only believable, it had actually occurred at some time.

I was set back by the "decadent" color. A cacophony of cerulean, crimson and chartreuse which left me looking like a late-nineteenth century Parisian poet. "Oh yes!" Lubin murmured in reply

to my objections that the color wasn't Morris. "Morris did many small paintings around that time in which he used a brighter palette than the large symbolic paintings." My decadent look, he explained glibly, rose from the fact of my suffering from a severe cold, very likely the decisive lapse in health which led to my later tuberculosis. "You really did look frail in those days, you know," he whispered. And of course he and Morris had painted together for a number of years just prior to this period so it was hard to dispute his memory.

I wanted to give the painting to the auction. Next day Lubin repeated his judgment in front of witnesses. I dictated a letter of provenance describing the painting as having been done by Morris in the winter of 1937-38. The committee accepted it with thanks. An original Graves' portrait of one of the junior members of the Northwest School!

The Sunday of the auction dawned, indeed had barely done so when it became apparent that it would be a huge success. The auction room in Seattle Center was jammed, a great ebullience lit up everyone, no one doubted that we were letting art make a difference in the world. And the "Graves" portrait sat on an easel at the front desk under the guard of Masha Siegel and Jan Thompson. It was exhibited under the rules of silent auction, and rumor had it that two or three bids had already been entered, one by Jay Jacobs. I looked at it briefly, still somewhat bemused and uncertain. Lubin had been positive, and I had written the letter of provenance. But that acid color! I wandered off in my usual state of indecision and indirection.

At about this same pinpoint of alleged time Lubin wandered in, accompanied by Don Lockman, occupant of the bottom floor of the house in which my studio crammed the upper, a tall wistfully thin communicant of sidereal enlightenment who lurched in about two o'clock each morning (after the Blue Moon closed for the night) and played Bob Dylan records until it was time for him to leave for work at a scientific supply house, a friend I had known for years without ever learning when he slept. Engrossed in being an observer of the tumulting throng, I took a few seconds to become aware of a

sinister presence attaching to my elbow and muttering opaquely into my ear. Awareness slid slowly into focus and I saw that my avatar was Lubin, clinging to my elbow and making obscure attempts to communicate something, yet whether in English or Yugoslav was impossible to say between his thickened speech and the hysterical clangor of the crowd.

I stopped. I listened, straining to interpret what appeared to be a new and more obscure keen leaking from Lubin's moustache onto my shoulder and thence crawling up into my ear where it finally rearranged itself like the letters in alphabet soup.

Enlightenment!

"Holy cow!" I moaned.

For Lubin was murmuring, "You know, I just remembered! I did paint that picture!"

"But you said..."

"I was drunk!"

"Both times?"

"Yes."

"But you're drunk now!"

"I know. But I know for sure that Morris didn't paint that portrait. I did!"

Ambling elliptically down upon us loomed Don's height, emitting soft bubbly giggles. "Hey! You know what? You can see Lubin's signature!"

Horror and disconcertance. No signature had ever before been spotted. We sneaked over, pushed aside some reverent admirers of Morris' genius and stared in frozen dismay. Lockman, paying no attention to diplomatic niceties, pointed at the lower right corner, where at the very tip of his finger, in minuscule pencil script, wedged into a tiny sliver of brush stroke, you could barely make out the signature, "Petric 37."

My stance as an authority on the thirties art of the Northwest School collapsed into sudden ruin. Recovering with a silly smile I loped over to Jan and told her, "Get that damned painting out of here as soon as no one's looking! And burn that damned letter of provenance!"

Which, as they say, came to pass.

Lubin received the tainted masterpiece in the back alley and scurried home with it, where it perished a couple of years later when his ashram burned down.

A couple of years later I mentioned the incident to Morris.

"What a pity I wasn't here! I'd have been glad to sign it and no one would have known any better because Lubin was plagiarizing my stuff all the time in those days!"

Morris, as usual, expressing his love for Lubin upside down.

Well, so what? Lubin died last year and went on to the backroom of God's private Blue Moon, where he sits, a badly shaven Buddha, smiling, eyes twinkling, shivering with pleasure in the vibrations given off by the confrontation of liver-red and chrome-green. The portrait, naturally, is hanging on the wall over his head.

Storm Clouds

By now I had become integrated into the tribal circle. My position was much like that of an ailing youngest child. Everyone worried over me, fussed and fretted, and at the head of the fretters stood Kenneth and Margaret, watching over everyone but lavishing on me a concern which must have often driven them to near distraction, so patent was my genius for causing trouble, a genius which Margaret ascribed less to innate skills than to Lubin's wayward influence on me, although conceding the obvious fact that I suffered entanglement rooted in the pelvic perplexities of the female.

But Ken and Margaret oversaw all of us, even finding time for their young son, Tobey, who along with their androgynous dog, Mike, was often consigned to my care as a baby sitter when he was not in the more skillful hands of a beautiful and nubile Irish girl from the neighborhood, who had been declared absolutely off-limits to anything more than a strangled, "Hello!" from me by a hard-

eyed Margaret, who had no intention of losing a really good baby sitter to my faunish fancies. They used their stable position to help us all, feeding, steering, bandaging, advising, loaning, consoling, affectionating. As curator at the Art Museum, Kenneth was able to steer small jobs to us, and I often found myself taking tickets at lectures or shuffling paintings in the stacks for a few valuable dollars with which to flesh out my meager salary at the Art Project.

Time is unreal. This whole period only lasted four years, yet it seems like the major period of my life. And the first year or so of it floated in wonderment and conjurement, golden and ambient, marred only by the nervous undercurrents of malice between Lubin and Morris.

But now began a series of small incidents by which the universe presaged the shattering of our circle without giving any hint of just how and when the consummation of this disaster would arrive. Most of them occurred as examples of the idiot vagaries of the human spirit when it isn't checked by the gravitational pull of humor.

In late 1938 Lubin announced plans to move to San Francisco. He was tired of the drizzle, he had severed his ties with the Art Project in a dramatic manner (quite by accident flinging a panful of wet grout into the Project Director's face), and his heart and genitals were with Gail in the Bay Area. Needing funds for the move he made unusually heroic efforts to sell a few drawings and paintings. Now in 1938 this meant selling things for five or ten dollars, often on time payments of one dollar a month, swapping paintings for food or sparkplugs or records or books or condoms. If you wanted a large sum of cash, such as one hundred dollars, it was inevitable that you would approach the office of Dr. Richard E. Fuller, President of the Seattle Art Museum. From Dr. Fuller, you could always expect a courteous and gracious response, with a good chance that he would make a diffident purchase of something for the Museum collection.

Lubin locked himself in his small shack on the rear of a property on Tenth East, later occupied by Jim and Margaret Fitzgerald, where he turned out a whole suite of ink drawings overnight, sav-

agely grotesque to the point of incoherence. It being a period of war
and fascism, he validated the drawings as protest. Dr. Fuller re-
ceived him politely, leafed through the drawings, paid little atten-
tion to Lubin's gargled explanations, which tended to get lost in his
moustache, folded the drawings back into their folio, and gave as
his considered opinion that they were indeed interesting but hardly
of the quality incumbent on acquisitions for the Museum.

That afternoon Lubin and I gathered ourselves into a booth at
the Deluxe Tavern, a block from Cornish, where we were well-sta-
tioned to intercept the young daughters of the bourgeoisie as they
tittered their way between home and class, way stops on the over-
land route to middle age and tedium. As was usual when Dr. Fuller
failed to heed the cry of creative distress, he became a symbol of
callous indifference to the sufferings of mankind, an oddly unbal-
anced response since, when he did heed the call, he was even more a
symbol of the same indifference. Lubin fell entire into the shit-pile
of malice, envy and invidious resentment. Unmoved by the fate of
Europe's millions, our bourgeois had refused the drawings because
of their controversial nature. This was a switch of major propor-
tions. Which walnut concealed the pea? Lubin had never given a
damn for the fate of anyone before and he and I had strenuously
tried the case of Individual Freedom versus Social Responsibility
only a few nights before, when, leaving the State Burlesque, where
we had witnessed Henry Fonda in *Blockade,* John Ford's drama of
the Spanish Civil War, wedged in between strippers and comics, we
fell into verbal dispute about the duty of young poets and artists to
go to Spain (where Franco's Moors could kill them at leisure), I of
course arguing for the cause of heroic death and Lubin calling me
fifty varieties of idiot, the dispute mounting in rage and disbelief
until it astonishingly erupted in the middle of First Avenue, cross-
ing to climb Marion Street, under a pale silver moon and, witnessed
by not even an indigent drunk, erupted into a full-scale civil war of
our own, fists futilely flailing the lambent air, occasional caroms off
protruding eyebrows or cheekbones, and continuing acrobatically as
we crawled up and over to Third and University, where an all night
coffee-and joint promised respite from our labors and we subsided

into mugs of hot black coffee, tired and triumphant, having settled nothing but our frustrated gonads which had wisely accepted combat as a fruitful substitute for the venereal exercise which had been denied us by his girlfriend's absence, my own girlfriend's periodic fickleness and our lack of four dollars for the two of us to enter into the world of commercial concubinage, leaving us with the quarter each needed for the movie.

In any case, as fate would have it, Lubin unburdened himself to me that afternoon in the Deluxe, and I, my usual illogical self, rallied to the cause. That evening I was due for dinner at Callahan's, after which they were going out and I would babysit young Tobey. Margaret was happily immersed in the steam and clatter of the kitchen, the baby was already dropped in bed, and Kenneth and I lolled comfortably in front of the fireplace.

In passing, the matter of Lubin's trip came up. Ken and Margaret were only too hopeful for his success, as they hoped that a successful transfer to the Bay Area on his part would put an end to his bohemian influence on me, and I might make a more serious attack on the problems of art and life.

The reference to Lubin brought me up with a start. I launched into a passionate and intemperate polemic on the indifference of the wealthy benefactor of art to the attempt by a great soul to express his horror at the bestiality of fascism and war. I invoked Picasso and the spirit of Guernica. Kenneth remonstrated mildly. Dr. Fuller, he understood, had turned the drawings down purely on the question of artistic merit.

This reasonable defense of Dr. Fuller provoked me to ever more unwise hyperbole. Kenneth, changing from his usual ruddy complexion to flaming red, answered snappishly that he had seen the drawings, that Fuller had consulted with him about them, that they both agreed that the work was careless and incomplete and that Dr. Fuller had never even understood the alleged controversial content of the drawings because of their confused form and Lubin's boozily mumbled commentary. In point of fact, Fuller had offered Lubin an out-of-pocket loan which Lubin dramatically and grandly turned down, even though it was an obvious gift since no one in his

right mind would have contemplated repayment by Lubin as even a remote possibility.

I don't know what foolish and idiotic riposte this drew from me. I had declared myself in a friend's cause. The myth of Highland Scot and Southern Rebel had locked me rigidly into a stance and not for the last time. Try as I might, and I didn't, I couldn't shut my damned mouth, the ultimate pompous foolishness was uttered.

To Margaret in the kitchen the sound of the skirmish must have been dismaying and incomprehensible. What had happened to the golden glow of friendship? What had happened to the selfless search for artistic truth? She had no chance to investigate. Just as dinner was about to be consummated on the table Kenneth's temper gave way under my incessant yawping, the constant musketry verbally aimed at Dr. Fuller which was actually ruining Kenneth's whole evening and destroying his digestion.

His face turned white with frustration and anger, and he finally rasped, "Well, I agree with Dr. Fuller! And if that's the way you feel about him that's the way you feel about me and you can just get the hell out of my house!"

Stunned and numb, my mouth dry , my throat tight, my knees trembling, I rose, stumbled through the hallway, collecting coat and sketchbook, speechless, drained of anger and aghast at what I had done but too dumb to realize what it was. I closed the door behind me as quietly as if I were a burglar fearful of waking the house. As the door clicked shut I heard the swing door of the kitchen as it opened. I heard Margaret's startled voice squawk, "What?" but the front door latched and I stumbled down the steps and up the hill. As I neared the corner, I thought I heard the front door open, and, from the corner of my eye seemed to glimpse the silhouette of Margaret standing there peering into the evening mist, but pride wouldn't let me stop and I rounded the corner and sped for home.

No angel with a flaming sword stood over me, but it would have been appropriate. Like Masaccio's *Adam and Eve* I had been expelled from the Garden. And over someone else's quarrel! If I had only known, Lubin at that moment was hilariously drunk, totally

forgetful of Dr. Fuller and the struggle for peace or that he had that afternoon lit a fuse leading to my firing chamber with his meaningless recital of his wrongs. His only regret, in the fading hours of that day, was that he had not accepted the burlesque "loan" by which Fuller sought to give him money without burdening the Museum with meaningless drawings perpetrated merely to motivate a scam.

The night passed. I slept fitfully. Early next morning a sharp rapping shattered my sleep. I fell from bed, stumbled to the door and opened it to find Kenneth, embarrassed, stammering his concern, but smiling. It was all a silly misunderstanding on both parts, let's forget it, Margaret has breakfast prepared, get dressed now and let's get going. In ungracious confusion but with a heart full of joyful relief I dressed hurriedly and rushed out to jump in the Model A. All of us, Ken and Margaret, young Tobey in his high chair and I my very self rollicked through a happy breakfast, the sun sparkling on the Cascades to the east.

Nothing was said of the quarrel. Secretly I knew I had made a fool of myself and a boor as well. Ken and Margaret also knew it, but in their fond folly let it lie. I resolved never to do anything quite so stupid again. But I didn't keep the resolution very well, and it didn't seem to matter right then, as we finished breakfast, bundled sketchbooks and the baby into the car and set out for the shining mountains.

This quarrel had strange tendrils reaching into the future. After a few months Lubin returned briefly to Seattle. Callahans had him to dinner one evening. His stay in San Francisco had exacerbated some raw nerve and he was not his usual jolly Buddha self. He expressed bitterness towards most of the good companions. Celia hadn't stood by him. Morris had always treated him with downright contempt, and in this crisis had become even more infuriatingly supercilious. Guy masked cold indifference to people under a pose of pantheism. And Bill, he was just a cold-blooded little ingrate.

Kenneth had listened indifferently to the tirade, mildly turning aside Lubin's abuse while Margaret fussed with the baby, wish-

ing it would all end. But Ken jerked upright when he heard my name. Lubin persisted. Kenneth turned positively choleric. "Bill!" he exploded. "Bill? You damned fool, he's the only friend you've got! He stood up for you every step of the way. He stood up for you so damned hard that I lost my temper and threw him out of the house, and it was all because of you and those lousy drawings!"

Whereupon Kenneth lost his temper again and threw Lubin out of the house!

It had all started over Richard Fuller. Lubin and I merely expressed the frustrating impotence of our poverty and insecurity by blaming him for his wealth and social position. And Kenneth, who had worked hard and long to make Dr. Fuller's Art Museum work, had gotten into the quarrels with us essentially because he defended Fuller against our half-baked polemics.

So it was indeed ironic that the next big explosion concerning Richard Fuller, a shy and diffident man, involved Kenneth. In the cultural boom following the war, museums in the United States emerged from the ambiguous obscurity in which they had slumbered during the depression. Intense competition reigned and the day arrived when only the trained expert and lettered academic could hope to hold administrative jobs in a museum. And so it came to pass that one year Kenneth and Margaret returned from vacation to find that Kenneth had been replaced by Dr. Sherman Lee as Curator, Ken being offered a sop in the form of an offer to remain as Assistant Curator. Ken chose to leave.

And so began a period of intense economic difficulty for Ken and Margaret. I knew nothing of it at the time. My connection with my friends and with the art world had dissolved completely as I immolated myself in the foolish charade of changing the world, losing myself in activism, and generally acting the typical damned fool painted so vividly centuries ago by Cervantes. To make it all more impossible, Kenneth and I had totally broken off our friendship over politics. I had written a review of the Northwest Annual for the *Peoples' World,* a West Coast Stalinist weekly, a review which was remarkably bland. But it contained some reference to internal Museum matters which had reached me by some obscure channel.

"RED" POLITICAL PERIOD FOR AUTHOR BILL CUMMING
—— ALIENATES KENNETH CALLAHAN

Fuller was furious, Kenneth wrote a bitter Red-baiting letter, totally devoid of substance or logic, and I replied to both with stinging vitriol, and that was that, the door was closed, Kenneth and I were estranged completely and the great golden circle of friends was closer to total extinction.

Indeed, by this time, the quarrel between Kenneth and I was perhaps the final schism of our circle. Morris and Mark had ended their friendship with a chilling quarrel, arising over Mark's bitterness when Morris was the first to be accorded a major New York success for paintings done in the "white writing" technique claimed by Mark as his own child. The quarrel had caused incredible scenes in Seattle. Mark claimed Morris had stolen the style in deceitful fashion, that he had deliberately sneaked into a closed-off studio to view Mark's latest work and avail himself of his recently acquired link to high art circles in New York to beat Mark into the big art scene. Things reached a point where a middle-aged lady, one of Mark's epigones, accosted Morris on the street, screamed, "I could kill you for what you've done to Mark!" and proceeded to attempt just that with the comic-opera weaponry of her handbag, with which she pummeled Morris enthusiastically in a spasm of self-righteous mania.

As if this were not enough, Morris and Mark independently of each other launched attacks on Kenneth on the occasion of an article on Northwest painting written by him for *Art News*. Kenneth had been writing columns for *Art News* for several years, but in this case, Mark and Morris, who felt that the columnist had slighted them, wrote letters to the Editor, that most fatuous of pastimes, claiming foul in that the columnist clearly suffered a conflict of interest in passing judgment on his colleagues.

In the middle of all these whimsical skirmishes, Guy stood aside, smiling innocently and with evident relish, attacking no one, allowing no one leeway for attacking him. His infuriating pacifism succeeded in alienating him from everyone in the long run, since it allowed him to pass judgment on everyone else merely by not passing judgment.

So our provincial innocence had come to an end with the wan-

1. KENNETH CALLAHAN VS BILL CUMMING

2. MORRIS GRAVES VS. MARK TOBEY

3. GRAVES + TOBEY VS. KENNETH CALLAHAN

ing of the thirties and the dawning of the forties. The process was subtle and simple. Success arrived. Artists were soon to be taken into the web of the abundant life. Morris was discovered, Mark became enraged, Mark was discovered, Kenneth was unearthed, Morris and Mark parted company with Kenneth, Guy was brought blushing out of the shadows, and stylistic similarities having been noted, philosophical similarities were uncovered. The intelligentsia came to the startling conclusion that a remarkable school of painting had hatched unheralded on the shores of Puget Sound, nestled between the Olympic and Cascade Mountains. This indigenous grouping had worked in isolation far from the main currents of American painting of the thirties, untouched by social realism or by echos of the school of Paris or of German expressionism. Warmed by the Japan current, open to the breezes blowing off Fuji, and expanded on the wave of guilt engendered by Hiroshima, the Northwest School bobbed into view in the pages of *Life Magazine* in the persons of our four mystic painters. The hothouse rhetoric of Nancy Wilson Ross added intellectual tones to the corpus. Northwest mysticism blossomed, only to get trampled in the hurley-burley of Abstract Expressionism. The apotheosis was completed when denigrators appeared, heatedly dismissing the Northwest mystics as effete, trivial, and only related to Zen by virtue of imitativeness.

And out of this success grew most of the quarrels and schisms which shattered our circle. What did we possibly get to replace the friendship and the love? My own schism with Kenneth at least grew out of a wholesomely illogical political disagreement, totally irrelevant, having nothing whatsoever to do with art. But the other quarrels all reduced to triviality and pettiness the very thing which had drawn us together in the first place, the focus of our talents into creation of an idiom devoted to creating a language with which to express the singularity and uniqueness of our experience of the Northwest earth. And the fragmentation grew out of the intervention into our consciousness of the judgment of the work of the four leading practitioners by outside experts and intellectuals. The war had played its part in driving us in separate directions, but in the long run this could have been undone with the return of peace. The

introduction of individual jealousies and hostilities within our circle of friends by the action of external forces was disastrous. We had shared generously in mankind's general follies and pettiness without being shattered by them. Now we were shattered, and permanently.

News of the internal dissensions reached me slowly. The war I spent for the greater part incarcerated in Firland Sanatorium, flirting with death, particularly when an arterial hemorrhage of the lung inundated my cubicle in blood. Released after a year-and-a-half, but unable to work, I spent some years carrying an incredible pneumothorax of the right lung which led eventually to serious complications, necessitating two bouts of chest surgery following further hemorrhages. This continual flirtation with death so infuriated me that I lost my temper in the late fifties, resigned from the radical movement and refused to suffer any further frail health, becoming astonishingly healthy and robust.

Erosion continued to cut us apart. In the late fifties I dropped in on Margaret in their new house, their second move since the little house on East Ward, where I had been taken in and sheltered and nurtured in the thirties. We sat constrained and hesitant in their living room, sunlight seeping through French doors, flowing and undulating over the floor, rising to halo her blonde head as her soft modulated voice crept out around me. Twenty years had passed. Impossible! Margaret still sat radiant, her cool eyes regarding me with some secret amusement which would pursue me forever, her soft voice teasing my ears with its hints that perhaps I had been born to something greater than the feverish clatter in which much of my life seemed entangled. I sat there, skewered, still the same unlicked cub of twenty years gone, enthralled by the sonorities of a spirit which soared beyond the range of my earth-bound parameters.

Between us lay the painful corpse of the dead friendship of myself and Kenneth. Our quarrel, a stupid schism over a stupid issue, had drained our friendship of its lifeblood. Shorn of illusion about the Fatherland of the Toiling Peoples, trudging painfully on my way out of the whole tendentious bog of ideology, my pride was

FRAGMENTATION

still too stiff to allow me to beg Margaret to act as intermediary. Flailing in despairing outrage, I lapsed into silence. Our talk stumbled aimlessly into awkward lapses. We sat there encased in present sunlight, but oppressed and flattened under the weight of the past, unable to get out from under it.

Twenty years gone I had passed through the door. And now this leaden despair. So it hadn't been enough just to pass through the door. I had passed through, been admitted into friendship and creative striving, but I'd held it too cheap. And what of the others, who had presumably known better? Perhaps we'd all held it too cheap. The Plane of Magnificence was just too hard to maintain for very long. Maybe it was all beyond us.

Would we have done differently if we had known then that already within the flesh of Margaret, our good angel and our guide and our goddess of earth, and my own special guru, the tiny cells were arranging themselves, taking their places, expanding and enlarging, assuming bewildering disguises, limbering up for the fatal dance?

I doubt it. Like heedless children, we ran our course with the usual mixture of folly and glory, of wisdom and ignorance, of greatness and pettiness. When it was all over, our circle was broken, individual friendships were shattered, and Margaret was dead.

The Bohemian Life

Somewhere, some time Lubin and Celia separated, I had separated from Dorothy. For a time we both had apartment-studios over the American Legion 40 and 8 Club between Second and Third on University. Both of us were working on the Federal Art Project. We earned the lowest scale for artists, sixty-six dollars per month, nine dollars less than the wage paid carpenters and custodians.

On the project during the day we fritter away much of our

time. The Art Project is not set up to work. The noble dreams of its initiators are eroded at each step down the ladder. If, in the chain of execution, the dreams run into an incompetent or disinterested director or administrator a whole chunk of energy is removed from the vision. The vision started with someone like Eleanor Roosevelt. In the case of the Seattle project, it met and was dammed up, eroded, lost, vitiated by a Project Director who somehow, whatever his own plans, managed to use up the energy of the artists in false starts, trivialities, noncommitment. So that our days were used up in aimless sketching much of the time, trivial studio tasks at other times. In other words, we held jobs just like most people, jobs which meant not much to us, out of which we generated little energy and into which we were unable to pour energy which could flow into the community.

After work, our real life starts. At 5:00 P.M. we finish up whatever we have to do. The assembled animals mill through the same big lofts I had seen on the day I met Morris. Meaningless witticisms, mumbled commentaries, flatulent warnings against the dangers of the city, interrupted anecdotes, all burble in the air around our ears as we crowd into the elevator. We're so packed that our feet are stacked against each other's or even overlap them. The elevator creaks its protests. Or are they threats?

We never descend without visions of the whole affair plummeting into the basement five stories below. The occasional clerks, salesmen and warehousemen from import houses or novelty manufacturers who manage to crowd into the elevator when the Art Project empties eye us with disdain. To my eye my colleagues are only remotely connected with the muses, but to our neighbors we are all a gang of anarchists, free-living free-loving bohemians, around whom hovers the faint odor of debauchery, carriers at the very least of a vast array of social diseases. And on top of that we are living off their taxes! They cram themselves into the furthest corners while we undulate lasciviously against our middle-aged sculptress and our fading secretary. It brings a little joy into our hearts to know that we terrorize the petty bourgeoisie.

Around the corner is a tiny tavern. Lubin and I lead a proces-

sion of babbling rioters up the street and into the tavern. We jam ourselves around the tiny corner table. Irene, Alf, Agatha Kirsch, Fay, Jacob Elshin, Lubin and I. That is more or less the weekly gathering with variations on odd weeks.

Most order beer. Our white-haired watercolorist, Agatha, orders a glass of red wine, which she sips as she recounts her adventure of the day. She had been permitted a field trip to do a watercolor on Alki. Getting off the flat-wheeled orange trolley she set up her easel on the beach, sat down on a three-legged stool, squeezed out her tubes of color, happily began dribbling water and pigment over her paper. Her enthusiasm for painting knows no bounds. Soon she had lost all sense of time, lost touch with the beach, the children playing, a swimmer or two, dogs romping on the shale, passersby.

Then as she paused to rinse her brush, she sensed something. In the middle of her back two little pressure points became activated. She froze in sudden panic. The pressure was real but unidentifiable. Without moving her head she allowed her eyes to sweep to the left and to the right to the furthest limits of peripheral vision. Nothing to right, nothing to left. Her panic rose. She was virtually frozen in place on a warm summer day. Whatever was there must be directly behind her. She decided to risk all. Fearfully she swiveled around on her stool. No one was anywhere in the vicinity, no one was even in sight except for figures in the far distance.

The pale sun shone at its noontime brightest, casting short shadows. About twenty yards behind her stood the mens' bathhouse. The sun cast a slight shadow on the side facing her. In the middle of the shaded wall she saw a darker rectangle of window. And in the middle of the window, suspended in the darkness of the bathhouse interior she saw the pale whites of two eyes watching her. She choked a tiny scream back onto her tonsils. Hurriedly, in frozen motion, like a manic sleepwalker, she packed up her supplies and her easel and stool and her half-finished painting. At intervals she stole furtive glances at the bathhouse. Each time she saw the eyes watching her, recording every movement, recording each feature. Packed, she tiptoed up the beach as if she might slip away unnoticed if only her footfalls made no noise. The eyes followed her until

she passed behind the angle of the bathhouse. At that point they couldn't see her. And she realized that at that point she couldn't see the eyes. She had no idea now where they were. She had reached the sidewalk. Two blocks away lurched the oncoming box of a streetcar. She bolted across the street, reaching the stop simultaneously with her orange savior, scrambled on, noting that she was the only passenger, dropped in her token, staggered to one of the cane seats and slumped down exhausted.

So shaken was she that she had told no one of the incident until now, the wine warming her tongue, the chatter of her friends opening her heart. For hours she had found herself whirling around, even in the safety of the project lavatory, looking for eyes. A whole lifetime of repressed emotions had focused in one afternoon of fear out of a pair of casual eyes staring out of a darkened window.

Following Agatha's harrowing tale we sit primly for awhile, until Irene stirs her somnolent and luxuriant flesh into motion and announces, 'Time for me to go!' Everyone jerks into action, spilling packages, picking them up, helping each other into coats, carefully draining the dregs of our glasses, pocketing change, crushing cigarettes into the meager dregs of the beer glasses. With a rattle of overshoes the bohemians sweep out the door and spill off in their various directions.

Lubin and I are left standing on the corner of Western and Madison. Ahead of us yawns the night, the density of its blackness spilled across with lights. We sniff the air, savoring the scent of flesh and sin and danger. Up the block we glide, past the red brick Federal Building up to First Avenue. Restaurants abound, called in the vernacular greasy spoons, a vanished breed fifty years later, their places taken by the modern fern-filled gourmet establishments where you have difficulty telling whether you're eating your salad or the decor.

In many cases, today you eat your filet mignon or your escargots right on the spot where Lubin and I dined in the thirties. What in those days was the Pittsburg Cafe became the Brasserie Pittsbourg. As late as the sixties it was the Pittsburg and Jack Stangl and I used to eat cheaply there. In the thirties you could eat

even more cheaply at the Pittsburg and dozens of other greasy spoons. Country sausage, applesauce, mashed potatoes and gravy plus your coffee at the Market Cafe next to the Joe Desimone Bridge in the market. And for all that you paid thirty-five cents. Unless you wanted apple pie, which would cost a dime extra, with a piece of cheese thrown in. You didn't always have the extra dime.

Somewhere on First we enter into the blinding white light of a greasy spoon, run by some Japanese or Yugoslav or Greek. In those days ethnicity doesn't exist. Whoever you are, whatever your genes, you serve hamburgers and sausage and ham and eggs and black coffee and apple pie with cheese. So we stop and eat for a quarter, perhaps indulge in a sweet. Over our coffee we smoke. My pipe. Lubin's incessant cigarettes, ten cents a pack. Nervously he shakes a fag out of the pack into his palm, clinches it between finger and thumb, lays it reverently in the middle of his lower lip, under the black moustache, compresses it between his lips, lights it, draws a deep breath of blue smoke into his lungs, shuts his eyes briefly in ecstasy, dribbles the smoke out his slavic nose, opens his eyes and winks at me.

In the midst of the swirling smoke and the steam from the coffee urns I glimpse the dark angel hovering over his shoulder, who will call for him finally and definitively in 1980, totting up the final bill for those tens of thousands of cigarettes. But it doesn't matter, Lubin's here now at my elbow, peering over my shoulder at the astonishing sight of these words flowing onto the paper telling about a mythical life which we allegedly led almost fifty years ago in a mythical city next to mythical water under mythical mountains. He chuckles softly, his old careless smile and he's humming. What else? An old Piaf tune…"non, je ne regrette rien!"

We talk a great deal of art. We talk of Modigliani and Pascin. If you were to wander in you would see a cadaverously thin, dark-haired boy with pallid skin listening to a stocky, dark-complected slav whose cigarette bounces on his lower lip as he talks, smiling much. You would start back, to be sure, certain that there before your eyes sit Modigliani and Pascin talking of Modigliani and Pascin.

Absurd! Drugs and wine killed Modi long ago and Pascin cut his wrists in 1930.

Once upon a time there was proof for all this. Lubin and I, wandering up Stewart Street on a sunny Saturday morning, came upon an itinerant street-photographer standing by a battered tripod surmounted by an ancient camera. On one leg of the tripod hung a tin cup of clear water. On a second leg hung a tin cup of developer. Over the camera hung a frayed and stained black cloth. Surveying this domain and keeping out a weather eye for cops stood the proprietor of the establishment. A hawk-nose dominated a face carved out of granite, out of which flashed the eyes of P. G. T. Beauregard. A long black morning coat, possibly recovered from looted Yankee baggage trains at First Manassas, flapped negligently in the breeze over nondescript trousers of indeterminate age and color which could also have come out of the back barrel of Father Divine's Son Bill's place on Yesler. He invited us to stand for him in his parlor, which was synonymous with the curb of the sidewalk, disappeared under the cloth, called out, "Attendez!" and discharged a little tray of flash powder. Out from under the cloth he came, dashing it to the pavement in his hurry, waving a small rectangle of tin, which he drowned in the cup of developer. Standing in a coma, he counted slowly to himself, his eyes rolling up into his skull, searching some trismagistical meaning in the clouds fuming his brain, his lips moving in cadence until, reaching his count, he suddenly came alive, rescued the rectangle of tin from the developer where it had bloomed into a random splotching of dark and light, dropped it in the clear waterbath, rinsed it back and forth, pulled it out, dried it on a towel and handed it to us. No negative! This was one-of-a-kind, a true daguerrotype just like you see in expensive books on the history of photography.

What did it cost me? Fifty cents. And if it hadn't disappeared down one of the myriad cracks of my life over the last forty years, I could show it to you, a real historical document. In front of your eyes you'd see, standing on Stewart Street on a summer morning, the mass of a Greyhound bus passing in the background, their arms over each others' shoulders, the old friends Amadeo Modigliani and

Jules Pascin disguised as Bill Cumming from Tukwila and Lubin Petric from Butte.

By the time Lubin and I left the greasy spoon it would be almost 7:30, time for the first evening performance at the State Theater which stood at First and Madison. The State was Seattle's premier burlesque, home of Meyer Fritcher, a veteran comic, home of Ginger Dare, stripper deluxe, temple into which filed the young and the old, the poor and the poorer, the literate and the illiterate, all male, all in determined pursuit of the dream that escaped them when they woke at 5:30 A.M. that morning. Lubin and I would bolt for the balcony, whose panoramic view of the stage gave the charm of a Degas pastel to the scene. With a few minutes left before the stage show, the newsreel would be winding down. *HITLER THREATENS, MADRID FALLS, FDR CHATS, THE YANKEES WIN, THE DODGERS FALL, SUCCESSFUL FBI TRAP VENTI-LATES PRETTY BOY FLOYD* and the film ends, the spotlight leaps out after a short pause during which the voice of the electrician is heard muttering obscenities, the white light bounces wildly off the bald head of the organist, the drummer parts the curtains with a long roll and the treacle tones of the announcer spill out into the violet air and we are lost once more in a dream as the assembled company, six girls and two comics, go into a frenetic tap dance routine. And then come the strippers and the comics and the strippers and the black-outs until the premier danseuse winds up the performance standing bare except for a tiny g-string pouching her venereal arch and two tiny pasties covering her nipples until in a Wagnerian flash, lights shoot up blindingly, music of the organ and drum deafen, and she whips off the pasties, stands triumphantly extending hands to heaven, lights immediately fail and we are left hanging by our thumbs with a fading glimpse of what our eyes insisted really were her bare nipples.

The vision never palled. The pink and blue spots bathing the powdered bodies, turning the roughened and rippled flesh to baby-bottom smoothness, no lumps, no bumps, no scars of appendectomies or caesarians, no rippled thighs. In my stuff is a drawing I made in 1939 of our favorite, Ginger Dare, naturally from San

Francisco. Her entrance, stepping with all the nervous style of a gaited horse, would smash me down into my seat in a nausea of desire and passion. My eyes would record each contour of her wide hips, wasp waist and frail ribcage with large firm breasts. I drew dozens of images of her, lithe, narrow-waisted, unmistakeably Parisienne. Lubin, cynical and sophisticated, toughened by boyhood in Butte, was perennially amused by my romantic passion. "You're a real nut!" he murmured.

And proved it.

One Sunday morning he woke me early. He had just come from an all night party in the dressing rooms of the State, he said, and he had met Ginger Dare. He would see to it that I met her too and he wanted to see my face when I did. I nodded, torn between the temptation to meet her and the desire to hide away from the ambush which Lubin was so obviously and cynically planning.

A day or so later, walking down First Avenue in the afternoon, Lubin clutched my arm. "There she is!" He pointed to a young woman on the other side of the street. Tacky blonde hair, blotchy skin, sadly harassed by an obvious husband and two kids. Lubin's malicious grin widened. "Would you like to meet her?" he chortled.

"Nope, I guess not," I replied.

I stood a moment, watching the little family straggle into a cafe.

Lubin and I walked on up the street, silent, Lubin a bit contrite now. "If only you weren't such a romantic nut!" he wheezed, trying to keep up with my rapid lope.

"Who cares?" I answered. "I don't give a shit what you think, I still think she's beautiful!"

I really did and I still do.

Shuffling out of the State, dazzled still by the pastel lights and the last exploding image of powdered nipples, slow to adjust to the garish neon and electric glare of First Avenue, we stand briefly, then turn south and stroll down First Avenue toward Pioneer Square and the Skidroad. We become part of a great procession of males, shuffling, limping, dragging, rotating in an endless ritual of time-fill-

ing, time-transcending pedal meditation. The feet of these hundreds of soiled, lonely, thoughtful, restless, quarrelsome, hopeful men are tuned to every crack and bump, every slope and gully in the pavements. As we walk we read these contours, which reproduce the contours of the earth's first days, and our minds stretch out over three billion years, clutching at images which always escape us.

Around Pioneer Square's baroque comfort station, its popcorn wagon floating slightly off the ground on clouds of ammonia vapor wafted upward from the urinals, sit, stand and recline the hardcore of Skidroad. These are the ones who have been reading this terrain for so long that they have become fixed like Buddhas, rooted into earth and concrete in Neanderthal splendor, saying little to us but quite a lot to the fellows who have just finished the wall decorations at Altamira and are packing up to go over to the new job at Lascaux.

Nine out of ten of these anchorites are Native Americans, called by everyone, in the thirties, by the simple word, "Indians." They look at us out of dark obsidian eyes which cannot conceal that they have never yet managed to get over their innate sense of superiority. Baffling. We never do penetrate behind that silent gaze.

Carried along on this gentle tide, warily avoiding the looming figures of the cops, who can turn instantaneously from patronizing somnolence to eruptive violence given sufficient provocation, we parade on down around the corner of Washington and on to Occidental, to Free Speech corner. This ground had been staked out in the early years of the century when hundreds of Wobblies and Socialists and radicals had waged war to ratify the First Amendment of the Constitution along this one-block stretch. Casualties had been great, but the day had been carried. Elizabeth Gurley Flynn, then the incredible Rebel Girl of Joe Hill's poem, climbed a lamppost, chained herself there and berated police and vigilantes, particularly those who appeared to be Irish. The battle won, she descended, tucked up her hair and sat down on the curb, where, observing a detective eyeing her revealed and lovely ankles, she snatched two dollars out of her purse, tossed them to him and grated, "Here! Go get your ashes hauled somewhere else and keep your dirty eyes off me!" I met her years later, much older, with tattered traces of

youthful beauty hung around her face, enormously swollen, her wit faded, her mouth mechanically repeating the rote phrases of jargon dictated by the Stalinist party line. A sad hulk of a once great ship-of-the-line but the beauty still shining dimly through. You held your peace and dipped your head in salute to what she once had been.

Around Washington and Occidental there are soapboxes everywhere, each supporting a prophet. It is a decade of prophets, not of gurus. With Old Testament fervor they deliver brimfire messages on texts from the *Daily Worker* to *The Militant* to *Ecclesiastes*. We stop on the corner where the House of David holds forth. Today in an age when even first graders try to grow beards, the effect of the bearded prophets of the House of David can't be understood. In 1939 beards are so unusual that they almost inevitably signify House of David, except in British Columbia where they are the mark of the Doukhobors. Behind the beard may lurk a patriarch or a twenty-year old. Indeed the House of David is famous, and this chiefly because of its barnstorming baseball team. The team is made up of semipro and professional castoffs, few of them believers. They play good baseball, and are capable of upending very good teams. They tour continually, playing against local champions, semipro all-stars and pickup teams of off-season big-leaguers. To the best of my memory they don't cross the color line either by hiring black players or by playing against the great teams of the black leagues.

We stand against a wall sketching the bearded sectarians. One of them ascends the soapbox and delivers the sermon. The others line up behind and around him, delivering responses like a Greek chorus. Two gentle beards circulate through the crowd, handing out tracts, soliciting nickels and dimes for the cause of the Prince of Peace, whose gentle exhortations are having little influence on the world as we edge toward total war. Every now and then the speaker descends and another steps up to take his place. They are a sect in which everyone delivers the message. Their gentleness is impressive. In an era of gentle people they are startling in their docility and liquid softness.

Consequently we are startled when one of the circulators stops

in front and addresses us in a low voice shaken with tension. We strain to hear. His accent is early Ellis Island. I look at Lubin, Lubin looks at me. He shrugs and continues to draw. A terrible anguish washes over the face of the prophet. His voice becomes urgent, he strains to make himself intelligible. All I understand is that we are breaking the law. What law? What have we done? We look to see if there is a No Loitering sign on the wall behind us. He becomes incoherent, his hand raised with index pointing to heaven. A great light begins to filter into my reeling brain. I catch the phrases "God's law" and "graven images." Lubin starts up in anger as I grab his sketchbook away from him and hurry up the street. He lurches after me, too surprised to punch me, retrieving his book and angrily sputtering, "Are you crazy? What's the big idea?"

"Don't you get it? He's telling us that we're breaking God's law by making graven images!"

"So what, for Christ's sake?"

"Lubin, it's bad manners to draw them if they don't want to be drawn!"

Snorting derisively at the naive niceties of my idea of etiquette, my friend lights another cigarette as the dark angel smiles over his shoulder and we continue up the street.

We round out of the Skidroad and move up past the Atlas burlesque, next to the Smith Tower. We never enter here, as popular report has it to be a literal flea-hop, where the fleas wrestle the customers. We walk on up Second Avenue past University Street and walk down a flight of steep stairs to a nightclub called the Spinning Wheel. Here we sit and sketch an array of strippers, dancers and singers who lack the qualities I love in Ginger Dare for the simple reason that they are all impersonators of female rather than female. The Spinning Wheel is what is now called a gay club, but in those days we don't make such categorical fragmentations. No one bothers us. Perhaps we aren't attractive, I muse. And then the entertainment is actually good, very professional. One famous transvestite was nationally famous for his rendition of "A Good Man is Hard to Find," and during the late show, even the vice squad gumshoes in a mellow mood, the whole audience joins the star in

his show-closing rendition of his feature number, "A Hard Man is Good to Find." The show closes in a raucous babble of catcalls, screams, giggles, snorts and general hilarity as we stumble up the stairs into the night air.

It's after midnight. Our sketchbooks are bulging. We wander back down to the International District, south of Jackson, up an alley to the Green Dot, our favorite speakeasy. Prohibition is gone but not speaks. In our state, where liquor-by-the-drink is limited to the wealthy in their private clubs, the plebs strike back through the speaks. You brought your own bottle, they sold you mixer at the price of whiskey. None of our friends are there this night, we haven't the price, and the bouncer genially pushes us out, the amused black faces watching without enmity. Depressing. I wanted to draw the dancers. At the Dot the floor was possibly six by six feet. Ten couples dancing on a dime.

The night's beginning to run out. What strength sustains us? We've been wandering since 5 P.M., over eight hours. We wander up Fifth, turn right up Stewart Street, aiming to arrive at the Scandia Bakery about 4 A.M. when the bread and cakes are coming hot out of the oven. We reach it, our feet limp with fatigue, our knees turning to silly putty, and sink onto the high-backed counter stools. A buxom grandmother waltzes over and takes our order. At this time of morning she's ready for polka or hambo. The other customers, nighthawks of other species, eye us warily as we flip through our sketchbooks, talk in muted excitement of the people behind the sketches. Our pancakes come, rolled around lingonberry sauce. We dump sweet maple syrup over the whole thing and bask in infinite sweetness.

When we emerge, night is gone. It's 5:30 of a Saturday morning. No project today. Streetcars hold few passengers. Workers coming home from a night shift. Others starting a day shift. But there are few workers whose jobs include Saturdays.

We blink in the morning twilight. We are abashed because we are without girls. Perhaps Lubin shouldn't have allowed Celia to slip away. Perhaps I shouldn't so resent Georgia's ambivalent fluttering between my impatient virility and the sensitivity of her other

lover, a gay ballet dancer. At the moment we're estranged, a result of my boorish behaviour. In a week or so she'll come by, scratch on my door like a kitten.

But right now finds me standing alone on the curb in the cold, gray light with Lubin.

We walk down the street. The faces are multiplying as morning comes on. The middle-aged, worn down with work, worn down with looking for work. The young, many of them just off the rods from the Midwest or East or South. Earlier in the evening I had refused to give Lubin two dollars so that he could buy a bottle. Later a kid who had just dropped off a freight from Kansas City hit me up for a dime. I gave him a dollar. Lubin exploded in rage. "How can you do that? You give some bum a buck and won't give your best friend money for a bottle!"

I shrugged Lubin off.

Now I remember the kid. A couple of years younger than me. What good would a dime have done him? So I gave him a dollar.

Over his shoulder I saw the dark angel nodding at me. The angel watched the kid walk away, then held up his hand, holding a card like the route cards of streetcars. But the light was bad, my eyes were unsure. I couldn't see what it said. I never knew whether the kid clutching my dollar was on the route to Bataan or Iwo Jima or Anzio.

Guy Anderson

Sometime before Christmas, 1937, Kenneth and Margaret introduced me to Guy Anderson. Guy was short, rather dark, diffident and vivacious, reserved and friendly all at the same time. Of all the painters of the group he is the one I would most likely cast in the role of a Zen master. I have never known Guy to raise his voice in argument, never known him to express spiteful or angry feelings,

and I can hardly say the same for any of the rest of us and myself in particular. His warmth is impersonal and almost detached, imposing no emotional obligation on his friends. So much of his life was lived in monastic retreat that I was a trifle startled in recent years when he laughingly confessed to me that he was really happy to have moved his residence into the heart of metropolitan La Conner, and that he had got to the point in his life where he greatly enjoyed the anonymous companionship of the crowds at the La Conner Tavern.

Guy had a tremendous interest in the art and craft of paint. Immediately upon meeting we plunged into murky pools of the shop talk which serves as adhesive for painters. His tastes varied from mine, his a pronounced interest in painting which directly poses spiritual questions, whereas my greatest interest was in painting which presented the human condition through the gestures of the human body.

One night in late 1937 Guy and I, wandering down First Avenue, passed the Florence Theater, a flea-hop which in later years became a porn-shop. Guy brightened when he saw posters informing the world that *Lost Horizon* was playing that day.

This sentimental tale of everlasting life in a Himalayan hideaway did not move me particularly, but Guy was anxious to see it and we went in, proffering to the cashier the 30 cents it took to freight our two bodies into the worn seats of the auditorium, where we hung suspended between reality and fantasy for the next two or three hours. At THE END we rose, stumbled out and repaired to a nearby greasy spoon for coffee and doughnuts. I listened to Guy elaborate on the miracle of film, how he did not grudge it an innate superiority to the inertia of painting. After this excursion it was too late to catch the bus to Foster, that bus having left a good half-hour before.

We stayed overnight in a hotel on First Avenue. In the morning, we came down to the lobby, rested but hungry. Guy had to report in to the Art Project, I had to catch a bus for home. In the lobby, Guy said to me, "You go on out the front way. I'll meet you on the corner." I went out, and a couple of minutes later he came

out by the side entrance and joined me. The mysterious performance amazed me, but I couldn't help inquiring the reason. Guy laughed, "We're close to the project and you don't know who might pass here on their way to work just as we come out of the lobby."

I was utterly baffled. Later, after my naive edges were buffed down a bit, I realized that in the sophisticated world of the big city I was entering a world where gossip was more likely to be set in motion by two men coming out of a hotel in the early morning than by a man and a woman. Guy's conduct was simply one of many examples of the exquisite sense of consideration which has always been characteristic of him.

Guy was seldom in town for more than a few hours. He worked in the field, reporting to the project once a month, when he could generally be expected to spend an evening with all of us at Callahan's. The subject of *Lost Horizon* came up one evening. Guy was moved by the mystic implications of what the rest of us considered rather shallow. His main point was the power of film art, a recognition which he shared with such diverse eyes as Lenin's and Hi Tle Rudolph Arnheim's. "I don't care if film pushes painting into oblivion," he stated. "If movies can reveal more powerful truths than painting or other conventional arts I'm just glad to see it."

What was important was the realization that film was more than a popular art, that it was not inherently shallow (as many thought), that it was capable of stating truths, the profundity of which was only limited by the capacities of the people making films. My own contribution to the discussion was that the power of film to reveal truth rises out of its essential character as a popular art. Painting, I felt, had lost much of its power as revelation because it had gotten to the point where it could only reveal to a limited circle of mandarins. This little discussion contained in germ the essence of many of the ideas of the Northwest School, as it would later develop.

Trip To La Conner (1) MORRIS GRAVES
(2) GUY ANDERSON

Morris' original move to La Conner was to live in a burned-out beach house on the hill above the waterfront. The kitchen of the house faced on the edge of a rock cliff behind a backyard scruffed with blackberry bushes. The house, while badly charred, was structurally sound.

Morris carted beach sand for the livingroom floor, interweaving burned stumps of driftwood into his heterogeneous collection of old chairs, end tables, bureaus and writing desks. At night, in the glow of candles or oil lamps, you soon became convinced that you were free-floating far below the surface of the ocean.

Sometime in the summer of 1938, Morris summoned a whole party to visit him during the summer dance ceremonies at the La Conner Reservation Longhouse. Steever Oldden, Dave and Jeri Lemon, Lubin, and my wife, Dorothy, and I sailed up in Dave's sloop, slipping noiselessly through the turbid green night waters of the Sound, sliding into La Conner through the morning mist, the town looming suddenly out of nothing as we negotiated the slough between town and Fidalgo Island. All night we had been accompanied by a band of ghostly spirits out of the pre-white past, who dropped sullenly away as we moored into the commercial mutter and snarl of the La Conner waterfront.

As the day wore on, others arrived—Faith Craig, Bonnie Bird and her husband, Ralph Gundlach, Erna Gunther and two or three anthropology types. That night we trooped over to the longhouse and spent a dispirited evening watching Indians of the Northwest coastal areas dance for their conquerors. The dancers were listless. The fires smoldered dull. We were invaders and intruders, bringing to the ceremonies only our curiosity and our patronizing minds.

Next morning, Lubin and I went out through the thorns of the close-set blackberried backyard and I stepped out into space and disappeared down the face of the thirty-foot cliff, leaving Lubin teetering on the edge amazedly peering down at me.

LIVING ROOM - IS 2 words

His silky murmur drifted down. "What happened?"
"I fell off Morris' goddam cliff!"

Voyage to the South

In the winter of 1939 Lubin opted for the Big Move, the one
from Seattle to San Francisco, a powerful attraction to flesh marbled
with cold and damp as well as hearts moving in stagnation more
easily imputed to Seattle's weather than to the artist's own innate
sogginess. Lubin's irresponsibility extended all the way to himself,
indeed originated there, and it was easy for him to conclude along
with several hundred others that his talents would bloom more ver-
dantly in the freer air of the Bay Area than in Seattle's arboreal
moistness.

My erstwhile mate, Dorothy, and Lubin's own love, Gail,
were already ensconced on Telegraph Hill along with a general gag-
gle of refugees from northern climate and its attendant spartan crea-
tivity.

Fay Chong, having announced his intention of driving south
to visit relatives in San Francisco's Chinatown, Lubin and I an-
nounced our intention of driving south with him, sharing expenses
and chores, Lubin eventually staying there while Fay and I drove
back.

January of 1939 was not just wet. It was total cataclysm. We
drove down the coast highway in the midst of a winter storm, one of
the most horrendous in history. The Pacific hurled its entire armory
of wind and water at the coastline from Alaska to Mexico. Fay's
Model A, dainty and fragile, tringled along in unbelievable naivete,
accepting the buffets of the stormy gusts with sensuous abandon.
Inside the frail shell the three of us huddled in terror during the
more violent of the cosmic fusillades. The shrill keening of the gale
was more than enough to drown out any conversation should we
find the ability to open our mouths.

ARTIST FAY CHONG

We drove straight through. Often we stopped to climb out on the beetling cliffs of the Oregon coast, staring fascinated and fearful down at the surf as it frothed back and away from the indifferent cruel rocks. Out on the gray-green horizon, visible at times through jagged rips in the cloud banks, we could see the tiny silhouettes of coastal freighters, the smoke from their stacks wisped like torn silk, their holds bulging with American scrap-iron on its way to Pearl Harbor by way of Japan.

After each intermission we would clamber back into the Ford and drive off. Miles would unroll in utter silence, each of us draped in mute soliloquy, unable then or later to utter more than the briefest of banalities. Nor in the years to come would any of us be able to discuss it. We had glimpsed an image of the cosmos so vast and so dense as to deny any hope of penetrating its heart, leaving for our grasping only those defined parameters accessible to our eyes, the cloud-obscured horizon off there at the limits of vision, and the surly waves breaking beneath our feet.

A few miles above Crescent City we made our first stop in California at a loggers' tavern. It was night and memory vouchsafes only an image of we three hesitant on the threshold, hoist on that split second when the whole tavern turns as the door opens on the confused rattle of the Pacific storm and we confront the diffident stares of giant loggers immersed in the dim yellow light leaking from the ceiling to throw great pools of purple shadow on the floor, while the garish face of the jukebox shakes with frenzy as the Andrews sisters' voices trundle out on the smokey air.

And in memory we pan from that image immediately to San Francisco, dropping down off the Bridge on a bleak morning swept with hoodlum alarms of vagrant winds that sent rain and trash splashing against curbs and the sides of buildings.

Following that descent trudged a week of vacant days, out of which I remember clearly only the last, during which I trailed two secretaries to their Telegraph Hill shack to enjoy a drink and a half-hour of mating-dance ended by the imminent arrival of their stockbroker dates. The weather fluctuated from a torrential cloudburst to

wintry sun to a sudden evening freeze. After a party at Dorothy and Gail's, Lubin and I said our farewell. The wet porches and stairways of Telegraph Hill had frozen in the sudden drop of temperature and I stepped out the door onto sheet-ice so that my farewell was consummated in my falling down the Hill into Chinatown, where Fay somehow maneuvered me into the car and we left on the journey back into the dark north.

I slept, waking far north in the Siskiyous. It had been middle of the night when I fell down Telegraph Hill. Now it was morning twilight. We ghosted through a snowswept landscape, lost in the silence of white. Our trip had been spent largely in the outreaches of the cosmos, lost out of time and tangible space with only a brief comic interlude represented by San Francisco. Now the Bay and Puget Sound seemed equally distant, galaxies away.

The radio had been playing when I woke up, something Spanish, unrecognizable through the static. After a weird heartstopping skid as we crossed a dark ice-clogged stream over a gray bridge the radio cleared and I recognized the music, Falla's *Three-Cornered Hat*, and I thought of Spain where I had nearly gone in search of romantic death, and saw spread out across the white valley floor the ranks of the International Brigades break from the cover of the trees, red banners snapping loud in the breeze, bodies falling in the popcorn scatter of fascist bullets, and in the front, his body caught eternally in half-fall, scarlet spatters frozen in the air beneath him, Thane Summers, who had journeyed from Seattle to die on the Ebro a year or more gone.

The useless vision faded. We emerged from the mountains, crawled cripple north along the coast highway, a section of which fell into the ocean just after our passing, and drove back into Seattle in the early morning of a wet, gray day.

Mark

On my first visit to Ken and Margaret's I had noticed at the top of the stairs a small tempera of an Algerian landscape, rendered in cool grays in a quiet self-contained style. In the lower right corner was the signature later to become so well known. "Tobey."

Over the next two years Mark's name hung much in the air over our conversations in the downstairs living room, spoken always with an air of expectancy, always embroidered around his future return with a filigree of the same expectations of children awaiting the annual visit of Santa Claus.

Margaret sketched for me a vivid impression of Mark's sojourn in Seattle during the twenties and early thirties, his time at Cornish where he was more wrapped up in theater than in painting, his quiet war with the dragons of philistinism. Throughout 1938 we awaited his return, if not breathlessly, at least impatiently. Sometime during the spring or summer the question of economics was tentatively solved with the proposal that Mark be brought into the Federal Art Project as Studio Manager. How this proposal would possibly work out in view of the fact that Mark would be junior to Bruce Inverarity as Project Director is unclear to me now and was probably just as unclear then. It is likely that its feasibility was of less importance than the fact that it surmounted the economic problem of how to finance Mark's return from England, where he had been in residence for sometime at Dartington Hall.

The ins and outs are murky, but of a sudden Mark had returned, almost in some quasimiraculous manifestation. One day we were all sitting around Callahan's dining table speculating idly about his return. The next day he was here, floating around the living room, appearing within the esoteric confines of the public market, materialising in the sculpture studio of the Art Project where he lounged nonchalantly, kneading and molding clay into small figures.

According to the books, Mark returned in late 1938. Accord-

ing to my spastic memory he returned in 1939. In the eye of God, who's an indifferent scholar, it's immaterial.

What is material is that one evening on my arriving at Ken and Margaret's for dinner I erupted into the living room in my usual delinquent hullaballoo only to stop short in embarrassment as a middling-tall beard, smoking a cigarette with continental ease, stood up and advanced upon me, hand extended, not to strike but to shake my hand once that had been disengaged from its usual load of sketchbooks, pipe and gloves.

Mark's face was full-fleshed, his nose perched solemnly in the center. While generous, his nose was not large, and its substance seemed less of quantity than of quality. In full flight, walking through the Market for instance, his nose pointed and his body followed, pulling his companions along. Out would come his sketchbook, into his hand would leap his pen, and, nose transfixing the subject like a laser beam, he would quickly and quietly record the linear experience of his self tangled in the nets of the great city. In due time, home in his studio, the pen lines enveloped in clouds of watercolor, he would transcribe these drawings into temperas in which linear and planar idioms would interweave in a dance that might well have actually been a combat.

Once, frustrated, he turned to me in quiet despair, groaning "Tempera is so exasperating! Whenever you try to define a plane, you have to edge it with a hairline to keep it from fading away!" And this offhand bit of shoptalk, tossed off with the banal insouciance of a standup comedian, rankled and grew in the reaches of my consciousness, to emerge years later in the form of the wide contours or auras which edged not my figures but the negative spaces around and between them.

Mark had returned to the soggy ambience of the Northwest from the Arcadian glades of England, England on the verge of the blitz. He had been teaching at Dartington Hall, where he was associated with the dancer Uday Shan-kar. Later, in 1939 or 1940, Shan-kar came to Seattle, dancing at the Moore Theater, where, among his audience, I lay in ambush, drawing his languorous parlays and ambitious glides in a Japanese laundry-book. Among his

Pike Place Market sketches

accompanying musicians, little more than a boy, was Ravi Shankar, his younger brother. Somewhere else in the auditorium sat Mark, his sketchbook in hand.

He rapidly settled down into the circle, not surprising since we had always kept as it were a chair warm for him, and a chair at the head of the circle at that. Ken and Margaret's deep reverence for him was evidenced in their naming their son Tobey, a gesture which cast a certain shadow into the future. Each of the rest of us assumed a stance in relation to Mark in accord with our individual nature.

Guy, it seemed, approached Mark in a manner no way different from his manner toward a bartender or a flower-seller. Guy moves in a cool detached manner out of which he accords each being around him (man or woman, artist or civilian, young or old, animal or human, vegetable or mineral) the space natural to that being in contact with himself. His respect for Mark's skills as an artist or his wisdom as a man had little to do with the respect he felt and accorded to him as a being.

Morris, as usual, involved himself in a subtle and convoluted stance, one in which his own fierce pride in himself was largely masked by deference to the artistic and spiritual depths of the older man. Years later he came with Betty Bowen to dinner at my District studio. Over a dinner prepared by Roxanne, speckled with reflected color from the flowers banking the table, he confided to us that he felt that Mark was essentially a cold, cold personality, without compassion or love for anyone. And I remember how, in the spring breeze from the studio windows, I felt a sudden coldness, how Betty's face fell momentarily into disarray, how a protest sprang to her lips only to shrivel under the finality and certainty of Morris' gaze.

This was of course long after the schism which had totally fragmented their friendship. Perhaps it reveals on Morris' part a thwarted desire for a warmth and friendship that could never be achieved on the part of two painters both in the thrall of overweening pride and ambition.

Lubin had a similar story. During the late thirties he was close

to Mark, spending much time sitting with him at his studio, listening to his soft meanderings around art and the cosmos. Lubin's painting exhibited strong influences of Tobey. This was in itself an expression of deep-running currents in Lubin's self. His desire for an anchor to which to attach himself as an artist had been fed, then frustrated through his friendship with Morris, which was hardly born when it began to deteriorate. After the war, Lubin later confided, he had looked eagerly toward renewing his friendship with Mark, oblivious to the fact that Mark had moved on toward international success away from the easy bohemian camaraderie of the thirties. And Lubin for his part had sunk deeper into drinking.

The result was inevitable, and it came in a single blinding moment when Lubin approached Mark in front of a number of people only to be brutally cut down. Whatever the exact circumstances, the incident was final. Lubin, whose pride equaled that of any of us, felt devastated by the slight, to the point where, talking of the incident years later, his voice still shook with dismay. Morris, he said, was right. Mark was cold, cold, cold, a man who felt no warmth whatsoever toward other humans.

For my part, I was my usual cocky self. Mark's achievements dazzled me and I was fascinated by the subtlety of his artistic intelligence. But his transcendentalism clashed with my fierce and aggressive humanism, a humanism which cast its lot with the wretched and the oppressed, largely as a means of synthesizing the fragments of my own self. This drive was to precipitate me into the desert of political activism for a number of years. Worse yet, it put me into a mindset where I was driven to shackle my thoughts within the iron cage of thirties Marxism, which had little to do with humanism and compassion for the human condition. At the time I couldn't see that my initial impulse grew out of a desire to merge into a vast oceanic surge capable of moving one out and above the narrow confines of cold egoism. In this, ironically, I was moved by much the same impulses as those which moved Mark into his transcendental beliefs.

Arriving at Callahan's one evening for dinner, I was greeted by Margaret with the news that she had been talking with Mark, who

had high regard for my drawing, and that he would be happy to accept me as a private student, an apprentice as it were, in return for keeping his studio clean. My reaction totally dismayed her. The very thought of putting myself into a stance of servitude to a colleague, and to put myself into the impossible task of keeping Mark's studio clean and orderly, stiffened my neck, brought an angry flush to my cheeks, and put the harsh metallic clangor of Achilles into my voice. I had little grace at the time, and in this affair I was far from gracious. All that I could say was that I didn't think it would work, that I didn't want to study with Mark. Margaret, amazed and indignant, retired into her own shell, driven for once beyond the limits of her easy tolerance of my vagary and idiosyncracy.

Years later, as she was dying, I called on her, an old friend reaching out for the shards of common memory, and she recalled the incident in laughter.

How could I tell her that I could not be taught by Mark, but that I could and did learn from him over a cup of coffee or in his studio or in the rear rooms of the Art Project, listening to his sparse words dropped like seeds, a single phrase fastening in my mind, sinking tentacles into the gray cells, festering, growing, swelling until it burst and I would have learned noiselessly and forever some little hard-won bit that couldn't be taught in a conventional class or a conventional teacher-student stance?

Mark groaned about the need to drop a key line around a planal statement in tempera, and thirty years later it blossomed into the contoured auras of my big paintings. Once he stated bluntly that a nude of mine was beautifully sensitive but that the head didn't sit on the shoulders. How to make the head sit on the shoulders he left open. For twenty years I rooted, baffled, in anatomy books, drew countless models, until one day I saw the answer clearly and ever after took joy in telling it to my students, making it a little tribute to Mark.

One day we were at the Musuem, a big show of contemporary painting. We wandered in desultory fashion from painting to painting. He stood back, erect and quiet, his cold blue eyes traversing

the colored surfaces, saying little. Of a sudden his eye fell on mine and he shrugged, a sad gesture of exasperation. "Bill," he whispered, "modern art is the graveyard of the centuries."

Shocked, I could only stare wordlessly.

Over the years I mentioned his remark to other painters, to art lovers, and few could accept that he really said it. Because it seems to invalidate so much of our lives. After all, we'd put time and effort into being of the twentieth century, or at least its fourth decade, and it hurt to accept it as a corpse. Was this all we had struggled for, was this what we had been pilloried for in the media during the great 1939 But Is It Art controversy?

His remark hangs in my consciousness. I look at it.

At the time, however, his remark stunned me for a moment, and then I went on to live my life, we met at the Art Project every day and he continued to come back into Irene's sculpture studio where he would stand, nonchalant and graceful, carelessly modeling little figures in clay along with me. Eventually the assembled figures by both of us, a veritable Tanagra in miniature, covered a couple of shelves, never fired, simply air-dried. In the long run, they would be hammered into dust and oblivion by the Director, but for a long time they blossomed there on the shelves of the back room.

One day Mark stood there, kneading and thumbing his clay when I walked in, straight from an interview which I fondly hoped would lead to my journeying to France, thence to Barcelona, thence to Madrid where I would don the coverall uniform of the Spanish Republic. This fancy, which had already killed a number of poets and painters, was already doomed, since the League of Nations was about to eject all volunteers from Spanish soil, at least all volunteers fighting to defend the Republic against the fascist attack. So my idle dream was just that, idle, and there is little likelihood that I would be able to travel to foreign soil, shoulder an archaic rifle and march into battle against Franco's Moors who would promptly kill me. Perhaps Mark realized that I was in little danger of putting my fantasy into fact. Perhaps he simply looked at it. In any case he listened as I babbled, festooned in streamers of baroque rhetoric. Irene leaned against a counter for support, her eyes clearly express-

ing disbelief for the evidence of her ears. Lubin sat on an upturned box clearly nonplussed by my stubborn insistence on traveling to the other side of the world to my own immolation when I had never been able to decide on any trip of more than ten blocks without hours of indecision and doubt. Yet tender bruises around both his eyes and mine bore witness to the fact that we had engaged in actual combat over the subject of the Spanish Civil War not a week before as we stumbled up the middle of First Avenue at two o'clock in the morning.

As for Mark, he listened as he continued to knead and smooth little bits of clay into transient figures. When I finally ran out of breath and hyperbole at the same time, he glanced at me. His gray-blue eyes skewered me with no trace of awareness of my heroism. He paused a moment in his incessant modeling, a slight frown knitting his brow as he studied his work. At last he spoke.

"Goodbye!" he said. And turned immediately the conversation to other planes, to art and sculpture, to Buddha and Apollo, to earth and cosmos.

Eli Rashkov once approached me to sign some drawings from the late thirties. The manner in which they came into his possession was neat. He had dropped in on Mark in his District studio. As they talked, Eli turned over a number of drawings on the table and idly looked them over, with an eye to buying something. Eventually he came on a little pile of drawings different in tone from anything else. When he inquired about buying them, Mark smiled. Eli persevered. "Mark, these are the best things you've ever done!" Mark smiled some more. Eventually he sold them to Eli at a low price. Eli expressed his thanks and pointed out that they were unsigned. "Yes, but I can't sign them. They're by Bill!"

A few years later, on University Way, I ran into Bernis Thompson, who taught children's classes at the original Repertory Playhouse founded by Burton and Florence James. The Repertory Playhouse people were all friends of Mark, and Bernis had only recently spent an hour in conversation with him. He had asked about me, and she replied that I only recently returned from Spokane, where I had labored mightily to change the world without much

appreciable success. Glancing into her eyes, he murmured, "You know, abilities like Bill's, particularly his drawing, come so rarely. It's just idiotic to throw it away over transient things like politics!" Stung by an uneasy feeling that this was all too true, I recoiled into a defensive posture. "Well, you can tell Mark that Bill's working for a world where everyone can be an artist!" Fortunately, Bernis never repeated this bit of self-righteous piffle to Mark, who had already observed my talent for pompous foolishness.

My cocky agressiveness was only the reverse side of the coin to my abject self-doubt. In the presence of Mark's quiet self-acceptance, something seemingly as certain and centered as the personality of a mountain, my adolescent restlessness continually felt itself off-balance and frustrated. It was long since Mark had transcended his own restlessness and self-flagellation and had achieved such a state of outward balance as to sometimes seem indifferent and detached towards the physical world. Starred from birth by the driving hunger of fire, I was puzzled and baffled by this seeming indifference. Accordingly, I tended to keep a certain distance from Mark.

Certainly at that time I would have rejected the idea that his interest in Bahai and transcendental philosophy arose from the same roots as my desire for a change in the social relations of human beings, namely the desire of any pure heart to immerse itself in the oceanic flow and surge of things immeasurably larger than itself. Now, forty years later, transient systems of belief and principle having passed over me, I can see this truth. I remember Mark's words and realize that he was always trying to tell me this, that in his own quietude and certainty, he knew that this is where I would come out after traveling the only road that was any good for me.

In the meantime he was leaving reminders, like the barbed *banderillos* of the bullfight. I recall in the year just before the war, we four—Ken, Margaret, Mark and I—went to the Palomar Theater at Third and University. The film is forgotten, but the highlight of the evening was the vaudeville. Dancers, singers, comics, acrobats, jugglers, all followed each other in breathless confusion, caught in the tinfoil glitter of spotlights in which they became

goldfish turning endlessly in a giant bowl. Each act fascinated Mark, regardless of its intrinsic merit. I recall in particular a singer whose clumsy stumblings over melody and pitch outraged Margaret and myself and drove even Kenneth to hunch down with his coat up about his ears. To our complaints Mark tossed an amused glance, continuing to watch the singer in open-mouthed wonder. When she had finished, we demanded of him why he had found her so intriguing in view of her pathetic inability to hold a melody together for more than three consecutive notes. "I know she can't sing!" he replied. "But didn't you notice the muscles of her throat? And her mouth, opening and shutting like a mysterious cave!"

A couple of evenings later, Ken and Margaret and I, sitting in their living room talked over this evening, how Mark had shamed us with his ability to look past the trivialities of outward illusion, past the ostensible reason for someone or something to the essence. The unfortunate singer was only unfortunate if you took her as what she was advertised to be, a singer. If you observed her closely without preconceptions you saw that she was really presented to the world to demonstrate the beauty of the muscles tensing and relaxing in her neck and the mysteries of her singing mouth.

Years later, considering a multitude of things brought to my attention by Werner Erhard, I remembered the Palomar and Mark. And I recalled walks and talks when he opened my eyes to hundreds of hidden miracles in the world around me, miracles hidden by our unquestioning acceptance of appearances, revealed only when the appearance, like wrapping paper, is ripped away to reveal the essence within.

I saw Mark rarely in later years. Once Roxanne and I stopped in at his house on upper University Way, where she and Mark chatted about music and he kindly refused her invitation to dinner. I sat detached, unable to focus on the changes of twenty years.

On an Indian summer evening in 1963 I walked up University Way. Ahead of me I saw Mark and his friend Pehr, strolling past the windows of early evening, surrounded by the crowds of students and street people. I pulled a record catalog from my pocket and made a quick drawing. Stowing it away in my pocket I strolled

along behind them until they disappeared. I didn't want to speak, didn't want to intrude on two old friends enjoying a balmy evening stroll. It's the last time I saw Mark. Soon he was spending most of his time in Switzerland, and before you knew it he was dead. The little sketch has been turned into a number of larger drawings and eventually I'll do it as a big painting. It's the way I see him. From the back, his elegant continental figure very straight, the tousled gray hair, the erect head elevated to scan the field for subject matter, the hands clasped behind his back. Beside him Pehr, bulky and lumpy, clumping along in asymmetrical whimsy, cane stumping on the sidewalk.

It's a great last look.

John Cage and the Cornish Riot

In 1938 Cornish by some odd chance hired John Cage to teach in their music department. John's avant-garde extravagances did not meld easily into the bland mists of Cornish Music, which at that time was headed, I believe, by Stefan Balogh, a Beethoven specialist and pianist. The department was competent and professional, not given to much outside the mainstream of European romantic and postromantic.

However John wangled the appointment, he immediately became a gadfly. Morris was impressed. His own musical taste ran to the exotic and the wayward, and John's manifesto proclaiming all sounds music appealed to the extravagant and the capricious in Morris.

Having grown up in music, well acquainted with the atonalists and parallel avant-gardists, *Les Six,* as well as Henry Cowell and American modernists, I was blase. Manifestos, polemical pronouncements, pejorative battle cries stirred little in me except boredom. Perhaps the height of foolishness was the famous manifesto of

Appollinaire, which began with a pretentious upper case "MERDE!" and continued "on De Vinci, on this, on that, etc. etc. etc." ad infinitum, and all of this poppycock produced by a poet whose poetry is among the most classical in French literature. So I didn't pay much attention to pretentious pronouncements, except for the political, where I had developed an alarming weakness for the pretentious pronoucements of the political left, particularly the rhetoric of the Bolsheviks, a rhetoric which had already receded twenty years into the past and hadn't even a shadow of relationship to reality by the thirties.

John at the time was married to the daughter of a Russian Orthodox priest from Alaska. John and Xenia lived in a small apartment near Cornish and Morris and I were soon interested guests along with Lubin. John was an amusing and entertaining conversationalist, whose nihilism contained not a shadow of the heavy seriousness of purpose of traditional anarchistic bohemianism. Far be it from John to let his untoward impulses put him into any position of suffering for his art or any other of the aberrations popular with young artists.

Politically John and Xenia were out of the mainstream of the advanced artists of the time, who then as now gravitated to the left, centering somewhere between New Deal liberalism and the various leftist currents. At this time I was wrestling with my impulse on the one hand to immolate myself in the fires of the Spanish Civil War and my impulse to survive as an artist at home. My flirtation with romantic death in the ranks of the Spanish proletarians aroused Xenia's scorn, and she caustically dismissed artists who became enmeshed in radical politics as idiots. I was less offended than amazed, because historically radical art has tended to embrace radical politics, and this has seemed logical enough until the inherent difference in the sources of art and politics suddenly open up and mutual disillusionment sets in, unfortunately to the detriment of art in those countries where radical politics has risen to power, having at that point the instruments of power in its hands with which to punish those inane and impudent artists who dare express their disillusionment openly. So Xenia was contemptuous and I was amazed and

John and Morris giggled in amusement. In the meantime the political right saw all of us as Red Russian threats to the stability of the Republic, and we would have all been devoured by any authoritarian power which might have arisen, right or left, since left authoritarianism would have seen us as irresponsible carriers of rampant bourgeois individualism. Perhaps Xenia was right!

Sometime in 1939 John gave a concert in which his music was hitched in tandem to the dance troupe of Bonnie Bird. While I was pretty diffident toward John's music, it would be a gesture of solidarity toward a fellow artist, and would help beard the philistines in their den. This was an irrestible call, since most of us were convinced that true art lived in a state of siege, under bombardment by the hired hands of Babbitry and Philistinism.

Morris and I appeared at the concert in company with Paul Velguth, a young composer who taught school in Kitsap County, having graduated from the University of Washington with a degree in music and a teaching certificate. Morris arrived carrying a bag of peanuts and a box of weighted doll eyes. The three of us went into Cornish auditorium seating ourselves about four rows down from the rear in the middle of the row. Paul and Morris immediately broke out the peanuts, shelling them noisily, dropping the shells on the floor where they audibly grated under their feet, and staring at other members of the audience through the pretend-lorgnettes of the doll eyes, held up pretentiously with little finger extended in sarcastic reference to the ladies of the Cornish bourgeoisie, none of whom to my memory ever carried lorgnettes, which seemed to be more a fixture of *Maggie and Jiggs* cartoonery than of real life.

I had never much empathy for bohemian exhibitionism. Consequently I sat in self-righteous alienation while Paul and Morris carried on their charade.

The concert proceeded, accompanied by a growing counterpoint from the middle of the fourth row from the rear. It proved to be John at his most provocative. John had doctored Cornish's concert grand, haphazardly loosening the strings so that they emitted a spiritless buzz at best, placing tin cans of gravel inside the box, beating on the keys with forearms like Henry Cowell. Meanwhile

Bonnie's dancers cautiously extruded heads, arms, legs and other disassociated bits of anatomy from behind columns and plinths scattered casually across the stage.

In a short while the counter-performance in our row created enough disturbance to attract the attention of the authorities, presumably the ladies of the Board, who sent a retinue of ushers to congregate at the ends of our row. The head of this patrol made his way with difficulty to the middle of the aisle and warned us in a hushed voice that if we did not cease and desist we would be requested to leave. Morris and Paul accepted this rebuke with innocent gravity. I started up in annoyance, "But I'm not doing anything!" The ushers withdrew, tossing back frowns of disapproval as they did so.

By this time the whole theater was dividing their attention between the two rings of the circus, half of the audience standing to see what was happening in the rear of the auditorium. And not only the audience! Dancers protruded heads not only from behind the columns as choreographed, but stuck out from the wings in an attempt to see what was going on. John ceased his rooting in the bowels of the piano, where he was carrying on what appeared to be some antique surgery without benefit of anesthetic, to peer over the footlights into the audience. It suddenly crossed my mind that John had been privy to Morris' plan but didn't know the schedule, and now, blinded by the lights, couldn't be sure if he and Morris were in sync.

In the face of audience curiosity, Morris and Paul maintained an amazing three or four minutes of restraint, sitting with innocent looks of interest and enlightenment on their faces, doll eyes buried in their box and peanuts forgotten. The audience's attention drifted back to the stage only to freeze into uncomfortable amazement as John mounted his first major attack on middle-class musical concepts by a furious attack on the piano's inner workings, snapping the slack strings manually, kicking and thumping with feet and fists on the keyboard, the box and the legs of the unfortunate instrument, shaking the cans of gravel which spewed loose pebbles broadcast into the Steinway interior, driving the piano which had never

endured anything more violent than Balogh's playing of the *Hammerklavier,* into abject retreat, creating what in retrospect would appear as a musical precognition of the Nazi breakthrough which waited in the wings for its entry next year. From behind a plinth at this moment floated the sweet girl-next-door face of Bonnie Bird, hanging there like the full moon while thunderous silence fell on the auditorium with the immediacy of Armageddon. The silence, several degrees more than total, stretched on interminably, John lying motionless half into the box of the piano, one leg twitching like the leg of a dying rabbit brought down by the hunter's gun. As the silence mounted, the tension grew. One or two puzzled souls began timorous applause, not sure but what the "piece" was finished. Who knows? I never saw the score. But I'll never know what was intended, because at this precise moment Morris went rigid in his seat, threw back his head, clenched his hands into arthritic claws and gave out with a bowel-wrenching groan which culminated in a Christ-on-the-Cross supplication. "JESUS IN THE EVERYWHERE!"

Pandemonium!

The ushers slipped their leashes, baying impotently for blood, dancing around in the aisles, unable to figure out how to get at the malefactors due to the press of spectators who were standing up, kneeling on their seats, milling like frightened cattle. Eyes bulging, jaws slack, a few hysterical whimpers when members of the audience got stepped on by the ushers trying to get at us.

Finally one of the ushers managed to fight his way through, leaving spectators bruised and battered. Face scarlet with exertion and importance, he hissed, "All right! That's it! You guys get out!"

Far be it from me to stay where I wasn't welcome. I had done nothing, had listened in rapt boredom, dutifully listening and watching. In icy self-righteousness I stood up and made my way out of the row, followed by Paul. The crush of the crowd delayed me and by this time the rear of the place, the aisles and the lobby were crowded with people who materialized out of the walls. This delay was critical, because it gave me opportunity to reflect on the fact that I was being ejected for no other reason than association with Morris and Paul.

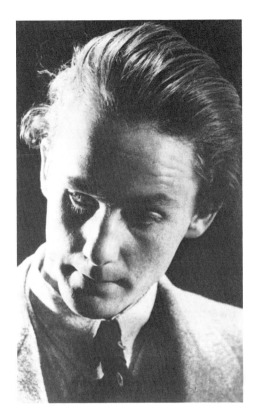

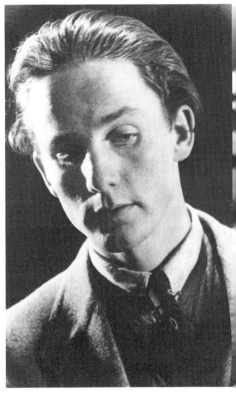

William Cumming, 1937
Photograph by Ernst Kassowitz

William Cumming, shortly before meeting with Morris. Ernst Kassowitz was a refugee from Hitler. Photographers fleeing Nazi terror introduced the 35mm camera to this country. His studio was in an old apartment on Sixth Avenue below Madison, still standing next to the Freeway. As he set up his Leica the radio agitated the air with a commentary by John C. Stevenson, a New Deal commentator of the period. The news was of the Spanish Civil War, the struggle to organize mass unions, a depressed economy, Hitler.

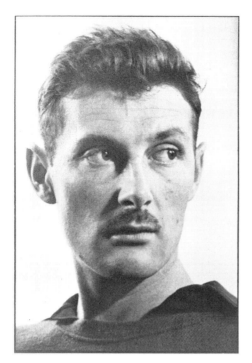

Morris Graves, 1938

The *Seattle Times* photo of Morris and his *Moor Swan*, which I clipped and pasted into my scrapbook. Morris four years before we met. ". . . his eyes, dark and liquid, seemed to look through people and birds and rotten fruit at the timeless patterns engraved there by the hand of God."

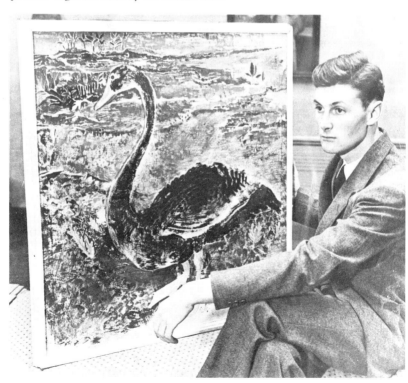

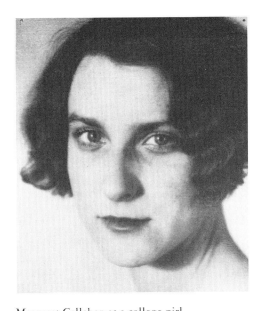

Margaret Callahan as a college girl

Margaret in the Twenties, basking in the light of Mencken, jazz and silent films.

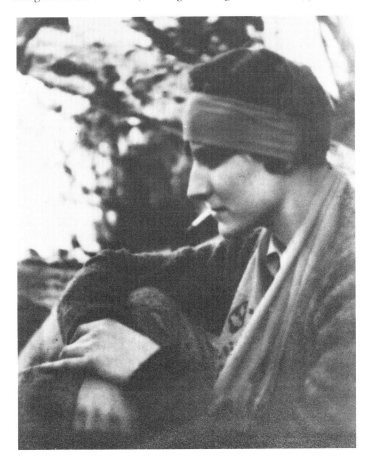

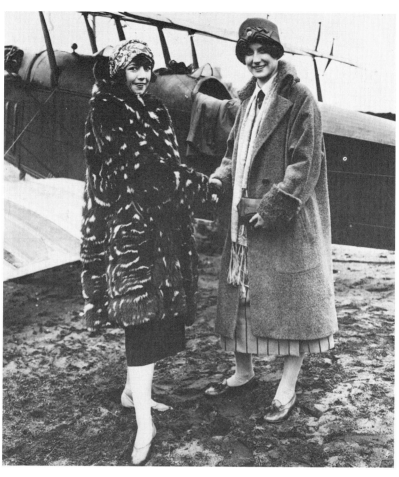

Margaret as reporter for the *Seattle Star*, interviewing someone who is definitely neither Anne Lindbergh nor Amelia Earhart.

Kenneth and Margaret aboard ship, bound for Mexico in 1932. This is nearest to my memoried image of them five years later.

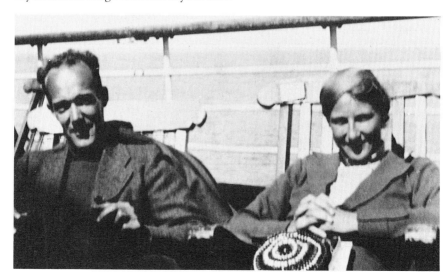

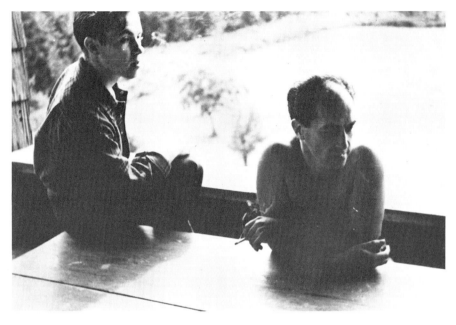

Guy Anderson and Leo Kenney at Granite Falls, about 1948.

Faye Chong and the model A, which, "dainty and fragile, tringled along in un-believable naivete" through penultimate Pacific storms, from Seattle to San Fran-cisco and back in the winter of 1939.

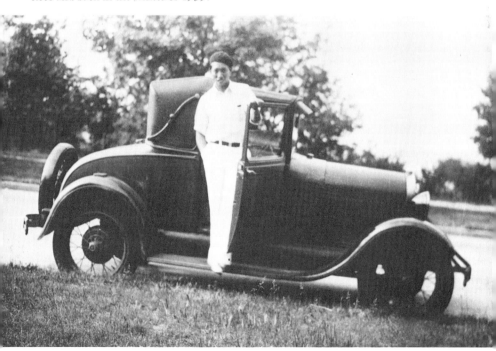

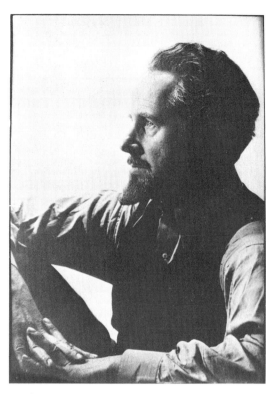

Mark Tobey, 1938

Mark and the Market

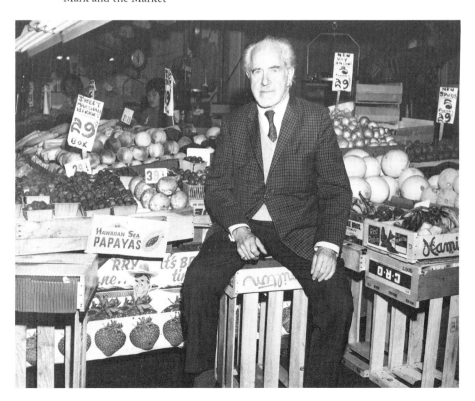

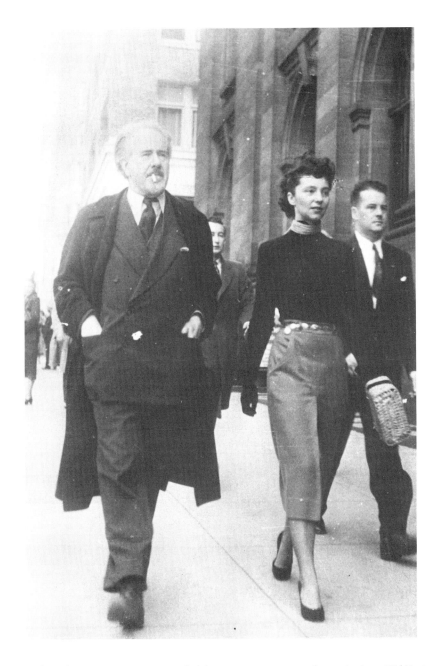

Mark and Betty Bowen surrounded by anonymous types from the late 1940's. The lady in the background turns to stare. Mark's hair and beard were still exotic rarities. *Collection of Leo Kenney.*

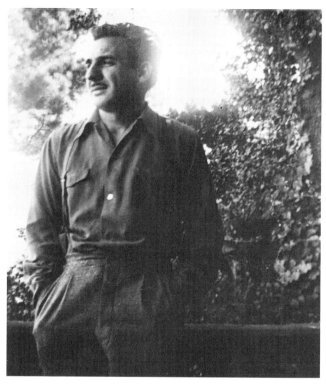

Lubin Petric in San Francisco in 1939. His eyes focus on a room in Paris, where the shadow of Pascin dangles on a wall.

Lubin seated outside my studio under University Bridge sometime in the early sixties. The years are turning and the cells are starting their dance.

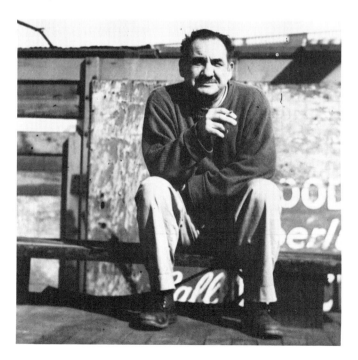

My drawing of Ginger Dare, featured stripper at the State Theater. Does her ghost haunt Fred Bassetti's Federal Building, built over the bones of the old State?

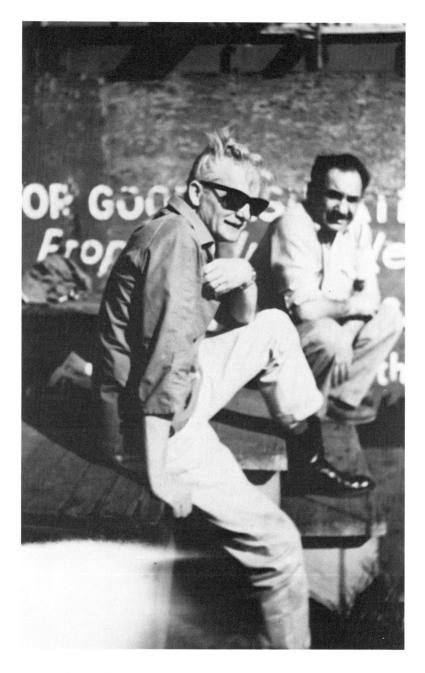

Lubin and I outside my studio. A vagrant breeze off the ship-canal has spiked my hair in a pre-punk manner. A wedding ring on my finger dates the picture as early sixties. I'm married to Roxanne, who's now an M.D. in Los Angeles.

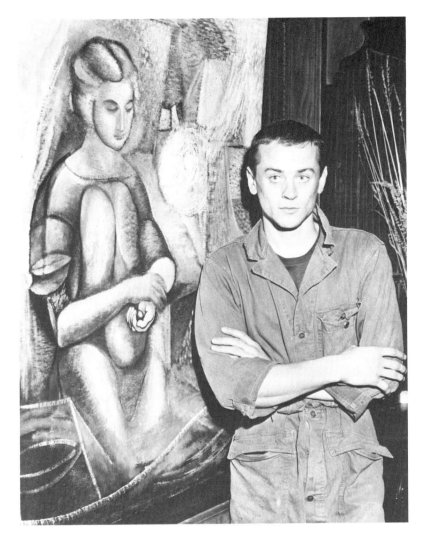

Dick Gilkey and his portrait of Denise Farwell. Behind his clear gaze linger memoried images of mortised bombardments of Japanese and U.S. Army artillery. *Collection of Leo Kenney.*

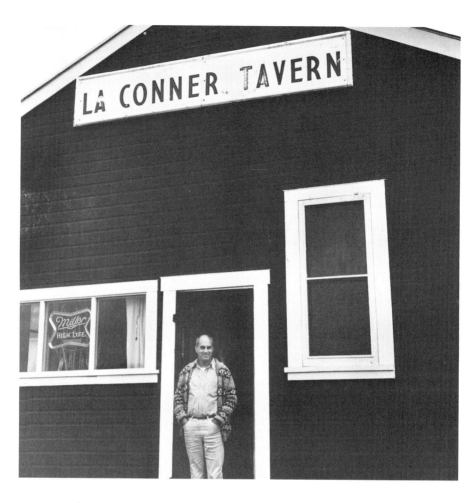

Guy Anderson in the doorway of the La Conner Tavern. He manages to look as if he owned it. He didn't.

Gilkey painting in the Skagit. Why the axe? It's not standard equipment.

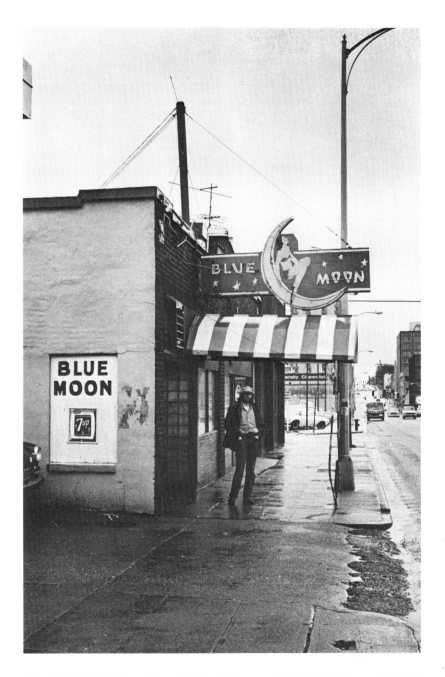

The BLUE MOON on Forty-Fifth. Unfortunately this isn't the real BLUE MOON. Note the glass-bricks, the superficial awning, the aluminum framed windows. Inside, the ancient booths have been removed and sold. Don't look for the ghost of Jack Kerouac here.

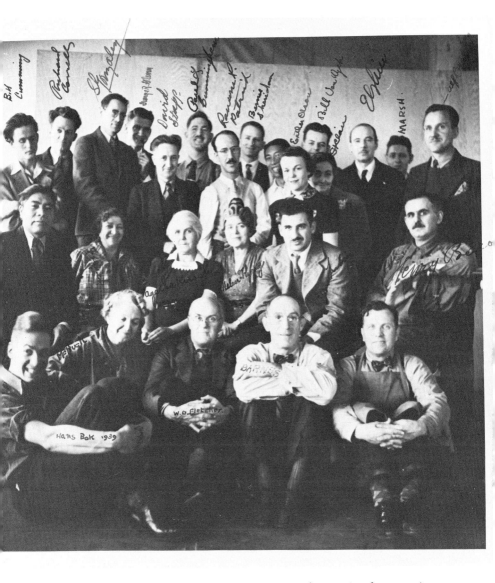

". . . the best reason for the Federal Art Project was to keep artists from starving to death." Well, here we are in 1939, not starving to death. At the same time, few if any of us are worrying about having to lose weight. In the front row, Hans Bok, Irene McHugh, and W. O. Fletcher, who led the crew of illustrators for the Index of American Design. In the second row, Julius Twohy, looking splendidly enigmatic. The white-haired lady is Agatha Kirsh, who was routed from Alki Beach by mysterious eyes in the men's bath-house window. Lubin sits like a Slavic Buddha. In the rearward conglomerate I stand in exasperated aloofness at the far left, next to Dick Correll. Next to Dick stands Salvador Gonzalez. In the middle of it all, Ransom Patrick, sober, next to smiling Faye Chong. In front of Faye, the project secretary, Esther Olson. Second from right, Jacob Elshin, plotting a Romanov coup. Morris and Guy are out in the field. *Collection of Priscilla Chong Jue.*

Portrait of Bill Cumming by Morris Graves. *Collection of the Portland Art Museum, Caroline Ladd Pratt Fund.*

As I passed through the door into the lobby my cup ran over. An usher standing against the wall made some unintelligible comment. Sudden rage hit me and I turned, cursing, and reached over a bystander to punch the usher. Frustration! Because of the crush my right cross, thrown without benefit of a left lead, was deflected, wobbled like a misguided missile, and landed on the usher's shoulder. Paul and I stomped on out, my rage mollified by my comic-opera combat. Outside the lobby we could see continued agitation, but as the minutes passed no sign of Morris, so we turned dispiritedly and walked up to the Deluxe Tavern and Steak House to wait developments.

Following our departure it transpired that Morris refused to leave under his own power, applying Gandhi's tactics and anticipating the peace demonstrations of the sixties by going limp. This faced the ushers with a logistical problem. They tugged at Morris' arms without result. The audience was now in uproar. John was standing on the piano bench, trying to pierce the blinding wall of footlights. More ushers rushed up, compounding the confusion. Clearing our row didn't make enough room for enough ushers so the aisles immediately in front and behind were cleared, allowing the entire crew to get at Morris. The whole squad now crowded into the three rows, attempting to carry, slide, urge and push Morris' limp body out to the main aisle. Morris simply collapsed off the seat onto the floor, where he lay wedged in a giant tangle of limbs threaded into the furniture. Ushers seized his legs, others lifted him by the arms, falling into a confused state of prayer, imprecation, supplication and plain cursing and snarling of useless advice to each other.

By extraordinary efforts they managed to drag him out to the main aisle and up it to the lobby where they paused for breath, leaning against the walls in vagrant disarray while Morris lay smiling flat on his back, euphoric and intent on studying the ceiling. Lying in this position, supine, the ushers resuming their tentative grips on his various limbs, making ready by grotesque breathing and invocations to each other, Morris was of a sudden assailed by the vision of a bosom surmounted by a matronly face peering intently down at him through a real lorgnette. The matron, reputedly Mrs.

Cebert Baillargeon, who had been alleged to go about armed with a lorgnette, studied him for an unconscionable period of time, enough to ascertain the identity of this specimen. "Mr. Graves," she cooed at Morris. "I've been waiting months to meet you," and turning to the stricken ushers with an icy glare, "please take your hands off Mr. Graves and help him up." Morris restored to his customary verticality, she proffered her arm which he took and thereupon she swept him back into the concert to the immense satisfaction and delight of John Cage, who very nearly fell off the piano stool at this arcane development, an ending similar to the final scene of Brecht-Weill's *Threepenny Opera*.

Lubin's Anabasis

War scattered us. Lubin it drafted, created of him a yardbird first class, then discharged him as a boozer. He returned to Seattle to find me married, father of four, drowned in the struggle for a better world.

The old bohemian days were lost down the drain.

Shortly after my wife, Lofty, returned from the hospital with our younger daughter, Karen, Lubin turned up on our Yesler doorstep with a friend, an old Yugoslavian longshoreman. It was wet and cold, a few days beyond New Year's. They stood on our little porch, noisily and hilariously drunk. Lubin shouted with joy at my face as I opened the door. "I thought I'd bring a real proletarian around for you to look at," he chortled, introducing his friend. At that point I recoiled under a peripheral glare from my wife. I stared stupidly as she nodded her head at the baby, who had just fallen asleep in her arms. I stepped out on the porch, shut the door behind me and talked a bit, uncomfortable and annoyed at finding myself in the middle of one more dumb situation.

Lubin understood. He had been a drunk for a long time and could read the signs. Through the window he could see Lofty holding the baby, her mother sitting next to her, Phillip and Claudia playing on the floor. The rigid backs of my wife and mother-in-law, the sense of righteous rage in their frozen faces, was all too familiar. He smiled at me, shrugged, collected his friend and faded away into the night, apologetic and bemused.

I went back in, uncomfortable and unhappy, an increasingly familiar syndrome. Playing at proletarian vanguard had enmeshed me in a way of living so arid, so lacking in human warmth, so tangled in dusty dogma and bureaucratic straitjackets that I was strangling slowly and painfully. As if that wasn't enough, the additional role of responsible husband and father had been assumed by me with only minimal skills, namely the ability to father children on whom I could only lavish a stunned and fugitive affection. I took them often for walks, on which I could turn the full flow of my baffled love, exhibiting for them the railroad yards, misappropriating grocery money for sweets, wondering by what right did I claim the privilege of being father to these small bundles of energy and hope and trust.

Lubin's body, his sloped shoulders as he turned away from our house that January night, haunted me. I had long ago learned to accept his drunkenness, but family and Lubin weren't compatible, nor was he compatible with the protelarian vanguard. Indeed the bohemian looseness for which he stood was not compatible with any of the synthetic belief-systems I had adopted, being the mark of petty-bourgeois anarchism, a role I was hysterically trying to climb out of, seeing nightmare visions of slipping back into the mire from which I had painfully climbed.

So I sat and brooded as wife and mother-in-law talked, infant slept and children played, and my friend and his friend staggered further and further out of my stupid life.

In the meantime the world continued to turn in its ponderous orbit. Eventually it turned once too often, and I fell right out of the ranks of the proletarian elite, straight back into the mire of petty-bourgeois bohemianism. Lubin and I saw more of each other, but

now a new constraint entered. I had returned to painting and emerged rapidly from my long voluntary obscurity into the light. I simply saw no way to take care of myself except by becoming a famous painter. So I did, while Lubin continued to live in the shadows. He sold his work as he painted it, selling directly to friends and acquaintances at prices considerably lower than he could have expected on the gallery market. Once we exchanged drawings, and he laughingly apologized for the difference in money value. I laughed, but the laugh was uneasy. I was only too well aware of the hint of burlesque in his apology. I was well aware of the subterranean flow of malice which could surface when he was faced with old friends' success. Constitutionally incapable of succeeding, he was also incapable of suppressing completely and permanently an occasional burst of sour envy, expressed most often in subtle byzantine ways, sly ironies or subtle self-derogation within which you found the poisoned needle of accusation . . . "You made it and left me here in the gutter!"

It was years gone before I realized that this desperate envy was the wrapping he used in which to present his wounded love for us all, a love which crawled crippled with how he had used time, time present, time past, dawdled with careless familiarity only to find time future suddenly apotheosized into time present whipping him down cruelly and without remorse, and it was late, too late, it had come and gone in a flash of an eyelid and he knew in his haggard gaze that the reckoning was building somewhere in his tired body.

After my marriage to Sue we left my District studio under University Bridge and moved to Capitol Hill. Lubin was fond of Sue, who liked him hugely and didn't find his drinking objectionable, merely sad. He became a familiar visitor, appearing at intervals somewhere between occasional and frequent. At the time, I was with the Woodside Galleries, and had obtained from Gordon Woodside agreement to show Lubin as the last artifact to be unearthed from the old Callahan circle.

When I broached the subject to Lubin, I was astounded at his vehement refusal. Although I managed to bore in and force him off a total refusal, he continued to resist giving a definite answer of any

kind. In response to my insistent question, "Why won't you do it? Don't you want to make a lot of money?" he lapsed into sullen amusement, parrying my questions with paradoxical whimsies.

He finally gave in to the extent of drawing me off into a corner where we could talk in secret. In a voice so low that my ears had trouble picking it up, he confessed. During the war he worked for a time as a signpainter, in a regular shop where his wages were recorded and taxes checked off, which unexpectedy forced him to file a tax return. Subsequently returning to gypsy life, he never filed another return. Now he feared publicity, certain that were he to show in a gallery he might attract the attentions of IRS agents.

So that's why he wouldn't show. At least that's how he explained it to himself, how he justified living in the shadows. He continued to drink, until a heart attack cast a pall over that. Friends took care of him until he was on his feet. One day he came by the Burnley School and filled me in on his long absences. I tried once more to lure him into a gallery show. He continued dodging.

Through the sixties into the seventies he lived on in careless obscurity, dusted with shadows, lost in the alleyways of the night. While I lived under the University Bridge, he lived across Lake Union in a ramshackle clapboard house resembling a medium-sized packing crate, although recent converse with Stan Iverson reveals that he for one is of the opinion that Lubin was living at the time in a houseboat. It was to this sanctuary that he scurried on the day of the great Birmingham Art Auction, clutching the small portrait of me. When the packing crate or the houseboat or whatever burned down, carrying Lubin's portrait with it into the anonymity of ashes, he moved into a storefront in Fremont. There he formed one of the early pillars of the insurgent art colony which grew there in soggy profusion in the late sixties and early seventies. Still later he lived in a cheery studio on lower Capitol Hill near Burnley School and even enjoyed for a time the dubious pleasure of a telephone over which his pleased drone would burble in delight each time you called him.

At no time did he ever enjoy more than a few crumbs of the largesse of the New Frontier, the Great Society or Nixonian abundance. His studio in Fremont, neatly kept with the shy care of the

aging bachelor, didn't even have heat. You wonder at the humble, uncomplaining asceticism of the hand which, palsied with cold and damp, wielded brush in fading light of a curiously foreshortened life.

Regardless of poverty, cold and eroding age, his studio table always held a bowl or two, a graceful Japanese vase or tea cup, arranged on a little bamboo mat, the bowl holding shy shrunken crab apples, the vase a sprig of cherry, the cup a handful of nuts in the shell. Nicki Louis saw much of him at this time, marveling later how he had turned his want into beauty.

Who had been a boozy bohemian, a laughing companion in the energy of our youth, turned mid-aged and then old in the rusting rains of this northern prison to which he had compulsively returned and from which he could not, would not, would not ever escape, who had grown old without child or wife, who hungrily warmed himself in the light of my ice age transformation into a prodigal and idiosyncratic parent of a gaggle of skeptical and bemused sons and daughters.

"No kids!" he whispered one day as we sipped beer in the Blue Moon. "Sometimes I feel lonely!"

He settled back with a quizzical half smile, face floating off into clouds of beery vapor and cigarette smoke to hang in midair, quiet and becalmed like a sailboat in doldrums, his eyes searching my face in quest of some hieroglyph that could explain the crazy and miracle-wracked paths down which had stumbled our clumsy feet since the night when he guided me south of Jackson to my first cathouse, a crackerbox crib on Dearborn where a sloe-eyed Eurasian greeted me in a throaty grumble. After my offering of two sweat-fried dollar bills, she accepted my starved and countrified body into the cathedral aisles of stubborn and mortal flesh, although the spiritual enlightenment of the act was sadly mortified by a sordid tussle grounded solely in dollar greed on her part and venereal greed on mine, wherein she sought by repeated muscular contractions to coax from me the promised elixir, while I, blessed by nature and the good Lord with amazing and insurgent stamina, sought to hold back and refuse my natural offering for the longest possible time,

and could have and would indeed have withheld it to the point of bankruptcy to the dear girl had not she resorted to peevish and petulant obscenities, demanding instant payment as it were of a tribute owed her and owed promptly enough to release her mangled conduits for the delectation of any further customers who might be in the offing, although I pointed out pantingly as I labored that there were clearly no customers within fifteen blocks, to which she hissed, "You damn fool I don't give a damn about no customers I'm worn out!" accompanying her words with sharp digs of her spike-heeled pumps and lacerating sweeps of her knifely fingernails, forcing me to a rapid finish followed by my exit guilelessly smiling into the suspicious gaze of my friend as we once more hit the road. Recalled out of this cosmic timewarp back into the vapor and smoky haze of the Moon, Lubin blinked and leered at me, whispering, "I always did wonder what went on that night down on Dearborn. Whatever did you do to that poor girl?" leaving me to gape shamelessly, wondering "Which of us is hallucinating?" still smiling guilelessly into his olive brown eyes.

After his heart attack he stopped drinking for awhile, then absentmindedly took up where he had left off. On Christmas Day, 1969, he came by in the evening, carrying a bottle of some yellow liqueur. He was boozily happy, sitting with Sue and me in front of the Christmas tree by our fireplace. With the awkwardness of a goodnatured bear he urged a drink on Sue, who drinks hardly at all. To her refusals he pressed harder, pouring a shotglass of the syrupy liqueur and offering it to her. What has to happen, happens, and it did. He lost his balance, teetering on the edge of the sofa, holding himself from falling by the contractions of a single segment of Gluteus Maximus, but unable to forestall the nervous tremor of his hand and arm which of necessity, trapped in the inexorable hold of gravity, slopped sticky liqueur on Sue's dress, an affair of yellow velvet, demure and lovely, of which she was inordinately fond. Uncomprehending for a moment, he drew back, rose shakily, swayed alarmingly, face sponged in sweaty tears of frustration. Sue laughed it off, sponging the liqueur away with a damp napkin.

And the spell was broken. He had successfully invalidated his

right to sit at our fireside, and he suddenly remembered a nonexistent invitation to someone else's party. He had forgotten it when he agreed to stay supper with us and now he was late, he was late and must leave, he was late and the shadows were beckoning, overjoyed to welcome their old friend back from the dangers of happiness and sunlight.

He came by school one day with a pair of spurs which he had picked up long ago in a junk shop. He mumbled obscurely, pleading ignorance of the lore of the vaquero, hinting at the possibility that they weren't even authentic spurs. "They're probably too small for you!" he moaned as he scrutinized my feet. "And they're no use to me because I don't ride."

He brightened up. "Maybe they'll fit Sue!"

Of course they fit Sue. He knew they would and they did and he had paid his tribute and even a bear comes out of the shadows sometimes. Sue pinkened with delight when she saw them and wears them to this day.

In 1980 I began drawing down on First Avenue again, where Lubin and I had drawn during the thirties. For forty years I have been working off and on around sketches for an ambitious painting based on images from the palaces of flesh, a painting to be called Belshazzar's Feast, which makes no sense at all. I dropped into a sleazy burlesque theater where I began drawing the naked flesh of the dancers and the oblique faces of the patrons in a small pocket sketchbook. Out of the dark aisle next to me a decrepit shadow crawled painfully into the row ahead of me, hobbling awkwardly on a cane, stumbling against the edges of the seats. Passing between me and the stage lights, shadow startlingly resolved into profile of Lubin, wasted, wasted, wasted, wasted away to a ragged tatter of what he had been, the thin beak of nose poised regretfully over the subversive straggle of moustache like a timid bird about to take flight. He tottered into a seat, trailing agonized shards of breath, sitting there mutely staring into the aqueous luminescence of the lights, shattered gaze gorging on the fading vision of naked flesh like a drowning swimmer who rises one final time to the surface, throwing a last reproachful glance at the lights and the shore.

I started up, instinctively reaching out to touch his arm. My mouth opened to speak his name. But my tongue stiffened and my arm locked, the stage lights froze into an icy glitter, the dancer's turbulent flesh congealed into luminous pot roast and I broke the cosmic log jam by snapping shut my sketchbook, lurching to my feet and fleeing silent up the murky aisle and out into the lobby, where a stripper dressed for the street turned startled and paint-rimmed eyes on me. I stood, shakily breathing, oppressed by the tawdry rug, the cheap gawd of cigarette and candy machines, the tinny recording accompanying the dancer on the stage. I glanced skeptically at the curtain closing off the aisle, expecting that at any moment Lubin would hobble through, having somehow recognized me in the turgid darkness.

But the curtain didn't open.

Instead, the walls expanded, opened up like some fantastic blossom in a time-lapse hallucination, the ceiling rose, the grimy spackle faded, and in place of the seedy space of today unfolded the ancient crimson and gold tawdry of the old State Lobby, where Lubin and I had drawn in the thirties. On the walls hung blownup photos of the featured strippers and in the center on an easel stood an oversize cardboard cutout of Ginger Dare, minus her stretch marks and children and husband, scrawled autograph flinging her love riotous to the world. In an ornately framed wall mirror I stared back at myself, at my moustache bright red and my hair dark brown, and the door to the men's room opened suddenly and out strolled himself, Lubin, no cane, no limp, no gray in his hair, dark and sleek, an Oriental prince, elegant in his shabby depression clothes, smiling once more like Buddha, his eyes twinkling as he took my arm and steered me back into the darkened auditorium of flesh where the odalisques of passion posed in petulant tumescence.

The fire engine lips of the strippers parted in simulated lust and my small-town ears heard once more the siren call of their smoky voices. What was it they were saying? I strained toward the stage and finally caught the magic words they had been whispering to me for forty years . . . "Draw me!"

A few days after, Stan Iverson called. Lubin was dying of

cancer. He was staying with Don Blevins who cared for him and saw him through this last painful passage to the shores of the great ocean, that vast sea over which we had watched, mute and shaken more than forty years gone during the winter storms of 1939, in company with Faye Chong, dead now of a heart attack.

I called and spoke to Lubin, suggesting lunch. He put me off gently, pleading visits to the doctor which made impossible any social engagements. However, the treatments were working wonders and as soon as they were less frequent he would have more time and we'd celebrate at lunch.

"But," he added, "all those cigarettes! I never had any idea they could do this to me!" Shock and wonder wriggled through the interspaces of his voice, pushing aside his carefully contrived pride and we both knew we'd never again take lunch together.

He died shortly after, having wasted away to about seventy pounds or so I heard. The weight of a small child. Who had been comfortably fleshed, a hairy bear, whose hemispheric cheeks had ballooned around his Buddha smile. Who had been loved by some, rejected by many, whose voice, low and confidential, had caressed so many ears over so long a time with honeyed visions of the pastures of grape and barley-malt, who had worn ordinary shoes over the cloven feet of Pan, whose mandates, anathema to Apollo, had been signed by Dionysus.

My last gift to him was not to speak. Not to let him know my witness to his agony in the sad temple of toppled flesh, not to visit him, not to drown him in futile sympathy, not to assault his wasted body and despairing pride with the shocked eyes and sympathetic voice of useless friendship. Not even to go to his alleged funeral, if there was one, which I doubt.

It had come down to this, down from the evening at Morris' in 1937, when he had strolled into the cluttered front room, hairy brown bear, great nose supported on anarchist moustache, murmuring his Byzantine and diffident greetings to the thin starveling from the country. At the end, my greatest gift to my friend could only be silence in the blinding agony of farewell.

I thought of an evening when he had sat before the fireplace in

my studio on Capitol Hill. It was shortly before the outbreak of the war. We sat listening to Mahler's *Song of the Earth*. When the long elegiac notes of the clarinet and the voice of Kerstin Thorborg had fallen silent, we sat mute, gazing out at the purpling sky of evening over the Olympics. After a while of silence, he rose abruptly with a muttered farewell and left, wrapped in my unspoken goodbye.

We were young then, and relatively unmarked. At the time that transient goodbye seemed only an interruption in the restless journeys of our youth. Perhaps we should have seen a precognition of the last farewell forty years later. If we sensed any of this in the clinch of the music of Mahler and the poetry of Li-Po we put it aside with the superstitious unease of the young in the presence of imminent sorrow. But it had lain in ambush for forty years.

And the years turned over and my friend grew older and slightly rusty, sitting, quietly dignified, in poverty and radiance, sleepily arranging his little still lifes on his table, painting and drawing with a wistful gesture of his brush or pencil, listening to the sky sagging off onto the slanted off-ramps of the century. Who had been my disreputable companion and mentor. Who had been harshly regarded even by the tolerant eye of Margaret, who had been quietly cut out from the company of more fortunate friends, who had been bonded in the old circle only by me, yet even by me once turned away from my door, o treason and faithless heart! Who, while the intellects and cool typewriters churned out their tomes on metaphysical meanings in the painting of his erstwhile friends, had gone on smiling, abashed and awkward, erased from the tablets of achievement, indeed had achieved little, like some ancient Buddhist monk, nodding in sleepy meditation over some graceful artifact rescued out of a sinking junk-shop sometime in a forgotten summer now lost out of the calendar of days.

Was it imagination that conjured up in my eye one day, gazing through his Fremont window, no answer having come to my knock on his door, was it imagination that conjured up the stocky figure of old Buson, master of haiku and painting, sitting in silent communion with my old friend while the westering light flowed around their legs, rising like the tide until it dissolved them in gold

and pearl, centuries away from the lost or misplaced days of youth?

Perhaps in this world which we have constructed out of linguistic trickeries, silence is the best of gifts. Silence—or the oblique confusions by which poetry evades the flatulence of logic and reality.

Whatever, it had come down to this after forty years, an abrupt and silent parting.

I see him sometimes in dreams, strolling down First Avenue in his old elegant shabbiness, smiling, a cigarette between his lips, his breath rosy with boozy bouquet, flanked on his right by Master Buson and on his left by the Old Man Mad About Drawing, Master Hokusai. Stepping out of the shadows of the alley, arms around each other in bibulous camaraderie, stagger the incorrigibles, Sharaku and Pascin. My old friend is well escorted through the streets and alleyways of my dreams.

I have a postcard sent to me by Tom Robbins. It shows the Spot cleaning shop on Madison. I first saw the shop years ago, probably in the late fifties. It is a small white frame building, covered with signs in bold letters rendered in blue, yellow, red, black and white. At the time I thought it a great work of art and still do. To my surprise when I described it to Lubin one day as we sat outside my classroom at the Burnley School, he giggled uncontrollably and finally gasped, "Did you know that I painted those signs?"

All I could say was "I should have known!"

The shop stood for years and many peopled learned to come by and stand rapt over Lubin's masterwork.

Then a year or two ago they painted the signs over.

But an enterprising photographer had shot it before this disaster and turned it into a color postcard published by Dial Press.

So you can still enjoy it. How beautiful it is in its suchness.

Still, there's no denying it. No one is going to write a book about Zen symbology in the signs painted by Lubimir Petricich.

The Northwest School

Early one evening in late autumn of 1938, dinner disappeared, dishes done and young Tobey off to bed, the Callahans and I sat in front of the living room fireplace of their home on East Ward, lolling in lazied numbness. The deep surfeit of appetite within and fire-lit warmth without put us into a deep state of blissful balance with the universe, silencing if only for the moment the clamorous jangling of the mind.

And so we remained for a time, indolent, sated, inert, our eyes wandering from the sinuous dance of flames to gaze unseeing at paintings and drawings, at furniture and rugs or at each other, upon which some recognition would bloom in eyes, and lips would draw up into a smile or drop some casual affection into the air. Eventually our gaze would be drawn to the bay windows fronting the east and we would regretfully measure the gradual ebbing of light from the sky. The Cascades sported their first veilings of snow so that they stood out muted white against the deepening blues of the sky, while the intervening foothills silhouetted deep forest green before them, marching down in ranked gloom to the shores of the big lake, unseen to us, until after a brisk walk over a couple of hills they spilled into the Callahan yard, where the cherry tree punctuated everything with a joyous yelp which turned out to be not the cherry tree at all but Mike who had burst into view from behind the house, chasing something anything in a mad frenzy of atavistic motion, leaping up, falling down, rolling over, all the while uttering his peculiar strangled cherry-tree yelps until growing aware of our patronising observation, he turned his frenzy into embarrassment and subsided into a furious attack on fleas infesting his nether regions.

Well, this frenetic interruption drew us up and out of our lethargy, the three of us rising into a moderately animated show of laughter at Dog Behavior, and this animation communicating itself gradually to our entire numbed physicality, our limbs calling out to be stretched, backs hunching into tense arcs while shoulder blades

rotated slowly in scapular saraband, hands rubbing away the tears of laughter from rheumy eyes, and of a sudden we were simply there, sitting around the fire, properly alert and aware, and we were indeed three by-now-old-friends, lives ranged around things like books and music and painting and friends, around whom loomed an earthly context into which the envelopes of our physical bodies had been placed by the cosmos itself, and this had forced itself into our consciousness even before Mike's mad follies, branded itself forever into our vision as we gaped in satiety at the mountain wall to the east, over which now as if to flatten us permanently into adoration and wonder, over which edging a bit at a time in agonizing slow motion, over which now rose the silvery-orange harvest moon.

The reborning conversation died on our lips.

Faces froze into dismayed ecstasy, and in the eyes of the three observers you could have watched reflected the slow rise of the lunar goddess in her manifest nakedness. The great silver body of disclosed delight appeared itself in montaged stages of visioning in which were no temporal progressions but rather an implosion of simultaneous images.

Margaret rose swiftly and turned out the room lights.

Now only the light of the fire (dark smoldering earth god) and the unfolding silver sheen of the moonlight lit the room.

The watchers sank ever more deeply into a silence of hopeless joy, their faces bathed in the slop and overflow of lunar lightfulness, their hearts clutched by the gentle squeeze of God's hand, language forgotten, time lapsed and abandoned and they becoming aware now of other presences in the room, that room whose lineaments had begun to lose their familiar contours, that room which took on the close hug and grip of the ancient womb cave. The other presences moved and muttered, hairy arms hugging Neanderthal bodies in dark spasm of dawning love, overhanging brows knotting in painful attempt to recall memories of the rising corpus of delight. The presences squatted as we three sat, each trying in numb desperation to language the goddess, put name to what rose before us, over us, around us, within us. So that we could be. So we could rise from a state of inchoate and voiceless instinct and become. So that we could invent ourselves human.

Eventually the great orb broke away from the clutch of the ridged hills and rode free into the darkly blue sky. Room phased into total silver and the presences faded in the intensity of light, the furniture and the paintings on the walls and the shelves of books and the three watchers materialised themselves and Margaret rose with a nervous giggle and turned on the lights.

And that is when it happened.

Or perhaps one should say that is one of the many times when it happened, one of the many births of what people would someday call the Northwest School.'

It was born over and over.

Morris and Guy sitting over an iron stove in an Edmonds shack, talking over sketches scattered around them on the plank floor. Kenneth sitting in his living room painting a gouache on an improvised easel as Margaret sits reading aloud from Rebecca West. Tobey lounging over coffee and roll in a greasy spoon on First Avenue, dropping scraps of comment like confetti over the table, Lubin and I prowling restless the Skidroad, sketchbooks in hand, appearing derelict images of the creatures of night and rain.

And on this evening, Kenneth, Margaret and I, hesitantly recovering from the mute daze into which we had been cast by the prosaic rising of a seasonal moon, sitting around the fireplace, talking of painting and of earth and the great water of the Sound and the air and light of this region, this context of our lives in which we are formed and molded and shaped.

What people would come to call regionalism was no ism to Kenneth. His consciousness oscillated between two poles. One was anchored on the universal flux of art, the craft and calling of what are called painters. The other was anchored in the context of his physical surroundings, where he was, where he had been accidented by some cosmic gesture. Here he was, on Northwest earth, here born, here nurtured, and blowing through him were the winds of image, blown from all quarters of earth, carrying the seeds which would fall literally on this earth to bear fruit in his paintings.

And that is how simply and directly Kenneth existed and

painted. No one ever painted more directly out of the immediate flow of existence. Brush in hand, Kenneth was the embodiment of be here now.

Transformed by spasm of rising moon, we talked that evening of our earth. My consciousness before meeting my friends had lingered on distant horizons. Moon rising, dribbling its light through the window of the wash house where I slept behind our family home, riding silver and unattainable, tantalizing as it rode out of sight, was for me then only a symbol and a sign of the Paris of Renoir and Monet, Pascin and Modigliani, the city to which I would someday flee, there to live in a modest sky-lighted studio complete with gold-limbed, moist-crotched mistress.

That had come to an end and I had gone through a startling artistic adolescence when Margaret one night rudely knocked the cataracts off my eyes, enthusiastically trashing my imitations of Paris modernism, opening my vision to the truth of what I had invented in my sketchbooks where my pen and brush had shadowed the moving figures of real people on real streets of my real home, this real search ranked round the edge of a real body of water under a real sky.

So that through the nurturing of Ken and Margaret, their joyous conjoining of the spectrum of world-art with the direct experiential awareness of the here and now of our Northwest, I was brought to the edge of what would be my art.

Kenneth talked in his staccato manner of the transformation of his vision after his Mexican visit, where he had been deeply affected by the monumental greatness of Jose Clemente Orozco and the intimate directness of Rufino Tamayo. Sitting there, his pert figure perched alert in his big chair, cigar curvetting like a baton, a continual smile of self-destruction bracketing his thoughts, he seemed almost apologetic about expressing these things about what to him was his sole reason for being.

And Margaret?

I see her now, long legs curled under her, her gray eyes lighting first on Kenneth, then on me, as the conversation eddies, her smile as she interjects her own observations, remembrances of some-

MEXICAN MURALISTS

one on a Guadalajara street who lies now in her ebullient remembering and, sitting here, I suffer sea-change, I lose memory of that evening, everything fades, all except Margaret, and it is indeed Here and Now, 1984 in Upper Preston, and I sit at my typewriter conjuring up something gone, something torn beyond grasp of memory. I feel instant loss, my neat train of memory shatters.

So again I sit and recreate that evening and Margaret trills yet once more in that room of faded silver light, "Oh if you had only been there with us! The Mexican people! They live in such poverty with such dignity. And Orozco catches it all in his paintings, the only one who does. He gets that direct existing with a certain real space that most people in this country seem to have lost. Maybe it's because we don't occupy a space long enough to grow into it!"

Kenneth smiles ruefully, agreeing.

I nod in eager alignment, leap into the talk, babbling with eagerness. "You know I get it now, what Margaret meant when she told me to stop trying to paint like Pascin, rather to stop trying to paint Pascin's people. I have my own people in my sketchbooks! They're different. They belong to this earth. You know they really are separate and distinct. I guess it's the mist in our air that encases them and we live our lives more apart from each other than people in Paris or New York or London, but more together at the same time I guess!"

I paused, then plunged on. "Our color's different! The mist in the air grays the color, so that the color field is muted or soured. You know the tempera emulsion Kenneth taught me really is the perfect medium for our part of the world. And I've noticed how, when there is a field of color that's been grayed by the overcast of mist, pure colors like neon signs or traffic lights really break through, they sing out sort of like Bix's cornet in the middle of Paul Whiteman's violins, or like Louis' four-bar break on *West End Blues!*"

I collapsed, embarrassed.

And, so far as I remember, that's the first time anyone ever bothered to construct a theoretical hypothesis for one of the essential tenets in the mythology of the Northwest School. Indeed, the mist

in our air does even in summer lay a slight wash over local color, so that the color-field shows up as grayed or muted. Within that muted field, splashes or shapes or calligraphs of pure color sing out with astonishing brilliance. All of the Northwest School painters have made use of this at one time or another, some more regularly than others.

That night it rang out into the fire-warmed air and hung there. Kenneth eyed it speculatively a few moments, hummed morosely, squinted his eyes and assented. "Well by golly I think you're right, about the mist in the air graying colors generally!" Seeing perhaps the ranks of his paintings over the last several years. Seeing his color, selected without thought in direct touch with the world, the pigment picked up on a flat oil brush, picking out the slate gray-blues of the Cascades, the angry green-gray, blue-gray spume and wrack of our inland Sound, specked with cobalt and cerulean, pure; how touches of pure color, a logger's red shirt, the glow of a neon sign, how these pure touches sing out in a field of gray, how they have leaped out of the real world into his painting; and now he sits mildly astonished as this baby of their circle languages what Kenneth has been doing all these years, how this is one of the things they have all been tending towards, and he remembers things Mark said at various times before he left for England.

Margaret smiles. She stirs suddenly, steps into the hall and returns. "I thought I heard Tobey turning in his sleep. I thought maybe he had something bothering him . . . well, how about having our pie and coffee now?" and rising, without waiting answer, she hurries into the kitchen from whence comes rattle and slide of dishes and cups and silverware until she calls me to act as waiter and in a few minutes we are all sitting again around the fire, moon's silver faded and replaced by thin yellow light of the room lights, and there we sit, mumbling through mouthfuls of coffee-logged apple pie.

So that is how I remember how something which could conceivably be called the Northwest School was born, dozens perhaps hundreds of times, in the paintings and drawings and shoptalk of a half-dozen people breathing this air on this earth in a parcel of time labeled the thirties.

If I had on pain of death to give it some form, I'd say that what
I saw was Kenneth's paintings of the mountains, of loggers and
merchant sailors, of forests and water, his steely gray blues and non-
descript greens and bronze and umber, his running calligraphic
stroke, seemingly favoring limber flat oil brushes forming the ma-
trix of the style.

Mark, I never saw as wedded to this earth. He had a cosmopol-
itan's eager awareness of the unique qualities and tone of the region
and this is refracted in his paintings. In his Market drawings and
paintings, he dipped closest to the rest of us, and there his drawing
is imposed on bodies that don't seem to pick up the tensions and
releases of angularity and consecutive gesture that seem to me to be
fleshed in our people.

And though this all may be true, Mark is surely of the school,
and how do I see him? Perhaps as a much-traveled older brother of
us all, a sensei, one who was here first, who has seen much if not
just about all, who returns and passes through us and leaves cling-
ing to each of us some bit of his awareness. Without his touch, we
should have all lacked the true beginner's mind, which in a sense is
one of the primary qualities of our stance toward art and the world.

Morris peopled our Northwest with an incredible bestiary,
fantastic creatures, birds, rodents, people-shapes set into relation-
ship with the world of our mist and mountain and sea breeze, with
the observer, the toucher of his vision. And when he left here, he
left some of the original adolescence of his vision, became deeper
and subtler and different, so that it is easy to say, "Well I really
liked Morris' older things better!" overlooking that if Morris hadn't
grown up and away we should have liked him not at all except that
we could have gloried over his stagnation, which would have
pleased us.

In my view, Guy is the Northwest thing, whatever it may be,
in the sense that everyone else left. Mark to the cosmos. Morris to
the plateaus of subtler consciousness. Kenneth to a universal dance
begun on the day when Margaret started reading to him Toynbee's
Theory of History, and he began groping outward away from particu-
larity of region to the universality of infinity.

As for me, I continued to stumble away toward my mythic studio in Paris, the mythic skylight and the mythic mistress.

Guy stayed here. Even when he went to New York or Paris or Patagonia or wherever, he never left La Conner. Guy's soul is stuck so deep in the La Conner mudflats that if he were to leave on a spaceship to settle on Mars he would still have one foot rooted at least kneedeep in La Conner mud. His painting is so primitive, so absolutely out of this earth and rock and rotting wood that he might have painted the damned things at about the time that the cavemen were decorating Lascaux and Altamira. And he does all this with an arrogant modesty that is infuriating. Under all his unassuming simplicity lurks a master who never loses sight of his superiority as he draws in his skillfully awkward manner, slaps on his muddy color like a kid making mud-pie, inscribes his cabalistic signs and symbols.

So we have a tidy picture of the alleged Northwest School, except for the mavericks who don't fit the parameters of literary description. The greatest of the mavericks were no doubt Jim Fitzgerald and Margaret Tomkins. Since to my knowledge they never indulged in Eastern philosophy or religion, they don't fit the most important of the standards ordained by writers on the idiom. But they consistently evolved in a tough gnarly style intimately meshed into the contours of the region, orchestrated in the sombre violence of Northwest color, and they themselves were far more mortised into the actual earth and water and sky of the Northwest than Mark, or for that matter, Morris in his later manifestations.

Jim's great bronze fountains, the Repertory Playhouse fountain in Seattle Center and the Kennedy Memorial fountain in the plaza of the IBM Building, are so much of a piece with the terrain of the Northwest that it is difficult for me to conceive a pantheon omitting his name. And the harsh disclaimers with which he and Margaret dismissed the rodomontade about regional mysticism and suchlike only showed up for me as cover for injured sensibilities. And if this were true, it would be understandable. For in the late thirties, when I first met them, Jim was a recent migrant from the

LA CONNER – near Anacortes, Mount Vernon

classes of Tom Benton and Margaret was an accomplished California watercolorist, and they journeyed far as creators who were almost totally formed and nurtured by our land and seascapes, who interrelated with the physical reality of the region over a long period of years, without any discernible reaching out to the mystic magic of Zen and Tao, hence interrelated directly in the creation of an idiom which shared generalities with Abstract Expressionism but whose unique subjective qualities are indelibly marked with the sombre, distanced aloofness of our land.

Lubin, who circled satellite around first Morris, then Mark in the thirties, occupied a space of his own. He was never to be accorded even my dubious role of stepchild in the circle, and doesn't even fit the picture of prodigal son, since he spent his whole life as prodigal and never once was acknowledged as son. Morris treated him generally with patronizing condescension, and Lubin tired of playing the role of the hopeful stray mutt and ceased running in circles around his former brother-in-law. At that point, Mark returned to Seattle, and Lubin gravitated to his field. Mark having a tendency to welcome disciples, Lubin enjoyed for some while a pleasant illusion of belonging, a relationship with a stronger, more decisive painter who didn't talk down to him, didn't resent him for personal reasons, and who evidently respected and accepted him. What ended this idyll would appear on surface to be Mark's annoyance with Lubin's bohemian habits, his boozing in particular, and the eventual public snub cut so deeply that Lubin was never able to talk about it without strangled hurt choking him.

As a painter he did not grow into his own idiom. His most accomplished things bear the influence of Tobey. And so what? This is reason to not see his place in the circle? He was of the Northwest, even in the seeming pathos of his badly structured life script, child of the hardrock beehive scramble of Butte, kid called Bud emigrating to the west and ocean-lapped shores, looking for friendship through the bottom of a bottle, restless, formed of immigrant genes. Adding his two-bits' worth. Standing a bit to the side in any group portrait. Victim. And my friend.

The postwar painters who were nurtured for the most part by

contact with Mark or Morris are hardest to evaluate in their relationship. Not so much in the case of Dick Gilkey, who was close to Morris throughout his gestative years, literally shot out of the South Pacific by hostile Buddhists and clumsy Baptist artillerists to bounce around his native Skagit earth, where he continues, slouching between his studio-home and the taverns of La Conner, where he one night fixed a morose eye on me as we unexpectedly tripped over each other, ending in an involved conversation in which I extolled the virtues of oil emulsion tempera and he exasperated it as impossible to manipulate. I remained convinced that it would be the ideal medium for his birds and animals and barns and marshreeds, and he evidently remains unconvinced. And his idiom is not so much Northwest as pure Skagit, not so much a regional school as a subregional school, if we are to deal in that damnfool nonsense.

Leo Kenney and Charles Stokes extended an area of patterned fantasy shadowed by Mark and Morris into rich almost-ritual paintings in which severely controlled techniques seem to mask subterranean spasms of violence and mayhem, and which I can never reconcile with the corpus of the actual human, the generous human warmth of them. Not all my colleagues welcome me too warmly, but Leo and Charley treat me on sight like a too-long strayed family dog, stopping short only of the ultimate insanity of throwing me a soup bone. And still I look at their severely structured architecture, the softly smouldering color, the geometric niceties, and wonder to myself, "What is hidden here? Why do I feel in danger?" recognizing that I feel much the same when I stand on the cliffs of Orcas Island overlooking the strait or stand gazing up the side of Mt. Rainier, at glacial moraine strewn with boulders the size of apartment houses. A sense of impending violence. A sense of danger. Of life at risk. Perhaps that is the sign of their bonding to the region.

The formal values of the alleged school have been talked to death. Tempera is the accepted medium, except Guy and Gilkey use oil, and Bill paints in an arcane tempera technique that mixes oil with water. It is a school of draftsmen rather than painters, except that Guy can't draw and Bill used to draw well but lost it sometime when he was stoned and now is a colorist and a lousy

draftsman. And of course they paint with unique color, except no one really can say with any accuracy what it is, or for what matter what the colors of the region really are, since color is an invention of the human imagination.

Art itself is an invention of the human imagination, a child of Merlin's Cave, something rising from pelvic centers, impenetrable to the logical mind. It has no history, no tribal accumulations of which we can say, "That is the Northwest School."

The logical mind being what it is, it will continue to categorize and analyze and generalize and explain and say, "*That* is the Northwest School!" Sometimes it will say, "That is *not* the Northwest School!" or even, "There is *no* Northwest School!"

Unbeknownst to us in the late thirties, as we stealthily stole silly down streets we thought to be secret, other minds than ours were readying the typewriters and the fonts of type and the reams of creamy book paper for the day when someone would announce the advent of the Northwest School, discover the Mystic Four, pontificate on the influence of the Japan Current and our soggy weather.

And it's all true. It's also all untrue.

What is true for me is that there was a group of friends where now is only a number of painters. There was a group of friends who really, truly existed and now none of them exist. Some are dead, the rest are tranformed into different beings.

There was a house with a fireplace and a dog and a cherry tree. In that house these friends gathered. They sat around the fireplace in a sort of circle, talked of painting and poetry and life and played silly parlor games. At the center of the circle was Margaret. She set out the chairs and she cooked the meals and she nurtured the conversations in which was created the vision of an art which would make a difference in the world. Margaret nurtured the vision of an art growing out of the natural morality of the universe as it is, no preaching, no propagandizing, no self-righteous gestures. The art ultimately produced out of this circle of friends tolerably conforms to this vision.

And ultimately there are no schools, no tribes, no circles. Ultimately there is only relationship one-on-one.

What Margaret nurtured in Kenneth or Mark or Morris or Guy I can't know.

What she was for *me* was my sensei, the one who was here first, who gave me a hand-up or a box on the ear or a handclasp or a kick in the ass.

Your sensei knows the way, having been here before you.

Supports you on your path, knows you as you are, accepts and loves you as you are.

Supports you to create yourself as you *really* are.

And if Margaret did this one-on-one to each of us, and if collectively we look like something called the Northwest School, then indeed Margaret created the Northwest School and the Northwest School could be called the Margaret Callahan Circle.

The Rock

Morris moved from the burned-out house in La Conner to The Rock, a shack plunked on top of a rock monolith somewhere on Fidalgo Island, an area of vertical peaks cluttered with vegetation, birdnests, dead stumps, crazy rock pathways, nesting herons, vagrant ospreys, delinquent cormorants, strolling watercolorists and plank shanties such as the one which now housed our tall friend, and in which he meditated and painted his mystic dialogues with little-known birds.

Sometime around 1940—France down in flames, Louis Aragon writing poetry underground as he awaited the birth of the partisans, Hitler mouthing platitudinous obscenities, dead boys from the sunken *Reuben James* littering the amber waters off Greenland, the planet turning—some time in that year, I being all of twenty-three, Kenneth fired up the Model A sedan one more time, loaded Margaret and me into it, drove down Roy to Broadway, turned

shakily onto Tenth North as the neon sign of the Deluxe Tavern winked its lewd leer eerily through the morning mist, rambled onto University Bridge, across and off it onto Roosevelt Way and pulled over just past the bridge to pick up a slender lady with hair done up in a tidy bun, a neat New Englander with ready smile and crinkled eyes, who stepped into the rear of the car, settled herself next to me and acknowledged my presence with a laugh. "Bill Cumming meet Betty Willis!" gargled Margaret in a casual shoulder-over introduction, and so we met well, beginning a friendship which would continue through my Firland Sanatorium years, in which her bright correspondence kept my drowning nose above water, and continues even now, forty years later.

Up the old Everett Highway we drove, through the noxious odors of that town and on north until we turned off at Conway, much as one does even now, through Conway, past the old Auction Barn and on across the flats until the Ford fetched up against a rock barrier closing off a steep footpath. Scattered around the barrier stood a gaggle of modest cars, Fords and Chevies, sentinel chariots of the embattled plebs, our friends who had arrived before us and were even now out of sight somewhere above.

Out we clambered, loaded ourselves down with baskets and boxes and thermos bottles and paper bags, and commenced the steep climb to Morris' aerie. Our sweating, stumbling progress was noted in the cynical gaze of eagles and hawks, of seagulls and marmots, as well as frogs and sundry insects. Pine needles littered the rocky path, creating an odorous carpet to soften the impact on our sneakered feet. Up and up, wondering "What in the world does Morris do to get his week's groceries up here?", fantasizing trains of burros loaded with essential supplies in the manner of *Treasure of Sierra Madre*.

When we had risen to where we gazed level at the peaks of the Three Sisters, glowering off to the northeast, oxygen had grown thin and weasely and we were on the verge of pulmonary distress, all save Betty who rolled as casually up the steep path as if she were strolling across the pool-table green of Volunteer Park. The pathway suddenly leveled out, gave one or two leaps upward and settled

down onto a rolling, acres-broad yard broken by bushes and trees through which the sunlight dribbled and dappled, pointillismed on a warm breeze. In the center, over on the westered edge of this natural porch, a cluster of figures draped around one tall figure and we had come at last into the company of our friends and of our host.

There they all were!

Leaked out of the melted gold of the sun, spooned carefully over the grass like some rare sauce, undulating and eddying slowly in the humid air, they turned casually to wave at us, last arrivals in this last of a decade's miraculous gatherings, all of us figures in a posthumous *Fete Gallant* by Watteau.

Morris, like a Maypole surrounded by spring-mad children, hovered in the group's center. Turning gravely around him in stately pavane, our friends lowered soft glances on us as we straggled in.

And memory gathers them now in her ardent embrace—Mark and Morris and Guy, Lubin and Kenneth and Margaret, Ambrose and Viola and Malcolm, Betty and Dorothy and all. And I, like Ishmael, watchfully peering wistful from the edges of the flood of this company of great souls into which I had been pitched straight out of country childhood, and from which I would shortly be torn, from which indeed each and all would be shredded apart by the storms of personal and public life, until at the end the ribbons of relationship would hang listless.

Scattered around in clots of chatter, we ate our lunch in a stutter of laughter, snickers, shrieks, and choked gasps, murmured enconiums on someone's fruit salad, sly panegyrics in praise of food, that treasured bounty which had so often eluded our grasp over the past ten years. At one point, a teasing gust of air, darting suddenly out from the ambush of trees, grabbed Guy's paper plate out of his astonished hands, balanced it madly in midair for several feet and slapped it upside down on top of Viola Patterson's meal, on which she had only now addressed her undivided attention. "Oh my gosh!" she gasped. "Now I have two lunches!" And so she did, and Guy was left to get himself another plate.

After lunch, Margaret and I strolled off to the edge of the rock.

Far below us the jealous fingers of the Sound fumbled around the base of the monolith, reaching in and around the rock to fondle and tickle at the tideflats of the La Conner plain, which had once been ocean bottom. All of this flatland had been taken from the ocean, appearing itself of a sudden as farms and two-lane highways and little towns with intersections and jails and public restrooms, and the stricken ocean had never left off plucking and diddling away at the edges of its lost domains. Indeed, with the gradual melting of the polar icecaps, the ocean stands to one day regain it all. Morris' rock will once more become an island in the midst of water, whereas in 1940 it was an island in the midst of air and bad news.

We gingerly toddled down the numerous paths basted crazily to the granite sides of the peak. Morris had designed his kingdom in his usual style, carelessly and casually hanging, dropping, arranging reminders of the dialectical interface of Infinity-Mortality in such way as to create a rhythmic chiming in your consciousness, a spiritual momentum out of which you created awareness within a context greater than your self.

At one turn of the path on which we stumbled pilgrimly, we were stopped by the still body of a crow, hanging dense and black from a low limb of chokecherry, silhouetting itself against a ripped fragment of blue sky to imprint its image indelibly and forever on our fleeting vision. In other places little wooden shrines made of soap boxes and packing crates held broken chards of ceramic, their glazes streaked with bird droppings, small artifacts out of the nether lives of humanity, ten-cent-store trinkets marked with immortality by the hand of true time.

Carried along buoyant on this wave of sentience, we talked of the war, of art, of the hearts of humanity focused in that moment on that pinpoint of rock and grass and trees. At the base of the rock swirled and draggled the smoky abyss of turmoil and catastrophe. How fragile seemed the artifacts of love and consciousness erected here on this island in space by our friend. As we crossed over onto another path, we met Betty. The three of us sauntered along, chatting. We found a threat in the ease with which Morris and Mark and Guy dismissed the threats surrounding us. They were con-

cerned first with the enlightenment of the individual soul. We were concerned with the threat of extinction facing the fleshly container of that soul, that too solid flesh which was already melting away in appalling numbers overseas. All of the ensembled cadence of this tiny rock top in the middle of a great tidal plain, all the shards and bits of feeling and awareness, were at risk, at extreme and deadly risk.

Margaret and Betty and I circled the rock two or three times and returned to the center eventually to converse and laugh and exchange loving glances with our friends until the sun dropped suddenly behind the Olympics, denied us its gold and its warmth and sent us at last stumbling down the steep path to our cars, the community of us gliding, sliding down the pine-needle carpet, goodbying voices trilling and dotting the evening air. Our friend stood watching us from the head of the path, tall and alone.

And the rock still stands.

Along the pathways the mountain ash still glitters with the drops of the blood of Loki, god of mischief, and from the rank stands of bunch grass the trilliums still pop shy-eyed.

And the foot prints of friends have been lost under the rush of fox feet and the brush of weasels' tails, buried under the matting of sodden leaves, lashed and gullied under rain and squall. And of the voices that twined warm through the humid air of that late summer day, none remain, the tremors and quavers of human heart have been faded and erased as from an ancient palimpsest, obliterated under the sounds of each new day.

Don't go back, for you will find neither footprint nor echo.

This splendor of friends flared briefly, then went out.

The People

Art Project Sketches

The process of getting on the Art Project took some time. First, I had to eliminate the Writers' Project, which someone suggested on the theory that since I had read a fair number of books I must be qualified to now write books. Accordingly, I hustled down to the project where Callahan's close friend, Paul Ashford, was employed. Ashford commissioned me to write a short piece on the antique battle of Seattle. I wrote a very light irreverent piece which totally missed the tone accorded Americana by the Writers' Project. While dealing in a light manner offensive to conservatives and patriots, the Project still managed a certain reverential air of worship of the common man and woman and kids, all those lumpy beings who spread like a plague, my kin included, over the North American continent. My only criticism was an embarrassed eyebrow and a gentle suggestion that I really would fit much better into the Art Project.

So I made an appointment with the Director. And on a late spring day in 1938 I started out to keep that appointment in the old Art Project offices in the Maritime Building. Tall, thin, ill-fitting clothes flapping in the spring breeze, a clumsy bundle of drawings and paintings clutched under my arm, longish hair jutting in tangles and clumps from my head, I stormed along Fourth Avenue like a runaway trolley, skirting the steps of the old Public Library, passing the supercilious stone lions with scarcely a glance.

Robert Bruce Inverarity, the Director, I met now for the first time. I walked into his office, he uncoiled himself from his swivel chair in an unending spiral of lankiness from which I recoiled as he extended a limp narrow hand spotted with red freckles to me indicating a chair with his other hand. All my savoir faire disappeared, undoing the work of several months of sophistication acquired under extreme difficulty. I sat painfully on the edge of my awkward chair, twisting my shins together in tibial agony, my hands wring-

ing each other in Kierkegaardian anguish. Inverarity sat languidly leafing through my pathetic collection. I sat in discomfort, watching his face for any sign of approval.

As he leafed through it, devoting a second or two to each piece, the work which had shone with the gloss of inspiration when I did it in my attic room or in my Profanity Hill studio, seemed to repel his touch, as if his fingers sensed some scatalogical veneer on my work. And with each drawing turned face down and away from his gaze, my spirits dropped further and I saw my work as crude, dull, uninspired rubbish. My sketchbook of drawings made from figures in motion drew a single glance before he dropped it like a dead fish.

My long hair now wilted, my pallid countenance turned even more pallid, my bowel stiffened in dismay. I looked at his face, a long horse face dominated by a great beak of nose beneath which dangled a scraggly toothbrush moustache. Occasionally his pale blue eyes, framed in blonde lashes, would glance at me with something resembling commiseration. My voice, replying to some question, flapped feebly out of my mouth, dropping off my tongue like a hyperoxygenated fish.

Eventually he found himself with no way to avoid a garish red and gold nude painted on a slab of driftwood. At this point my legs not only turned to putty but I felt myself sinking down towards the famous cellar of the Moscow Art Theatre's production of Gorky's *Lower Depths,* where the nude and I could finish out the evening performance disguised as a bundle of old rags.

A raised eyebrow, best Old-Boy manner. "The color's rather crude, don't you agree?"

"Yeeeeeees, I guess it really is. I just was trying to do something like Van Gogh."

Supercilious smile agitates the uneven hairs of the pale red moustache. "Ah, but you're hardly Van Gogh now, are you?"

A miserly smirk lifted the corners of his pastel pink lips for a brief instant and he uncoiled once more from his swivel chair. After rising on my entrance he had slid back down in a curious telescoping motion and had been seated ever since. Now he stood once

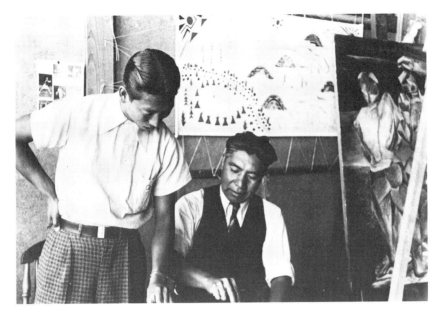

Faye Chong and Julius Twohy, in 1938. *Collection of Priscilla Chong Jue.*

R. Bruce Inverarity, director of the Art Project in Seattle. These sensitive hands wielded the hammer that powdered Tobey's clay figurines. *Holger Cahill Papers, Archives of American Art, Smithsonian Institution.*

Denise Farwell, a very formal portrait

Denise in her woolly bathrobe, seated by her cabin in the Cascades.

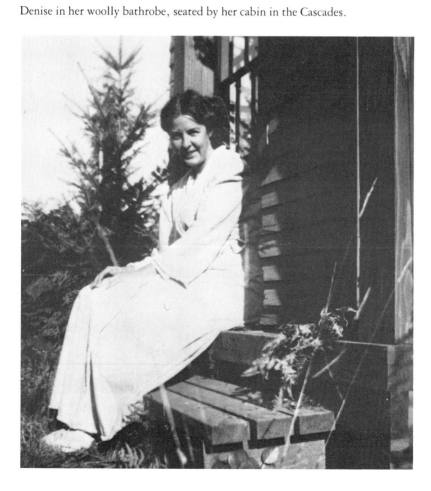

Emma Stimson and Betty Willis, c. 1948. Two women who didn't need to be liberated. They created liberation.

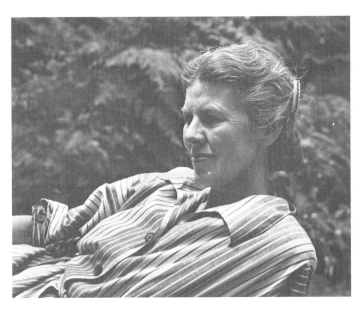

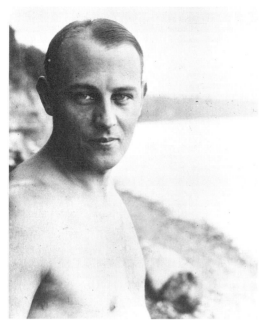

George Mantor, semi-nude, looking like an Aldous Huxley character.
Collection of Malcolm Roberts.

Malcolm Roberts, looking like an Evelyn Waugh character.
Collection of Hollis Farwell.

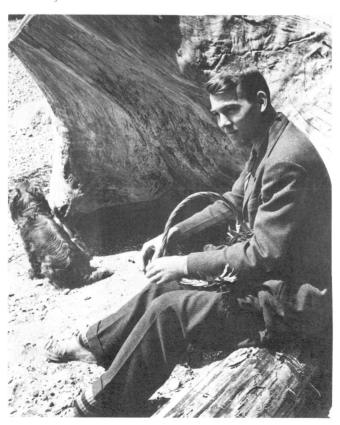

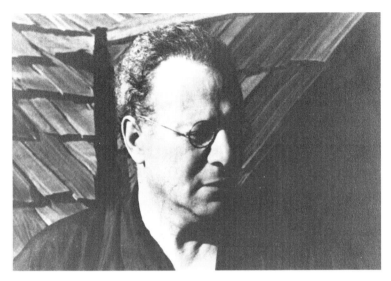

Ted Abrams, in front of his West Seattle shack. *Collection of Hollis Farwell.*

Kenneth Callahan at Granite Falls, 1950

Betty MacDonald and friendly chicken.
This chicken and her colleagues hatched
Betty's fur coat.

One of the drawings purchased from Tobey by Eli Rashkov. Eli
thought they were the best drawings Tobey had ever done. Later Eli
brought them to me for my signature. One of the major flatternesses
of my life. *Collection Eli and Esther Rashkov.*

Ambrose and Viola Patterson, 1964

Johnny Davis after he retired to Idaho State University. The bottle of coke must be a prop. It's not in character.

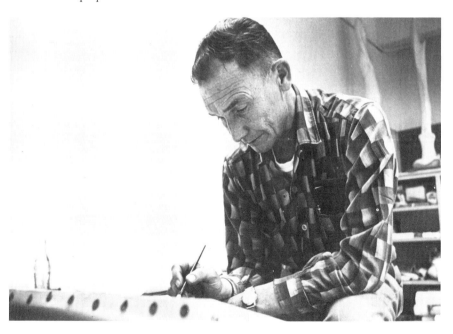

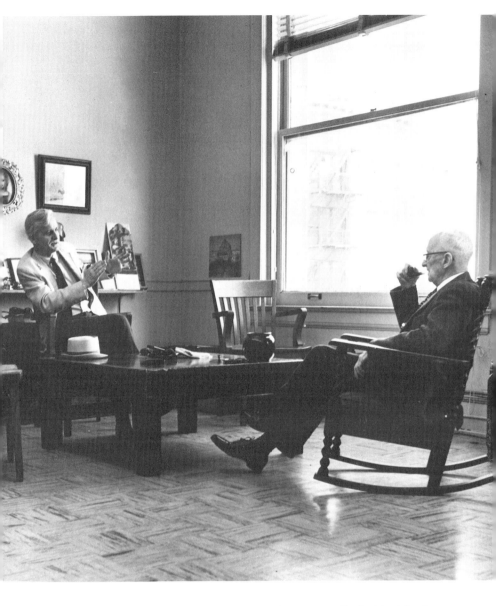

In the sixties I call on Eustace Ziegler. Is this the same studio I visited in the thirties?

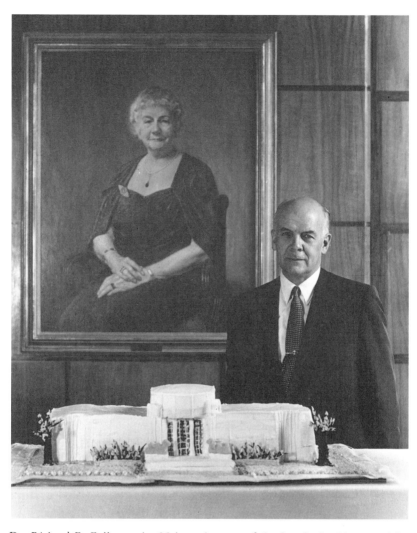

Dr. Richard E. Fuller at the 25th anniversary of the Seattle Art Museum. The portrait is his mother.

Facing page

Abandoned Factory, my first real painting, painted in 1939, not in 1941 as is thought. *Eugene Fuller Memorial Collection. Seattle Art Museum.*

Light Breaks Where No Sun Shines, the painting that won the Annual in 1960, marking my return to art after fifteen years of pulmonary and political subversion. All I managed to subvert was myself. *Northwest Annual Purchase Fund. Seattle Art Museum.*

Betty Bowen as Stirling Moss

Betty as Madame Racamier

Betty in front of Leo Kenney's portrait of Betty.

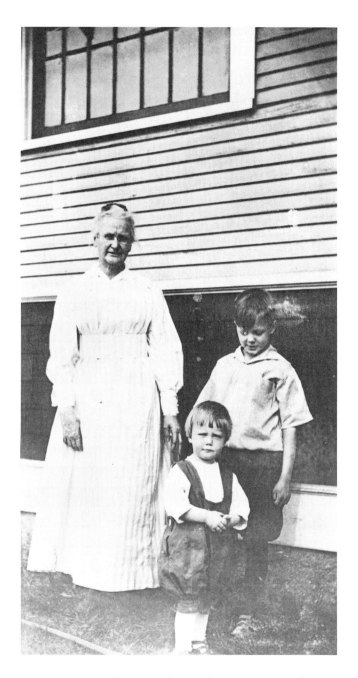

My Gramma, my brother and myself. As a girl in 1863, she
watched bluebellies burn her mother's house. Her people had
come through the Cumberland Gap with old Boone.

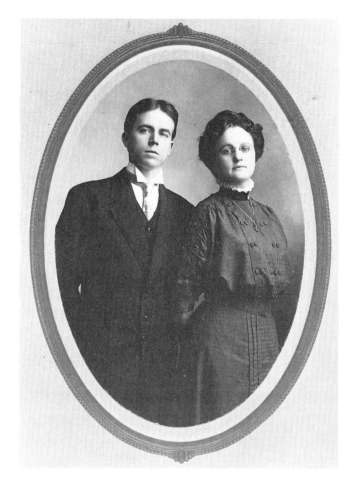

Dad and Missy before kids, before Depression, before the world turned sad.

Myself, Melvin and Joseph. Melvin will die at Pearl Harbor.

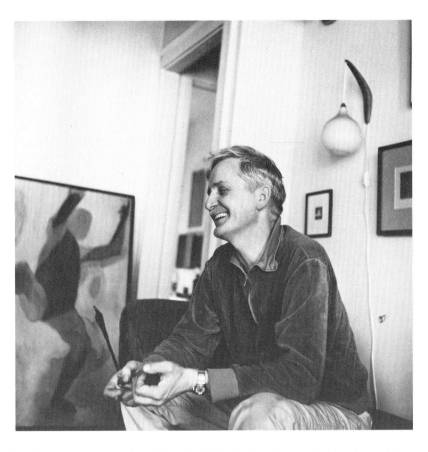

Myself in my studio under University Bridge in the sixties. I had just learned that "nothing is true and everything is possible."

more. This time he uncoiled even higher than the first and I found that he was even taller than Morris. His face hung somewhere in the sky, mouth flapping listlessly.

"Well, you're credited to us now. Be here at eight on Monday morning and we'll find something for you to do."

So I had nothing to fear, I had been detailed to the project from the start as an artist, and he had only to receive me, and all the rodomontade had just been his ritual to impress upon me his status as Director, as an authority, an expert, an administrator.

So I entered onto the Federal Art Project, less than a year from the day that I had waltzed over with the NYA task force and had met Morris.

At twenty-one I was a professional.

On Monday morning I stepped into the Art Project elevator at two minutes before eight. Inverarity hadn't arrived and I spent quite a bit of time chatting nervously with Lubin, who was painting in a half-hearted manner on a still life. Morris and Guy weren't around. They had intimidated Inverarity into field assignments, and Morris was safely wedged into a burned-out house in La Conner while Guy was teaching at the Art Project Center in Spokane.

I had already become aware of a strange phenomenon. Most art projects around the country buzzed with activity of a more-or-less creative nature, usually various works designed to enhance public buildings or public installations of some kind, these activities taking up the energy of a large spectrum of participants from painters and sculptors to carpenters and artisans. Additionally, in most cities the project artists were assigned much of the time to teaching free art classes which were open to anyone who wanted to study art.

But in Seattle, there were no free classes, and the so-called fine artists spent their time turning out traditional easel paintings and drawings with no apparent destination except the stacks of the project. Applied artists, on the other hand, were busy on small projects which could have been characterised as commercial art.

Eventually Inverarity arrived, looking a bit peaked. He ignored me for an hour, then called me in and suggested I make myself useful filing things, putting stuff away and cleaning up gener-

ally around the storage rooms. I set to work with more enthusiasm than might have been expected. I hadn't hired on as a janitor, but I was willing.

After three or four days in which my character was tested, he got around to assigning me a desk, informed me that I could draw on the project's storeroom for materials and left me to my own devices. By that time I had become wise to the way things were. I would draw or paint things that interested me, keep out of the way, and lean on my shovel. The transition from the Civic Field job was less than expected.

Daily routine took over. Every day Lubin and I arrived at eight. For the first hour we would mix with the others, viewing the work of the applied artists who had tangible projects on which to work. Eventually we would wander in to our desks, work something up out of our sketchbooks, idly wonder if there would someday be some use for what we were doing. Toward the end of the morning, we would wander into the sculpture studio where Irene McHugh would be engaged in turning out decorative clay sculptures, some of which would find use in public buildings. I would slump onto a stool as a model for Irene or I'd model little clay figures under her encouragement.

At lunchtime, Lubin and I would share brown-bag lunches, drinking coffee from the first floor cafe. As we munched dispiritedly on our sandwiches, we talked of art. Shoptalk, talk of our enthusiasms, Modigliani or Pascin or Kokoshka, lifted our spirits, and by the end of lunch we had come to life.

After lunch, Inverarity not having any real assignments to hold us at the Project, we could usually wangle field work, meaning a trip to the skidroad, along the waterfront, or out to Woodland Park, where we would sketch, filling dozens of sketchbooks over the course of a few months.

At five o'clock we would leave. The mixed bag of Project employees, artists, designers, stenographers, carvers, sculptors, and all the rest, would mill around, reluctant to depart into the tedious anonymity of their personal lives, putting off as long as possible the descent from what at least was called 'Art' into the desperate tedium

of triviality, the evening radio programs, an occasional movie, the gummy homogeneity of hamburgers and boiled potatoes.

Buoyed up by possession of what is carelessly designated as youth, Lubin and I would go up to Cornish School on Monday evenings, where we would wait outside the life-class in ambush for unwary girls. To Cornish girls, we represented two exotic species, the older man and the professional artist. Consequently, it was comparatively easy to pick up companions for the evening. Romance would bloom...up to a point. That point of no return was drawn differently by different girls, but it usually came somewhere between the sloe gin and the bedroom. We understood without much need for elucidation that our tenement studios were romantic, were exciting, were exotic, but that good little bourgeois girls were destined for waterfront homes with cute cuddlies to dandle on the knee and handsome bankrolls to pay the bills. Consequently, few of our alleged conquests stayed conquered for more than a few minutes.

The love of my life was a design student, Georgia, who divided her affections between me and a ballet dancer. The ballet dancer, I suspected, harbored androgynous proclivities which led me to wail in frustration at Georgia, "What in hell do you guys do?" Once, she brought him over to my studio, where he and she sat giggling on my sofa while I brewed tea in the tiny kitchen. Just as I was about to pour the boiling water into the pot, a torrent of giggles jangled the air and I threw the pot at the wall where it shattered. Georgia and Jack departed in sullen discomfiture. I fell into a chair and calculated how many days it would be before her nails would once more perform their kitten-scratch on my door.

Eventually she would return, and we'd go back to a brief interlude of movies, dance recitals, concerts or heavy breathing, and even more eventually I married a teeny bopper from the National Youth Administration Information Project, much to Georgia's surprise.

The project sculptor, Irene McHugh, was a buxom middle-aging woman of indomitable vivacity and good humor, amply fleshed and stocky. During the twenties, she was married to a wealthy realtor, who was first ruined by the crash of 1929, then

finished off by cancer. Out of the wreckage of that life she had retained a tiny cottage on Lake Washington near the Leschi terminus of the Yesler cablecar. And there, Lubin and I spent much of our time, particularly during the summer months.

I would spend much of the day on the Project lounging in Irene's studio, savoring her warmth, amazed to think that this woman who emitted a constant surge of electrical vitality could have a son older than I. As I would slouch into her space she would shriek with laughter at my loose-jointed ability to collapse into total insouciance. "My God! You should be a model!" she would cry. "Now, hold that pose a minute, while I get some clay and capture it!" And she would rapidly model a little clay figure of me. "How do you do it? You just seem to unhinge yourself!"

At the time I joined the Project, Irene was working on a clay bas-relief of pioneers on the way west, a project which when finished was destined for the lobby of some public building. The frieze bustled with traditional images, Conestoga wagons, dogs, oxen, horses and riders, women in long swinging skirts, children, friendly Indians. At about this same time an abscessed tooth drove me to the dentist where I was thrown into a chair, put under anesthetic, and the tooth extracted. Laid back under the dream stuff, I saw Irene's relief activated, the pioneers pressing forward, dust rising in clouds, wheels creaking, oxen blathering and horses nickering. Mainly, dust, which rose in thicker and thicker clouds until it virtually obscured the wagon train, until it actually seemed to choke me and I became panicky and heard a thin voice repeating over and over, "Mr. Cumming, Mr. Cumming, it's time to wake up, come on wake up now, Mr. Cumming . . . Oh there we are!", and I was awake, one tooth less, and the vision fading away.

Standing there in the midst of shelves of figures, barrels and boxes of clay, modeling stands, tables, stools, all covered with smeared clay or dust, I would casually model little figures from my head—athletes, nudes, a lion or tiger, horses. Lubin would watch, cigarette drooping from his lip. "You know," he ventured, "maybe you should be a sculptor . . . you really have the feel for it."

"I thought I was supposed to be a writer!" I laughed.

One way or another, Lubin was determined to get me out of painting.

Hans Bok

There was only one member of the project who was younger than I. This was Hans Bok, a large smooth boy, pasty and near-sighted with an ingratiating smile on nervous features. Hans drew constantly, fantastic creatures, aliens, Martians, monsters with eyes on stalks. While he drew, he whistled. Hans didn't whistle popular tunes or ditties. He whistled symphonies, operas, oratorios.

In 1939 after becoming studio director, Mark Tobey came to my desk one day, patently nervous and ill-at-ease. "You seem to know Hans pretty well," he ventured. "Could you speak to him about his whistling? You know, I don't mind people whistling, it's just that he whistles whole concerts at a time! Why he just whistled *Afternoon of a Faun* from beginning to end, and I'm really un-nerved!" Mark really was unnerved, particularly since he had little love for European classical and romantic music with its endless line, and I was a bit unnerved at the idea of asking Hans to stop whistling, so I don't know what happened in the matter.

Some years later, during the mid-1950s, I picked up a *Fantasy Magazine* in Louis Bruns' Ace Book Store. Something about the cover attracted my eye. The cover was signed "Hans Bok."

I turned to Ace. "I can't believe it! I know the guy who painted this!" I said.

Ace grabbed it out of my hands. "I've been looking all over for that!" he rasped. "I've got customers who'll pay twenty bucks for it!"

He continued, telling me how Hans Bok covers were collectors' items among fantasy addicts. I was stupefied.

Later I received confirmation of all this from Faye Chong, who

had kept in touch with Hans over the years. Hans had gone to New York during the early years of the war, from which he was exempt due to a leaky heart. In New York he had begun doing covers for *Fantasy Magazine*. In a short time they had become collectors' items. By the fifties, his originals were fetching tremendous prices. All this time, he and Faye had kept in touch, settling down eventually into a regular Christmas letter in which each would send news of his life and of friends and family. But just the year before I inquired about Hans, Faye's annual letter hadn't been answered. Two months rolled by, and one day Faye's letter returned in his mailbox. On the envelope, next to the name "Hans Bok" was one word stamped in red. DECEASED.

Faye Chong

Faye Chong was one of my closest friends. Early in 1937 Lubin had taken me one evening to the Chinese Art Club on Jackson Street, where weekly life-classes were held minus the annoyance of instruction. So far as I ever knew the club consisted of Faye Chong, E. D. Yippe (Yip Eng), and Andrew Chinn, all Cantonese. Faye was gregarious, courtly mannered, concerned about the wayward lifestyles of both Lubin and me. Down through the years his friendship stood fast, flinching away neither from Lubin's messy booziness nor from my dogmatic radicalism. During the era of the blacklist it was not easy to be my friend and many people preferred to cross the street rather than face the possibility of speaking to me, not knowing which pair of observing eyes might record the meeting for what set of investigative records.

So our friendship continued down the years. Occasional meetings, tea in some quiet cafe, always a friendly reunion at the Bellevue Arts and Crafts Fair, where Faye and Priscilla manned their annual booth. Then one year in the late sixties I saw Faye and Priscilla

at their booth and exchanged troubled glances with Sue. Faye responded in his old friendly manner, but his enthusiasm seemed forced. Something about his breathing, his enunciation of words, struck us. I glanced at him as I spoke to Priscilla, and I saw his face drawn and gray-tinged. He conceded that he hadn't been well, who had always been youthful and winged of foot, playing tennis every morning at Broadway Play Field with Andrew Chinn. Now his movements were constrained by some inner pain. Priscilla glanced at me, intercepting my glance at Faye, and I saw death in her eyes.

Within the year, Faye was dead of a heart attack. I allowed myself to break with my custom of refusing to attend funerals, and I went and found that it was the wrong place, the wrong people, a great mistake. I was looking for the shabby little storefront studio of the thirties, where the model would back up to the oil heater in the back room on winter nights, leaving her rear end glowing scarlet for the next pose, while Lubin, Faye, Andrew, Yip Eng and I would sip tea or rice wine. We talked about art and life, but at Faye's funeral the talk was of death.

Ransom Patrick

On my first visit to the Project, when I was still on the NYA Photographic Project, the artist I had seen standing in front of a huge canvas lashed to two-by-four framework was Ransom Patrick, a commercial artist. Ransom was dryly ironic, caustic at times, a Ring Lardner type. When I came to work on the project he was still working on the large canvas, a map of the Pacific Coast, the Pacific Ocean and Hawaii, installed eventually in the Sand Point Officers Club. Ransom took a fancy to my drawings of the figure, an idiom in which he was weak, and he inveigled me into drawing a hula dancer to be painted in the area of Hawaii. I did a very Frenchified drawing, and ran across the original sketch among my things a few

years ago. The figure could have come right out of Jules Pascin. When Ransom finished, my memory seems to see the dancer's pelvis fitting right over Pearl Harbor, but that may be self-serving memory, always seeking the appropriate tone.

At one time Ransom worked as a display-letterman for Frederick and Nelson, who demanded of their lettermen a highly dignified Roman style for showcards. Ransom would arrive in a state of falling-down drunk. Barely able to crawl up on his stool, he would totter dangerously, right himself and squint blearily at his pile of copy, select a card from the stack of pre-cut bits of illustration board, and seize a brush. Miraculously he would straighten as if some invisible cord attached to the top of his skull had suddenly tightened, pulling him straight up. Leaning forward, he would double-check the copy, dip his brush in paint, and letter the sign as if he were writing a grocery list, without ruling guidelines and without penciling in the spacing.

Somebody once asked Ransom if he could have done the above feat sober. "I don't ever recall being sober!" was Ran's studied reply.

During much of the thirties Ransom occupied a desk at Harry Bonath's studio. Harry was, himself, a legendary figure in Seattle art and a redoubtable drinker on his own. Consequently he had a certain degree of empathy for Ransom's weakness, and on many occasions drove down to the police station to extricate our friend from the toils of the law in order to keep his commercial art service running smoothly.

On one occasion Ransom, driving late for work and still under the influence of the preceding night of boozing, slid swift into the mazes of the Times Square salient which was ruled over by a famous traffic cop, a huge bruiser with slim legs and hips and a gigantic barrel chest, surmounted by a crimson face and a foghorn voice. Ransom's vision was clouded by the vapors of the spirits evaporating through his pores, and he had a great deal of trouble deciding which side of the square to drive on, a problem complicated by inability to come to any decisive conclusion as to what city he was in, the square and its traffic bearing a certain similarity to Dublin and the cop a

certain similarity to the Royal Irish Constabulary, a hallucination disastrous to Ransom's Sinn Feinish spirits, and leading him to circle the square in a paroxysm of indecision which continued to the accompaniment of blasts of the officer's whistle.

Eventually Ransom ran out of gas or determination or hallucination or possibly just ran into something. In any case he stopped. The officer planted a large foot on his runningboard, threatening to wrench it off out of sheer weight, and leaned down to peer in at Ransom whom he knew well. Exasperation overcame tolerance and he glared angrily and queried, "Just where the hell do you think you're going?" to which Ransom blinked, sighed and whispered sweetly, "To jail?"

And it came to pass. A few minutes later the arresting officer called Harry, whom he knew well, and said, "Well, we've got your bird in the tank, and if you need him today you'd better get the hell down here and bail him out!"

Which Harry did.

Ransom fell into unemployment when he took the cure, which caused him more dislocation of vital functions than did the drinking it set out to cure. During this trying period he got himself on the project in order to do the decorative map for the Officers' Club under conditions conducive to breaking the booze habit. At the time I met him he was getting off the sauce with the aid of a mysterious salve which he applied each hour to his tongue from a little tube. To the amazement of his friends, Ran got himself somehow onto the wagon and never went back off. Under his humorous and scapegrace exterior, he was a man of strong will.

Ransom served in the war, qualified for the G.I. Bill, went to college after the war, became a Ph.D. in Art History and ended up head of department at some Ivy League university. He married a nurse who had been instrumental in getting him off booze. She died of cancer. On a visit to Seattle around the late fifties, his old friends found his language incomprehensible. They found it hard to recognize the lineaments of their old friend under the hazy outlines of the academic. Eventually someone walked in somewhere sometime in an unspecified year and announced to some friends out of the old

days, "Have you heard? Ransom Patrick's dead. Cardiac arrest." It was a long way from the Maritime Building, but the old days didn't die as long as my little hula dancer flipped her venereals over Pearl Harbor in the Officers' Club in Sand Point.

Dick Correll and Wellington Groves

Dick Correll and Wellington Groves were two other allegedly commercial artists in addition to Ransom working on the project. Like Ransom they were only allegedly commercial. They were never successful enough at making money to deserve the description properly. In fact many fine artists made more money than they did. But they were described as commercial so that other artists who couldn't do many of the things they did could feel superior. Wellington Groves came from Grays Harbor with the intention of becoming a Cary Grant or a Douglas Fairbanks. Acting didn't enrich him much, and while art didn't make him rich it made it possible for his family to eat. I met him in 1934 when my exotic Jewish cousin Iona took me to meet him in his house up on Capitol Hill.

Iona had met the Groves and was anxious for me to meet them, to meet a real professional artist who earned money by his talents. They lived in a small frame house, filled with soft yellow lamplight, a drawing desk next to bookshelves on which stood books of reproductions of impressionist paintings. The house echoed with the soft animal movements of two small sons, who crawled on Wellington's lap to receive small sips of beer. Wellington showed me splashy watercolors in impressionist color. He loved to paint them at this time, but his first love was theater, and his eventual role was commercial artist. When Ed Burnley opened the Burnley School at Pine and Broadway, it was Wellington who put the commercial art department on a functioning basis. I saw him a lot during the project days and later at the Burnley School, then he pulled out, lived

across the Sound, owned a rowboat and one day left for a different planet, leaving behind a memory of his warm chuckling laughter, a wry humor in which you had to dig awhile to find the core of disappointed and frustrated dreams.

Dick Correll and his wife, Alice, lived in the Odd Fellows' Temple on Pine a block above Broadway, where I once visited their studio and listened to a 78-rpm recording of Grieg's Piano Concerto on a thin-voiced phonograph, the choppy phrases restlessly stumbling onto the summer air. Dick was a left-wing radical, an activist of the Jimmy Higgins type, a quiet calm man who did neat precise work and loved classical music. After the project he went to New York where he did book jackets. Later they moved back to San Francisco, and I heard occasional news through my family there. Dick's skin was so dry that it looked almost mummified and he lived with the innocent ambience of some ancient Egyptian, touched little by sectarian dogmatism, aware only that the world needed transformation, uncertain what he could do about it, but always ready to launch some project of signs or drawings in which his talent could become a weapon for the truth. As he aged, did he find like me that truth wears strange and bewildering disguises; did he find it increasingly difficult to define the parameters of truth within the stultifying limits of ideology?

Jacob Elshin

Soon after getting on the project I met Jacob Elshin, a former Tsarist officer and therefore suspect. Jacob was well known as a painter who had studied in the St. Petersburg Academy, judging by his attachment to naturalist drawing. When he arrived in Seattle in the postrevolutionary period which had tossed him out of his native land to become an emigre, he rapidly became well known in painting circles. He was a straight pictorialist, who laid a veneer of flat

strokes over pictorialist imagery. Cezanne having appropriated apples, Jacob laid claim to potatoes. He painted them by the wagonload, using a stiff bristle flat like Cezanne. The fatal flaw in his paintings was his use of an opaque impasto instead of Cezanne's lucid transparency with its constant undulation from warm to cold to warm, advancing or recessing planes without regard to traditional spatial projection. Jacob's potatoes were opaquely rendered in direct local color, leaving them impenetrable, lacking in the internal energy of his master.

After the war I was surprised to return to Seattle and find that Jacob had abandoned pictorialism, had turned to painting religious themes. In this phase he adapted the idiom of the Russian icon with considerable success and with a less opaque palette. His aggressive conservatism in politics was harshly augmented by aggressive conservatism in art. Annoyed at the constant advances of what he looked on as aberrant extravagances by painters like Graves and Tobey, he espoused the cause of solid traditional craftsmanship and eternal spiritual truth. When juries continued to award the top prizes to those idioms which aroused his ire while stubbornly rejecting his paintings, he plotted a flatulent revenge by painting a "crazy" modern painting, a senseless jumble of abstract daubs, which he sent to the Northwest Annual under a pseudonym. He won the top award. Delighted, he uncovered the hoax. He had proven to his satisfaction that juries didn't know what they were about, and he had proven that his paintings had been discriminated against under his right name. The other side retorted in kind. Partisans of either or both issued communiques. The planet continued to turn in its orbit, the universe continued to expand, the cosmos took no notice.

Julius Twohy

~

Julius Twohy was a full-blood Ute Indian. His paintings ranged from clumsy pictorialism to stylised narrative pictographs. He lived in a duplex on Rainier Avenue, just south of Jackson. Amazingly, the little row of duplexes still stands there, evoking images of Julius, stocky and round-fleshed, with his stocky, round-fleshed brood of kids, each time I drive by. His apartments bulged with an enormous brood of women and children, all of whom were assigned by popular report to him. Actually somewhere in the boiling crowd resided a legitimate wife and mother, and the majority of the encampment were probably the usual tribal families, but Julius never enlightened me and I never thought it was really my business, so simply ignored the gossip and enjoyed his company.

Julius turned to wood carving, not a traditional idiom among the Utes. Harry Bonath told a story which landed somehow in the Archives of American Art about a carving of a young girl in the nude, during the creation of which Julius became so enamoured of the model that he could not bring the work to an end, ultimately whittling it away into nothing.

While Julius was friendly, he was wary and reserved. Ethnic idioms were only beginning to win acceptance within the dominant Anglo-Saxon culture, and he seemed a bit dubious about friendship and help offered by white-skinned artists. Tobey encouraged the ethnic side of his art, spending many hours with him, but to what end I don't recall.

Salvador Gonzales

Present often at our bibulous gatherings around the table in the little tavern was a short Latin painter Salvador Gonzales, extremely hard of hearing. Salvador sat always silent, smiling in feigned compassion at our boisterous gabble, happy to sit with fellow artists and listen through his eyes. Behind his glasses, his eyes sparked with kindliness and empathy, but to talk was painful since even with a hearing aid he had difficulty understanding you. But he read facial expressions and manual gestures well and seemed generally to understand what he wanted to understand.

His paintings were rather large, and were rendered in that sort of conscientious cataloguing of factual data which is categorized as naive or primitive. His landscapes were compilations of leaves, trunks, burls, initials carved in bark, blades of grass and all the impedimenta of the world of illusion, rendered in a supernormal focusing of intense love. He had learned pretty much to paint by painting, and what he painted was the multitudinous images of the world as revealed to him by his own private angel, a world too intensely real to be given over to the bravado of nuclear politicians. He was still living and painting long after the war, and Bernard Flageolle saw him often and spoke of taking me to see him. But then Bernie died and I never heard again of Salvador.

The Spokane Art Project

Guy Anderson, around 1939, wangled a transfer to the Spokane Art Project, where he taught in the public classes, spending a couple of truly happy years away from the constant frustrations of the Seattle project. The Spokane project had a cohesive family close-

ness, encouraged by their provincial isolation and the fact that the project had been colonized from the start by a number of painters who were sent from the east, a policy initiated by the National Director, Holger Cahill. This policy of dispersing artists from sophisticated centers to rural and provincial areas did much to stimulate the slow-moving currents of national culture in the country. Today, with the homogeneity of the culture after forty years of multimedia immersion in every corner of the land, it is difficult to recreate this particular effect of the thirties. This doesn't change the fact. It happened, and people like Carl Morris, Hilda Deutsch, Joe Solomon and Ken Downer, working with natives like Guy, Earl Carpenter and Johnny Davis, contributed to the viability of the Spokane Center in initiating deep-moving creative convulsions in the eastern side of the state, probably the most lasting and effective use of the project energies in this state.

Through 1939 I lived in hope of transferring to Spokane. Both Lubin and I saw Spokane as a mecca where we would escape the shadow of Inverarity and where we would begin to expand on our own. But Inverarity was well aware of this aim of our requests and simply played us along, encouraging futile hopes without ever intending to allow them achievement.

Emma Stimson

Through the Callahans I met Mrs. Thomas D. Stimson, which was a pseudonym for Emma Stimson. Emma bought a couple of my temperas shortly after the purchase made by Dr. Fuller. She was a motherly, straightforward woman of great wealth who would have landed on her feet without a hitch if she were to lose every cent of that wealth. She once said sarcastically to Betty Willis, "I know that I'm in the position of a parasite, but what can I do? I have all this money which fell into my lap and I try to do good things with

it and I try to be a good and honest person. I doubt that the world would be any better if I threw it all away." It was a dilemma and I don't have any idea how it could be resolved. What is, is.

Years later, when my one-man show opened at the Seattle Art Museum in 1961, in the midst of the usual hullaballoo, I felt someone pluck at my sleeve. I turned. There stood Betty Willis and Emma Stimson, both a bit older and possibly wiser, but both shining with the particular radiance of people who had lived their lives for the most part with their eye on the greatness and the miracle of this life, the appropriateness of the world itself within the universe. They had little time for the follies and vanities by which so many people dribble their lives away. Both women were smiling as they told me their pleasure at again seeing me painting. Emma laid her hand on my arm as she said, "The good Lord didn't make you a painter just in order that you should throw His gift away."

It was a nice memory to carry away of that gallant and noble woman, who would still have been the same person if she had suddenly and miraculously been transported out of her wealth and set down in the kitchen of a tenement to take in washing for a living. Do you think that's absurd? Yes it is, and truth is generally absurd. The absurdity lies in the circumstances by which our lives are passed in trivial realities which we take for substance, so that we allow ourselves to be created by ourselves as rich or poor, male or female, black or white, when our true life is passed within our very center, where circumstance disappears. Emma Stimson passed her life pretty close to the center.

George Mantor

George Mantor, another close friend of Ken and Margaret, was a bachelor by habit and on principle, a commercial photographer and an enthusiastic lover of the arts and of iris, which he included among the arts. His father had been Seattle's fire chief, although

what this had to do with George I could never fathom. He was the quintessential aesthete, his face a carefully contrived mask of deja-vu diffidence, his voice a carefully modulated expression of so-phistiscated experience of every artistic current of the last fifty years. For George, the complete aesthete, there could be no real surprises, and he managed somehow to approach each new experience with a nervous innocence that guarded against his lapsing into the indifference of the mandarins.

At times one had to be prepared for rather grotesque expressions of George's religious fervor towards his gods. One of these gods was Johann Sebastian Bach. In the heyday of the cumbersome 78-rpm record, recordings of long, major works were a problem. Not only did the owner have to jump up and turn the record every few minutes, but transportation of an album of more than three or four records was a job for teamsters. One night George played Bach's *B Minor Mass* for a group of friends at Hollis and Denise Farwell's house. The record player was in the bedroom off a long living room, and the speakers were in the living room. George set the speakers in the middle of a long low bookcase under mullioned windows. Ranging in both directions were votive candles, carefully staggered in height, so that the candles next to the speakers were about sixteen inches high, diminishing down to four inches at the two ends. As we waited for the performance to begin, George hastily lit all the candles. Then he tiptoed hastily into the bedroom and put on the first side, tiptoed hastily back out, turning off the overhead lights, and took his seat near the speakers after shushing us. After every surface, which took only about four minutes, he rose, dashed precipitously into the bedroom, all the while quelling abortive conversations which started up inevitably in every interval. After turning or replacing the record, he repeated his dash back into the living room. By the end of the work, we were all in a state of sullen discontent, too intimidated to rebel openly, too exhausted by the choreographic performance of George to express much reaction to the music, too muted by the enforcement of monastic silence to do much more than croak dismally in mournful platitudes, followed by hysteria.

George was another early purchaser of my paintings. He coveted a small tempera of two old houses and their clotheslined backyards, standing where clinics now stand across from Seattle University. Painted in dark reds and umbers, it was a moody painting, one of the more elegant of this period of my work. I remember that I traded him the painting for a recording of a symphony by Roy Harris, which couldn't have cost more than ten dollars. At the time it seemed a good price for a small painting.

George kept his age a secret. But with the approach of war and the passage of the draft registration law he was finally forced to confirm his minimum age. All of us between the ages of eighteen and thirty-six had to troop down to the old Armory behind the Civic Auditorium and register a bid for the greetings of our President. An evening or two later at Callahans, George smugly boasted that he had not registered, "I didn't and I'm not going to!" He sure wasn't. Our little circle cackled with laughter. At least he had to be thirty-seven.

A little later, shortly after Pearl Harbor, I found myself incarcerated in Firland Sanatorium, victim of a dime-sized hole in the upper lobe of my right lung. Instead of the great patriotic war against fascism and other such evils, I was shipped out to the Richmond Beach institution to wage my own private war against the bugs. George, who had become a close friend, never once visited me. I was puzzled and hurt. Kenneth, on one of his visits, confessed that George had told them that his horror of sickness and sick people was so intense that he could not bring himself to visit anyone in a hospital. It was totally consistent with his life. Rather than create mediocre art (photography he considered a profession, not an art), he preferred to offer his adulation to art which had already established itself as good. His entire life was lived under control. His one indulgence in creativity was to breed fantastic iris, and his little house and backyard garden were a melange of the delicate tonalities of that plant. Never marrying, avoiding intimacy, his life could proceed with the quiet dignity and pleasing proportions of good art.

I last saw him at the auction of paintings for the Birmingham victims of racist violence. He greeted Lubin and me in his old lan-

guid manner, eyebrows raised in quizzical skepticism above a controlled half-smile of supercilious greeting. But then he had always viewed our antics with skepticism, a bit perplexed that good art might be created out of such disorderly lives.

People like George have always fascinated me. Their careful control of the structures and facades of their lives leaves us with no sense of their vulnerability. Perhaps they are able to maintain this icy reserve all the way to the opening of the final gate. At that point what happens? What happened to George's skepticism, his languid manner, his icy alienation from human attachment? In that last moment were there any regrets?

Jim Stevens

Jim Stevens was a Mencken discovery of the twenties whose Paul Bunyan stories were published in the *American Mercury*. He was burly, a hardnose type who had been, or should have been, a logger and was now a propagandist for the lumber trust, which occasioned a certain degree of tension since most of the Callahan circle were New Deal liberals and pro-union. As I recall, the evenings when Jim and Theresa came over were confined to apolitical discussions of literary trivia, footless gargling of biographical reminiscences of literary celebrities, and occasional lapses into heavy silences when Jim would sideswipe FDR or the woodworkers' unions.

It was through Jim and Theresa that Thomas Wolfe was introduced into the circle, not long before my appearance. Wolfe spoke of the Northwest with enthusiasm, and indeed spoke of putting down roots here where the trees and the mountains provided some sort of surrogate for his own gargantuan size and appetite.

Margaret greatly admired his novels and admired the man just as greatly, seeing how his subterranean flow of inchoate, unhar-

nessed emotion battered at the flimsy walls of his talent in a desperate attempt to expel every trace of his illogical, irrational reactions to a family life which was atypical only in the extreme intensity of its typicality. Seated in front of their fireplace in a normal cane chair, <u>Wolfe seemed to overflow not just the chair</u> but the room, the city, the planet, and the ironic conjugations were compounded by the small head placed on top of a gargantuan body, and the thin reedy voice emitted from a mouth like a wound in his face.

Mortality struck suddenly and in grotesque form. Wolfe went with the Stevens on a Princess boat to Victoria. On the trip he sat with a stranger talking books at length. The stranger had a troublesome cough and seemed feverish. He was ill with the flu. <u>Wolfe developed flu,</u> it compounded with problems left by an injury to his head during a Munich beerhall fight, <u>and pneumonia developed</u>. What would probably have been handled with an antibiotic a few years later became a fatal illness. In the middle of it all he was sent to a rest home in North Seattle which turned out to be a mental hospital and he launched out in a savage, desperate attack on those who sought to help him, suspecting them of trying to put him away. All of this is as I remember Margaret telling me in <u>1938.</u>

I doubt that I would have loved Wolfe so much as Margaret hoped. I immersed myself in his novels, falling prey to the sonorous rhetoric, admiring his incredible accuracy for real dialogue of real people, swept away by episodic patches, but I don't believe that today I could read one of his novels from beginning to end. The man himself might have been a different story. HE DIED IN BALTIMORE, MARY BARD JENSEN MET THOMAS WOLFE ON HIS 1938 TRIP.

Mrs. Harold Davis

Harold Davis, author of *Honey in the Horn*, was a close friend of Margaret's, but by this time he lived in Northern California and I can't recall his ever revisiting Seattle, nor can I recall much literary

activity over his name after his one great success. Which isn't too bad, because *Honey in the Horn* was not only a Pulitzer Prize novel but a good book as well, good enough to get Harold death threats from his old Coos Bay neighbors, who like Thomas Wolfe's townspeople felt threatened and slandered by the book which put their dog-eared town on the map.

If Harold never appeared, his wife did, with a memory full of stories of the writer. I arrived one evening for dinner at the Callahans and found a woman in her late thirties, attractive, with a heavy sensual mouth and blonde wind-blown hair. She had just arrived and on my entry was bringing Margaret up-to-date on the news.

The latest news was that she had reached an impasse in her life with Harold and had left him to rot in Northern California while she got some fresh Puget Sound air in her lungs in order to clear her head and figure out what to do with her life before it fell totally apart. As she told it, her life with Harold was ripped out of a Marx brothers' script. His transgressions were of the piquant sort that, recounted aloud, become hysterically funny, but which during their actual occurrence are uncomfortable, grotesque and exasperating in the extreme. Each story ended in laughter, and it was obviously a difficult decision to reach as to whether to live with or without the malefactor.

The most recent contretemps had broken the camel's back and put her into motion back to the Northwest. On a recent Sunday morning they had been breakfasting in the little farmhouse which they rented. They lived in the midst of a Northern California community of Portuguese fishermen and their families, on a hillside overlooking the Pacific Ocean. The road past their front door ran straight to the local Catholic Church. Each Sunday the entire Portuguese Catholic community trooped past their door on the way to church. On this Sunday, Harold and his wife got into an argument over the breakfast table, an old tradition among American literati, who are best advised to spend Sunday mornings under the covers sleeping.

Pressed into a corner during the argument, Harold abandoned

reason and became physical, pushing his wife out the front door, slamming the door after her and locking it. There she stood on the front stoop in her nightgown, pounding on the door and demanding to be let in. Up the road at this precise moment came the sounds of hymns sung by the advance patrols of Catholicism. Within minutes every Portuguese family living along the road to the north would pass, their voices raised in praise to the Lord and their eyes turned left at the sight of Mrs. Harold Davis standing in her nightgown on her front porch, knocking on her own front door and hollering to be admitted to her own front room. The prospect of this coming to pass caused her to redouble her pounding and increased the range of her voice from a holler to a shriek.

The neighbors were around the bend in the road. In another thirty seconds they would come in sight of the house and she would come into the range of their vision. She pounded harder and yelled louder. At this point, just a heartbeat away from the arrival of the worshipers and their interminable hymns, the front door opened suddenly and Harold's bare arm reached out, an earthenware jug of thick cream clutched in his sweaty hand. As she stared at the apparition he brought the jug smartly down on top of her skull, breaking it into shards of shattered clay and cascading a couple of pints of cream down her body, soaking her hair, running into her eyes and ears, rendering her nightgown not only wet but transparent in the extreme.

And so she stood as the battalions of the Lord marched by, their eyes turned sharply left, their voices raised in song, pausing only long enough as each rank marched by, to chant, "Good morning, Mrs. Davis!"

She finished the story, writhing in her chair, her sensual mouth agape in hysterical laughter, her ample breasts heaving and rocking under her sweater, her flesh alive in erotic saturnalia of joyful delight at playing her part in this mad sport. Margaret's restrained chuckle began to lose its restraint as my giggles mounted into brays of insane glee, both of us ignited by her total immersion in the bedlamite carnival, both of us joining her in a blaze of irrational mirth.

Ted Abrams

Ted Abrams came to Seattle a pudgy dwarf out of Georgia, an authentic Confederate Jew, a species not so rare as might be thought at first glance by those who love the obvious and obtuse. He evidently first appeared here during the First World War, opening a restaurant on the Skidroad which rapidly became one of the most celebrated gourmet establishments in town. For some years Ted prospered, but age and the depression found him living out his years in a sort of androgynous splendor in a tiny shack in West Seattle, existing on a modest private income which he had managed to save from destruction in the storms of 1929.

I met Ted one gray drizzly day in 1939 when Kenneth and Margaret and I, accompanied by the mad dog Mike, drove out to the lighthouse to walk, talk and sketch. Young Tobey stayed at home in custody of a buxom and beautiful young Irish girl.

We walked the beach for awhile, Kenneth stopping occasionally to do chalk sketches of the shore and the Sound, I myself jotting drawings of the shoreside wanderers and emigres, Margaret chatting excitedly of books and plants and life, and Mike curvetting and caracoling around in baroque circles of illiterate delight. After a time we felt the Puget chill settling through our bones and Margaret suddenly blurted, "Let's go see Ted! We haven't seen him for awhile and I'm sure he's got a fire going in the kitchen range."

So we did, and he did, and we warmed at his kitchen fire and basked in his chatter.

He lived in a small shack with a large central room containing books by the thousands, a stove, kitchen shelves with provisions, chairs, a sofa and a table spread with food as if for our coming. Radiating out from this central room were a number of small odd-shaped and odd-sized rooms, some little more than closets, as well as a bedroom, bathroom and storerooms.

Ted stood in the doorway as we walked down the path from the drive and welcomed us with a warmth that may have reflected

Jewish gregariousness, Southern hospitality or possibly just the friendly love of an aging and lonely man for his fellow-humans. Sitting us down in a variety of furniture, he served us wine in old glasses, and busied himself with the stove, from which soon appeared a bewildering spectrum of incredibly succulent foods.

Wedged into the array of normal artifacts and utensils, furniture and effluvia, the house was crammed with paintings, drawings, sculpture, etchings and first-edition volumes signed by names famous and infamous. Ted managed to live just above the alleged level of poverty with an aristocratic grace that seldom showed the strained and stressed crevices of daily life, a perfect example of the Depression axiom that the only way to live successfully poor was to live as if you were wealthy. The darker side did exist, though, and it must have taken all of Ted's careless grace to mask it. Lurking in the shadows of the house when I first entered it, was a burly and uncouth young lout. This, according to everyone who knew everything, was Ted's companion and lover. The casual presumption of this juicy piece of gossip still shocked me. No matter what peoples' conduct implied, I felt that no one had any right to draw presumptive conclusions for two reasons. First, it was their own business. Second, the sleight-of-hand by which reality fools us is so prodigal that no one can draw conclusions about anything without running the risk of dire disaster.

What was inescapable was that the lout quite frequently beat on Ted, leaving traces of bruise and abrasion around his face and eyes. Whatever the darker realities behind his presence, he made us all happy in the long run when he ran off to California with a voluptuous middle-aging woman who found his Neanderthal charms irresistible.

The disappearance of the lout solved a number of loutish problems, but left Ted in dire need of care, which was solved when his sister came out from Georgia to take care of him. We met her not long after she arrived, a tiny astonishingly fragile and graceful elderly nymph, blithe and clear-eyed, tending her grumpily satyrish brother, talking learnedly of books and painting and music and theater, totally unspoiled by all this cultural overeating. She re-

mains in my memory as a lucid soul whose name has slipped out of memory but whose spirit lives with the wholeness and peaceful centeredness of an Einstein.

My memory of the two comes to an abrupt end before the war overwhelmed us. There is a vague disturbing memory, Margaret's voice hanging somewhere in the closets of my memory, informing me that Ted had died and that his sister had gone back to Georgia.

Ivar Haglund

One other meeting in Ted's house remains vivid. One Sunday afternoon in spring Ken and Margaret took Ted and his sister off in a Model A to visit Alki Point, a pleasure much loved by Ted but long denied by reason of his tacky health. I stayed behind in custody of Mike who dozed in a corner while I curled up in a big chair engrossed in a book. I was raised from the chair by a thunderous knocking on a fragile door, which threatened to collapse under the attack. Before I could open it, the door sprang open and on the threshold stood another short stocky figure in ample flesh, pale eyes set over drooping lower lids. At the moment the whole apparition gave off an air of general hysteria.

"I'm sorry to bother you. My name's Ivar Haglund and I live next door. I'm a friend of Ted's and of the Callahans'."

"Yes. They speak of you a lot."

Running right through my reply he blurted out, "Listen! You wouldn't know how to get rid of a room full of bees, would you? I mean an entire room full, my bedroom!"

I hadn't any idea how to get rid of a room full of bees, but driven by a Spartan sense of duty I walked back with him to his yard. Creeping through the long grass for all the world like marauding Indians in a B Western, we gained the relative safety of the wall of his house directly beneath the bedroom window, which gaped

slightly open. From within floated the ominous hum of multitudinous wings, a hum of anger and threat. Raising up until our eyes just cleared the sill, we gazed into the room, then froze in terror and abject fear. The room was indeed filled with bees, flying, standing on edges and ledges, crawling over bedcovers, crawling into and out of any hollow containers, into lampshades, out of pillowcases. All were angry and sounded it. Furniture was covered with the weary, the curious, and the depressed. In front of our eyes, barely out of striking distance, the sill was three deep in black and yellow malcontents who glared balefully into our eyes, not yet collected enough to launch themselves across the scant inches between us. Hurriedly we ducked back down and retreated on all fours through the grass, praying that we would not be hit by a sudden raid from the rear.

Regaining the safety of Ted's porch, I slumped in a chair, while Ivar wandered off in search of someone who might be of practical help. My only suggestion was to burn the house down.

I never met Ivar again. In fact, I never really found out if it actually was Ivar or not. If it's of any significance to scholars, he wasn't carrying a guitar.

Walter Isaacs

Only the inner circle appeared regularly at Callahans, but other painters frequently joined our gatherings. Among occasional visitors were the University painters, Walter Issacs and Ambrose and Viola Patterson, as well as the academic moderns, Peter and Margaret Camfferman. These were diluted School of Paris, seeking the same formal values as Matisse and Picasso, Braque and Cezanne, and here lay the precise source of their inner weakness. The physical and cultural environment which had created a context for Parisian painting in the late nineteenth century was radically different from

the environment of American generally and the environment of the Pacific Northwest in particular. For the most part these painters produced good paintings without any quality reflecting the context of the land, sea and sky in which we worked out our destinies, the color, the tonalities, the contours, the tangible forms and sonorities of the Northwest.

Isaacs was head of the University of Washington School of Art. He saw painting as a self-enclosed discipline in which certain formal principles not only guided practice but actually motivated painting. The result was a painting in which everything was done correctly in order to bring about a result which exercised influence only on other painting. We were not moved. We all liked Walter, who was an adroit campus politician, but we considered his painting that of a competent mediocrity.

Ambrose and Viola Patterson both taught on the School of Art faculty, and Peter and Margaret Camfferman taught privately. The Pattersons both painted in a genial, laid-back academic Parisianism which gained in its nonacademic qualities as they went along, two lovable people who took the exigencies of the academic scene lightly. While the Camffermans had gone through the tedious formalities of academic training and generally followed sound academic doctrine as modified by the twentieth century, their use of formal principles was looser and gave greater play to their individual predilections for decorative contour and color, which made their general idiom close to that of the Pattersons. Ambrose Patterson had actually been senior in line to head the infant Department of Art at the University, but his maverick personality (he was an Australian) couldn't conceive of a life enmeshed in campus politics and administrative bedlam. In later years, well along towards his nineties, he launched into a series of flamboyant flower paintings, flinging out prodigal and astonishing cascades of color, casually slapped on in a fit of absent-minded gaiety so insouciant as to render suspect the very idea that he had ever set foot on a campus.

Isaacs was a drab, unimaginative man, a perfect department head, absolutely dedicated to use of the power of his position to reproduce itself continually, totally dedicated to building a bu-

reaucratic institution consistent with his stagnate concept of Cezanne's principles translated to a modern campus. He could not see that Cezanne had no principles aside from his brush and pigment. They led the way, carving out paths, which Cezanne and others later verbalized in cafe conversations for no better reason than that they were sitting there talking. And out of scraps of shop talk overheard by journalists grew towering hybrids of principles and soon whole schools of art in which these principles supported an entire unwieldy edifice of professors, assistant professors, teaching assistants, grad students, undergrads, wives and girlfriends, librarians, historians, aestheticians, critics, janitors and department electricians, all dependent for their living on the perpetuation of the mythology of the master's alleged principles; while he, poor, simple soul, sat at God's right hand trying to recall in a sort of alcoholic haze what it was he said to Monet that evening in July 1895 at the Cafe des Martyres when that saucy little model of Suzanne Valadon's had bared her buxom buns in raucous salute to Renoir and he, locked into a world seen through a screen of flat brush-strokes ranged in vertical axes, saw how protrusions of the ischial tuberosities warmed in scarlet sloping away to cool blue contour at alleged edges of the buttocks would create a dimensionality contexted out of warm-cool flat strokes without any use of chiaroscuro whatsoever.

When all is said and done, real painters are formed by their tools and materials, not by their principles, which always arrive after the act. Congenital existentialists.

One night at a preview Isaac's widow, Mildred, a gracious and charming woman, told me a story. She had been a student, fell in love with him, and her studies had ended in marriage. They spent their honeymoon on the Mediterranean coast of France, where each morning under the same sun which had baked the brains of Gauguin and Van Gogh, Walter would kiss his bride and set out with canvas, easel and color box to find subjects for his brush. Mildred found her days tedious and irksome, and she soon dug out her own brushes and colors, set up an easel on the porch of their cottage and painted a seascape.

Walter returned in the evening with his day's work, which he

was accustomed to placing on the front porch easel, only this evening to find the easel occupied by Mildred's effort. He climbd the steps, glanced briefly at the easel, crossed the porch, entered the house, put away his gear, and uttered the usual mantra of the American husband, "What's for dinner?" After dinner, as the purple evening shut down over the scene, he lit his pipe, settled himself in the porch swing and absent-mindedly stroked Mildred's hand, which happened to be her painting hand. All the while her painting stood on the easel, and all this time Walter hadn't acknowledged its existence.

The moon rose, night snuggled tightly down around them. Walter puffed harder on his pipe and drew his bride closer to him. Finally, he said firmly, "Mildred, in any family there is only room for one artist."

She smiled shyly into my eyes and laughed. "You know, I never painted another picture!"

The Henry Gallery was part of Isaacs' domain as head of the School of Art. For years it mouldered along, showing little of consequence, save for a small Delacroix lion in its permanent collection. Sometime after the war, Isaacs being on sabbatical, Betty Willis managed somehow to wedge herself into the job as Director of the Henry, and its walls soon blossomed with fantastic exhibits, chief of which were a collection of facsimiles of African Rock Paintings and an exhibit of photographs by Cartier-Bresson.

Soon Isaacs returned. His reaction was typical. He called Betty in and announced, "I will never allow a woman to hold the directorship of the Henry." And he was as good as his word. He promptly launched a search for a new director of the proper gender, hired him and offered Betty the assistancy, which she refused. At the time such opacity was not even noticeable.

Malcolm Roberts

Malcolm Roberts, son of a wealthy candy manufacturer, started as a Cornish student painting tightly-rendered landscapes and seascapes in which conventional vistas were interrupted by unconventional artifacts and exaggerated perspectives, the visible images of conventional surrealism, best known through the paintings of Salvador Dali at that time. Malcolm created quite a stir through the midthirties as Seattle's first surrealist, but tended to take it all with a grain of salt, having to all intents and purposes retired from painting by the time I arrived in town, this also being the best surrealist tradition. Unlike Duchamp, Malcolm didn't substitute chess for art. Since he had inherited a tolerable amount of money he was able to choose his way with some freedom. Eventually he turned to interior design, at which he had a flair for flamboyant and rococo opulence.

The world-weary, jaded stance of the Edwardian aesthete, made familiar by generations of English literature of the era of decadence, fitted Malcolm like a tailored suit. It is difficult to conceive now that Malcolm at this time, when I was a coltish twenty-one, must still have been short of thirty. So majestic was his ennui that he appeared to me to be at least one hundred thirty! In his presence, my normal verbosity froze into icy chunks of tongue-tied silence, chilled by the disastrous possibility that I would blurt out some ingenuous piece of juvenilia which would ignite the cold fires of Malcolm's cynicism. Yet, while I must have offered a tempting target at times, Malcolm never struck, and I was spared humiliation.

Years later, Sue and I ran into Malcolm on Broadway one evening. He spoke with warm appreciation of a small painting of mine which he had just seen in some gallery, expressing the hope that he would shortly be able to afford it thanks to an upturn in business. Of himself, he spoke only in diffident tones of deprecation. We shook hands warmly, parted, and we watched him walk down the street with a young companion, a wee bit hestitant in his step, his

back bowed slightly as he walked. Shortly after, I heard that he had suffered a stroke and was confined to a nursing home.

I always sensed under Malcolm's mask of supercilious snobbism a wounded self-image seeking to defend itself in externalized raillery. In spite of his acid wit I had never heard Malcolm utter anything truly unkind about anyone, and in our few meetings of the thirties, when I offered an easy target of provincial naivete, he had really treated me with kindness. Malcolm was a lucid intelligence, disguised much of the time as the classic blaguer. In between the drawled snobbism and trendy witticisms, if you listened you heard great honesty and a wounded heart.

Betty MacDonald

One Callahan evening in particular was rendered riotous by the febrile chatter and stacatto laugh of a frenetic young woman whose hair stands in memory as being on fire, a manifest absurdity occasioned by its hue of reddish gold. Beneath her hair her face played madly, the face of a gleeful fox. Round sallow cheeks set with greenish shadow sloped sharp to a pointy chin, her muzzle slit by a smallish mouth with a hint of asymmetric cupid's bow, prominent teeth bared in perpetual laughter setting off blue-green (or were they green?) eyes sparkling with unremitting malice towards the follies and witlessness of the race.

This was Betty Bard, later MacDonald, who wrote a number of best-sellers marked with a malicious light humor and a constant inability to take the world seriously.

We screamed in helpless mirth that evening as Betty recounted the stories which would eventually reach the world as *The Egg And I*, her Depression-era story of life on an Olympic peninsula chicken farm, which indeed would eventually be made visual in a successful film in which Betty and her husband would be meta-

morphised into Fred MacMurray and Claudette Colbert. Betty's stories were frisbied out into the heated air in a high voice crackling with excitement, each story plunging at last into a gale of wild laughter calculated to sweep her audience away into reflexes of insanity, in which laughter was indistinguishable from screaming.

In 1940 I was about to be involuntarily separated from the Art Project as a result of congressional sabotage of the Arts Program. Betty had just been appointed head of the National Youth Administration Division of Information in Seattle. Margaret on the spur of the moment threw out the notion of me going over there as Betty's assistant. Betty agreed as if there were nothing more important to the welfare of our nation on the eve of war than that another zany be added to the general staff.

There was a hitch. The NYA budget didn't allow her an assistant. I would have to join as a regular youth worker at twenty-five dollars a month—that is twenty-five dollars each month for working a six-hour day, five days a week.

It didn't seem too bad to me. I would make up the difference by sale of paintings. To whom, I don't recall. My worst problem was that I had no duties. Betty suggested that I paint pictures based on my sketches of hundreds of youth workers on various projects around us. So I did. This came to the notice of some of the political hacks in charge of the youth programs and they came down on Betty's head, accusing us of using the program to paint propagandistic images for subversion and overthrow of established law and order. This was all a tactical mistake as it threw Betty into a genuine rage in which she totally lost her sense of humor, fell instead into a fit of personal loyalty to a friend, and quite literally screamed at them that if they pushed this thing through, obtaining my dismissal, she would walk out. She stormed out of the meeting, still screaming, and the bureaucrats sat hugging their denuded egos, dolefully mute. Eventually someone moved to table the matter and they managed a weak-voiced vote of approval.

I knew nothing about it, painting away each day at my rather gloomy pictures compounded of black, blue, umber and white, whose gloominess was already being attributed to my antisocial rad-

icalism whereas in truth it arose purely from my total lack of knowledge of color and how to paint with it, a gap in my knowledge-systems which obtained for years and cost me much pain and misapprehension and was not repaired until much later, when in reviewing my 1982 show at the Foster-White Gallery, Eric Scigliano referred to my color as my strongest point, stronger even than my vaunted draftsmanship, and compared me to Bonnard, a comparison which nearly put me into a state of euphoric collapse.

I went on painting pictures, occasionally lettering signs, assisting Betty in paperwork which neither understood, speculating on when the war would start, arguing the role which would be played by Russia, watching idly as Betty typed the manuscript of *The Egg And I.* and marrying Ginny Hoyt, a bobbysoxer worker on the project, who became the mother of my first child, Kevin James, named after Kevin Barry murdered by the Sassenach in Dublin in 1916. Ginny and I combined wages to bring in a monstrous $50.00 per month, which I added to by sales for cash or goods-in-kind, so that we lived in a state of blissful somnolence, broken into in October of 1940 by my winning the watercolor award at the Northwest Annual.

Meanwhile all over the world the General Staffs were busy with plans to remodel the faces and the bodies of humanity in the name of various sorts of progress, all of which would be collected together under the conglomerate name of World War Two.

The project moved to a huge loft building at Twelfth and Madison. There we actually began to make preparations for our war. Our very own war. Our blood ran faster.

We were engaged to silk-screen armbands for Civilian Defense and I was deputized as a related-training officer under the State Department of Education to supervise the work, of which I knew so little that I had to consult my own workers in order to tell them what to do. We printed the narrow bands on immense sheets of sailcloth, which were toted up long ladders by a nubile girl named Cherry Tanaka, who later edited the Japanese-American Citizens' League newspaper after the war had ended and she had returned from a concentration camp in Idaho to which our New Deal admin-

FEDERAL ART PROJECT

istration sent her in order to restrain her from subversion.

This transfer of Japanese-American youth, mostly Nisei, to the Art Project was another sign of the times. Ostensibly they were transferred because it was considered, after Pearl Harbor, that they would be subject to attacks by American youth, they of course being not-American in the imaginations of the bureaucrats. On the Art Project they would be safe from attack. The bureaucrats were right, naturally. On the Art Project the Japanese-Americans were concentrated and were never subject to attack or indignity or humiliation or insult or any other untoward disaster, and the bureaucratic foresight was vindicated! And they were all cozily close together when it came time to round them up and send them off to the "relocation" camps.

It surely helped our project as it made certain that production of armbands for Civilian Defense would be carried out with the racially-gened precision of our Nisei battalions who did these jobs with neatness and precision under the silly guardianship of Betty and me.

Pearl Harbor marked out the destinies of many of my generation, but failed to impress my guardian angel, who punctured a big hole in my right lung and shipped me to Firland Sanatorium, where the casualty rates were double those of the battle zones. Betty had done her time at Firland a couple of years earlier and filled my days with hilarious stories of just how much fun I was going to have, wrestling with the bugs, and these stories duly appeared in her next book, *The Plague And I.* My date for going to Firland came two weeks before the date set for the alleged evacuation of the Japanese-Americans from the alleged war zone. All of our kids were destined for the camp at Minidoka, Idaho. The day before Betty and her husband were to drive me to my concentration camp, I said goodbye to our workers. I looked at Cherry, smiled, and said, "Well, I guess they consider me more dangerous than you! I'm going to camp before you!" And I never saw Cherry again.

Next day Betty and her new husband drove me to Firland. Ginny and I sat in the rear seat as Betty chattered happily along, buoying me up for the ordeal.

At Firland I was processed through the office, torn away from wife and friends, and a student nurse led me over a footbridge leading to the ward where my new existence would begin. As I stumbled numbly across the footbridge the car passed beneath me. Through the streaked glass I saw Betty's face, Ginny beside her, peering apprehensively up at me. Betty gave a cheerful wave of her hand, then the car whipped around a turn, disappeared behind fir trees and shrubs, and they were gone.

In spite of all her promises, Betty never came out to visit. After I myself got out I understood. Old lungers never like to go back, not even to visit. You might not get out again.

Betty's humor wasn't kindly, nor homey, nor gentle, nor friendly. It had the malicious edge of a scalpel, and it could cut. Betty saw the flaws of the race as vicious. The fact that these flaws generally ended in hilarious pratfalls didn't make them any less lethal in her eyes. She turned her acid humor on the stupidities of mankind because they enraged her.

Sometime in 1940 she was hospitalized for removal of ovarian cysts or polyps. I did an enormous drawing in brush and ink of a brown bear which she pinned on her hospital wall. She lay there after surgery, a bit wasted, her fox face sharpened to a point, laughing, as I pinned the bear on her wall. A few years later she showed up with cancer of the uterus. She died bitter, I heard, because she felt they could have caught the danger at the time of the first surgery.

Like most people who laugh a lot, she wasn't a person warmed by humor. She was deadly serious, and her humor was a serious shield against the fears inspired in her by the world. Like Billie Holiday she laughed to keep from throwing up.

The important thing was she laughed. No matter where the laugh started, it ended up joyous. The rasp of its sandpapered abrasiveness never obscured the pure joy that she derived from destruction of pomposity and ignorance. If sometimes her laugh seemed directed at helpless victims, observation showed you that it was more often than not directed at the syndrome by which people create

themselves helpless victims. Our office typist was an affected girl with mouse-brown hair and no eyelashes who littered the air with platitudes, malapropisms, banalities and truisms. Assailed one winter by hordes of flu germs she managed to absent herself from her duties for three weeks. On the morning of her expected return Betty faced me across our double desk, her eyes sparkling. "I will bet you," she giggled, "that Marie will walk in, hang up her coat, turn with her arms thrown out, and scream, Long time no see!"

"No bet!" I replied. "I wasn't born yesterday!"

And it came to pass.

Marie trotted in on high heels, her cheeks sallow from illness, her chipmunk teeth glittering in a baleful smile, hung up her coat on the corner rack, turned, threw out her arms, and screamed quite literally, "Long time no see!" while Betty went off into idiot brays of laughter.

Dr. Richard E. Fuller

My first meeting with Dr. Richard E. Fuller came about at Kenneth's suggestion. I had been turning out my first series of temperas based on the people and the streets of the Skidroad area, for the first time doing paintings arising out of my own experience, projecting the same vision as my sketchbooks, an eye for the world around me focused on color and shapes and textures appropriate to it rather than borrowed from French models.

For a long while after our initial meeting Ken and Margaret were overly kind in their evaluation of my paintings, but one night when I took over a bundle of stuff I fell afoul of Margaret's temper. I unveiled a stack of watercolors influenced badly by the weakest qualities of painters like Pascin, Modigliani and Marie Laurencin. Margaret lost her patience. She had leafed through the stack, glancing briefly at each, then handing it to Kenneth who would gingerly

accept it and lay it on a growing pile on the floor. Faced by such blunderings, Kenneth had a tendency to become totally miserable, avoiding any definite criticism which might hurt tender feelings. But Margaret was fed up. Brandishing my sketchbook, which was filled with drawings of figures from the street and Skidroad, drawn directly on the spot in their natural motion, she snarled in exasperation, "Why in God's name don't you paint these figures? These are your people, the people you know. I don't know anyone else who can draw them just as they are, in movement. You draw them with real understanding and love and energy, and then you paint these trivial little nudes with shoe-button eyes trying to look like Parisian chippies!"

This tirade was delivered so vehemently that I could only sit stunned and silent, nursing my wounds, not even able to admit that I really didn't know how to translate my sketches into pigment because I really knew very little about the craft of painting.

Kenneth sat stiffly, nodding affirmation to everything Margaret said, and chose at this point to enter the discussion with a suggestion of utmost significance to my future. Pointing out that I handled both oil and transparent watercolor clumsily, he suggested that I use tempera. Now tempera is a rather loose term, which at one end can mean the crude poster colors mixed with glue and water which are used to paint signs for the high-school dance. Again it can mean an arcane method used by the Florentine painters, in which yolk of egg is frothed with water, a method used today by Andrew Wyeth I believe, but a method only suitable to very tight realistic rendering.

Kenneth, however, used a formula for mixing oil and water, and gave me his formula that night and I've painted with it ever since, introducing a few variations of my own, but staying well within the parameters of the formula as he gave it to me that night. In any case I soon turned out a series of egg-oil emulsion temperas of Skidroad scenes, and not very long after had the pleasure of hearing Kenneth say, "I think these are really good and they're really your own thing. It's time for Dr. Fuller to see what you're doing!"

A few mornings later I was admitted to Dr. Fuller's office in

the basement of the Seattle Art Museum by his secretary, Dorothy Malone. Under my arm was a folio of small and medium-sized temperas. Dr. Fuller, tall, balding, self-assured, greeted me with practiced grace and a touch of genuine concern for both myself and my folio.

Seated behind his desk, he distanced himself so that we peered at each other as across a football field. His voice squeezed up into his head so tightly that at times it seemed to come with great difficulty and from a great distance. At the time I found this mystifying, but as time passed I came to realize the terrible agony of shyness which often made even casual conversations painful.

He fingered through my dozen paintings diffidently, often at a loss for some remark to ease the tension. I sat in a paralysis of anxiety, ill at ease, unable to utter anything except inane mumblings in answer to his questions. After looking at each of the paintings, he separated three from the stack, and said, "I want to take these home for my mother to see. If she likes them I would like to buy them for the Museum collection."

She liked them. He bought them. For the three I received one hundred dollars and no money ever seemed sweeter.

During those years I saw Dr. Fuller frequently. His shyness never blocked him from exchanging a few words of greeting, casual but deliberate. I believe that he felt quite ill-at-ease with artists, aware that he was looked on with a combination of envy and prejudice, aware that most artists greeted him with servile warmth only to bitterly criticize him behind his back, attacking him for his diffidence toward contemporary art and for what they considered his miserliness, not toward the arts, but toward them personally.

Yet in those years he provided 90 per cent of the Museum budget; it was his Museum and he was under no particular compulsion to buy contemporary art or the art of local painters. He was under no compulsion, but few artists ever went away empty-handed from his office.

Yet Dr. Fuller and I did have a falling-out, and it came about as a result of my frantic efforts to change the world. In 1948 I wrote a review of the Northwest Annual for the Stalinist *Peoples' World*.

The review was oddly nonpolitical for such a publication, and could have easily appeared in the *Seattle Times*. However, it included a paragraph about the shelving of a show of the anticlerical wood engravings of Leopoldo Mendez of the Taller Grafica of Mexico City, and this paragraph included material leaked through a Museum employee. Wartime euphoria had given way to the exigencies of the Cold War. Dr. Fuller was deeply offended. At that point he was obliged to send me a check for my painting in that same annual, which he had undertaken to purchase. With his calm acceptance of his bonded word, he chose not to cancel the sale, but instead accompanied his check with a note typewritten by himself, an interesting sidelight on the matter, since it meant that our private unpleasantness was kept to ourselves. The note itself enraged me. It was patronizing, it was shallow, it stung me harshly. I wrote a brash reply, in which I upbraided him for the assumption of guilt by association implicit in his charge that I had violated his trust by writing in a publication dedicated to the destruction of the American way of life. I wound up by expressing my deep-rooted opinion that the ability to write checks would appear in the eyes of history to be less socially useful than the ability to paint pictures. Suppressing any ethical considerations I vengefully published both his letter and my reply.

Wisely, I did not seize the opportunity to answer his patronizing reproof by returning his check.

So with this odd exchange of pleasantries, Dr. Fuller and I took leave of each other for awhile. The two letters were so inane, so self-righteous, that it is difficult to give them credence after more than thirty years. But they were written, it all took place just as I have described it.

One would think that we would never cross paths again. But we did. A few years later, after painting little and exhibiting nothing for a number of years, I came out of retirement and rapidly won all the major prizes in Northwest painting. In 1961 I won the purchase prize at the Northwest Annual, receiving word of the award by the customary note from Dr. Fuller, written in a remarkably cordial tone and informing me with great pleasure that my painting

had been picked for the honor by a rare unanimous vote of the jury.

A short time later, the curator of the museum, Millard Rogers, called to say that he had been instructed by Dr. Fuller to offer me a one-man show at the Museum for the following March, a show which would take place exactly twenty years after my first unimpressive one-man show at the Museum.

The show was a success, selling out almost immediately. For the first time I had really turned my talents to money. But more importantly for me was my meeting on the night of the preview with Dr. Fuller who greeted me warmly and with evident pleasure, expressing himself as most pleased to see me painting again after so many years of illness, not specifying whether he meant my pulmonary lesions or my political idiocies. There was no hint on either part of the rupture of fifteen years before. It seems unlikely that he was aware of my break with the radical movement. I had not engaged in flamboyant public recantations by which so many refugees from the left blamed their disillusionment on someone else.

A year or so later I attended a lecture on recent digs at Mycenae in the Health Sciences Auditorium at the University. There, leaving, I ran into Dr. Fuller and we exchanged greetings, he expressing surprise at my interest in a fairly esoteric phase of archeology. Soon after this meeting we met again at the Poncho auction. All was pandemonium. The auctioneer's voice, elevated to the decibel level of the Last Trump, made conversation difficult even at a shout. On the overhead screens the silhouetted hands of the auctioneer's assistants scrawled the bids in monstrous scribbles. I stared, fascinated at the handwriting on the wall, ominous, threatening. "Mene, Tekel, Upharsin!"

At that moment, as I strolled over to look at the paintings up for auction, I sensed rather than heard someone at my elbow. There stood Dr. Fuller, beaming in evident pleasure. By concentrating mightily, I could make out his message. He had been the successful bidder on a painting of mine, sourcing the monstrous scrawls floating in midair, which my habitually feverish imagination had changed into the ominous message of Belshazzar's Feast.

To my surprise, after this pronouncement, he continued talk-

ing, grasping my arm lightly and attempting to deliver his words into my fugitive ear, for all the world as if we were the closest of friends. Due to the catastrophic din of the auctioneer, I hadn't the foggiest notion of what he was saying until in a slight pause in the cacophony I caught the words, "Lion Gate!" Of course! He was discussing the lecture on Mycenae. Although I had no professional expertise in archelogy, he had been so struck by my attendance at an esoteric and difficult lecture that he was sharing with me his own highly professional interest. His expertise was immense, but he had more than expertise. To him the worlds of the past were real with an intensity which he could not accord the present, and his delight in being able to speak freely and without painful inhibition about a subject he loved led him to stand there in the midst of chaos, speaking loudly and to negligible effect, hearing little if anything of my stuttered replies.

It was an amazing incident. If on the one hand I was amazed at his easy forgetting of our unpleasant exchange, on the other I believe that his highly developed sense of honor recognized and acknowledged that I had voiced my attack on him to his face, directly, acknowledging him as a man and an opponent, and not slashing at him from behind.

In any case I had the opportunity to see him as a human being, stripped of the imagined trappings of patron of the arts, effete snob, or bourgeois bastard. And he was really much more than some conventional figure moving in front of a conventional public making conventional gestures, spouting conventional speeches. In 1915 he went to France as a volunteer ambulance driver, interrupting his college years in order to drive a clumsy hard-rubber-tired ambulance under fire on the Western front. During the years after he and his mother built the Art Museum he endured a continual bad-natured ribbing from many of his fellow bourgeois for his senseless squandering of millions on something so useless as art. His devotion to his mother was the source of endless bad jokes. One New Year's Eve at the Rainier Club, he was badgered by some wealthy boor. All evening the idiot addressed Dr. Fuller as "Dicky." Eventually the badgering went beyond the limits of acceptability. Dr. Fuller qui-

etly removed his jacket, folded it carefully, handed it to a by-
stander, turned to his tormentor, hands held formally in the stance
of the old-time fighter. His inquisitor took one drunken round-
house swing, initiating hostilities, whereupon Dr. Fuller delivered
a straight left jab followed by a whistling right cross, the classic
combination, leaving the dolt lying unconscious in his boozy vomit
as Dr. Fuller put on his jacket, finished his drink and left the party
to go home and wish his mother a Happy New Year. Thanks to his
carefully maintained good manners, it was easy to forget that while
at Harvard he had been on the boxing-team.

After the meeting at Poncho I saw him just once more, at the
opening of the Northwest Traditions show in the Modern Art Pavil-
ion of the Museum. I was now a Northwest tradition along with all
my old friends. Dr. Fuller had suffered a stroke shortly before. As I
rounded a corner I saw him ensconced in a wheelchair propelled by
his wife, Betty. My pleasure at seeing him was quickly checked by
my awareness of just how badly wasted the stroke had left him. His
speech was now painful in the extreme, a formless moan in which
syllables merged in a shapeless mass. He looked up apprehensively
at me as he clasped my hand. From his lips came a meaningless
mumble, and I saw in his eyes the humiliation accorded a proud
man by his own mortality, and in Betty's eyes a sad desperation and
pleading, and I smiled back into his upturned face and stepped
aside as Betty swept on past, trying somehow to protect her dying
husband from the strains of one more grand evening, one more
round of noblesse oblige, one more step in a dance that had been
destined and shaped long ago when he was born heir to countless
dollars, none of which could purchase one moment away from mor-
tality's axe.

Bernard Flageolle

Bernard Flageolle died of a cerebral hemorrhage in the late sixties. He collapsed during a portrait session in his little photographic studio in the Howard Building, opposite the Totem Pole, a haven where he escaped from the pressures of his work as a medical photographer in the Tumor Institute of the Swedish Hospital. His death was sudden and complete. One presumes he died happy. He was doing what he most loved to do, something which required no order slips, no pathological descriptions, no parameters of imposed structure.

I met Bernie and his wife Jessie at Irene McHugh's cottage near Leschi in 1938 or 39. They were expecting when I met them, happy with the clumsy joy of young marrieds, unmarked yet by the disillusions of the married state, but soon-to-be-marked indelibly and forever. When I met them again, once more at Irene's cottage, they had buried their stillborn infant and buried most of their hope with it. Mute despair hung over them in a great gray curtain.

Bernie had trained to be a mortician in Chicago or some such place, somewhere east of the Rocky Mountains. He had a capacity for sepulchral empathy with mankind's suffering that could easily have been translated into the demeanor and conduct of a mortician. It would, however, have done violence to the gentle poetic quality of his nature which leaned instinctively toward life and toward the expression of life in art and in the flesh of beautiful women.

All of his potentialities of course were put on hold when overtaken by the war, and our acquaintance was curtailed suddenly and definitively. I migrated into Firland Sanatorium where I was expected to die of tuberculosis, and Bernie migrated eventually to Italy, where he could well have expired of all sorts of things, including boredom.

It would be some years before we would again meet. Bernie's experience in the service was counterpointed by a grotesque experience which unfolded before war actually overtook him. His training

as a mortician had bestowed on him an interest and curiosity about human anatomy. Seattle College, out of which Seattle University would emerge, gave a dissection course taught by one of the fathers. The class was ill-attended, the father was old, the class fitted into none of the structures of the institution, the father dissolved the class in a fit of quiet despair, and followed up by bestowing on Bernie, in a spasm of Gaelic generosity, the one remaining cadaver. "You were my one genuine student," he told my friend. "May this poor corpse furnish you with many hours of joy!"

At this point, the father retired from teaching, sat down in his big chair, and awaited his inevitable summons from Dark Rosaleen, the spirit of the old forgotten earth. The summons came, the ancient priest nodded his acquiescence. Stepping out of his used-up old body, he was transported in spirit at least back to the earth of his parents, the ancient Land of the Sorrows, to the domain of Cuchulain and Deirdre.

Bernie with some difficulty moved the cadaver into a room in the Howard Building, opposite the Totem Pole. This room was attached to a large photographic studio which would someday house myself and Johnny Davis, followed by Dick Gilkey and Ward Corley, and finally by Jack Stangl.

Ensconced in his little room, his cadaver reposing blissfully in an old clawfooted bathtub half full of alcohol, Bernie began the dissection of his anonymous friend. Under a gooseneck spot and with a dissectors' handbook at his side, he began to gnaw away at the supinators and the deep pronators of the right arm, when fate intervened. Cadavers in ones and twos lost their priority, and fate decreed with shattering fanfare that henceforth cadavers would come in hundreds and thousands. Mankind cooperated enthusiastically, or if not enthusiastically, with zeal and application. This was the kind of thing that was old hat to Orientals and Europeans, but was a radically new idea to Americans, who had never quite adjusted to the violence of 1861–1865. Millions of us had just narrowly averted death in the form of starvation. Now in one badly mangled Sunday morning we found ourselves flung over our heads into the pastime of mass destruction, into which we eventually

threw our talents with such purpose that we achieved the impossible, the destruction of one entire city and an incredible thousands of lives in one blazing moment.

Bernie lost interest in his cadaver on the day that he received his greetings from our President, Franklin D. Roosevelt.

After stateside training he wound up in Italy, where he saw at close hand more cadavers than he had bargained for when he enrolled in his mortician's course. When the war ended he was still in Italy. Service there had endowed him with a great love for opera and a great distaste for dead bodies. Much of this distaste arose from his service on grave detail.

In the absence of its guardian, the cadaver had remained in the Howard Building. Each month Jessie paid the rent, aired out the room and refreshed the alcohol bath in which the corpse slumbered, indifferent and oblivious to the global convulsions shaking the planet.

Bernie returned, Jessie and he rejoiced in their reunion and stole a few more months of joy and illusion from linear time, and Bernie became a successful medical photographer. His interest in dissection never returned, visions of spontaneously dissected bodies loaded into plastic bags in Italy making it difficult for him to approach such a task with any objectivity.

He was weary of paying rent for an unresponsive guest.

The guest must go.

This was a simple decision, exceedingly difficult of execution.

How do you get rid of a cadaver?

Inquiries at Seattle University, which had succeeded Seattle College, finally settled one part of the problem. The good father had departed the planet shortly after Bernie departed Seattle on a troop train. Any papers pertinent to the cadaver and its legal status must have been in the possession of the father. Presumably they had disappeared with the disposal of his pathetic bundle of personal effects, rosaries, old socks and breviaries.

His friends from service suggested any number of solutions, most of them stolen whole out of old James Cagney or Edward G. Robinson films, and consequently totally unworkable. The flaws

were readily apparent. Dumping the delinquent corpse in a hole full of quicklime or dropping it in Puget Sound wrapped in a cement sleeping bag were attractive on first view but upon further analysis disclosed serious flaws. Any lapse in carrying out the script would necessitate an embarrassing disclosure of the whole question which could carry suspicion of complicity in the demise of the corpse. Not to speak of the horrid question of guilty knowledge on the part of all concerned.

Bernie decided that candor offered the best path. Wrapped in his aura of invincible innocence he walked into the office of the County Coroner, wearing his ruptured duck, sign of a returned veteran and consequently deserving of the emoluments and thanks due from a grateful nation. The administrative drone was not amused. Possession, simple possession of a corpse was not only socially undesirable, it was illegal. Bernie had no papers to establish just how the corpse met its end. How was the coroner to know at this point of time if death had come in a legitimate manner as prescribed by law? The only incontestable fact was that the corpse was dead. And, assuming that death had come in some such legitimate manner, it did not follow that Bernie had come legitimately into possession of it.

At this point, Bernie wished that he had never developed an interest in anatomy, an interest that had become increasingly preposterous. His chief reaction to his plight was peevish annoyance with his clerical friend for dying.

Eventually a resolution was reached. The Coroner lacked a rationale on which to base the imprisonment or execution of my friend. On top of all else he was a returned overseas veteran, honorably discharged, with a Good Conduct ribbon to show for his years of service. The cadaver showed no obvious wounds suffered prior to death. The presumption could only be that he had died legally. Bernie's clumsy gnawing on the right arm could only have occurred after death. The body had obviously been submerged for a long time in alcohol, a state which had most likely succeeded in achieving symmetry between his outside and his inside, since all his physical signs had indicated alcoholism as a contributing factor to his ultimate erosion.

All of these points Bernie had made in the very opening stanzas of his ordeal. The coroner now appropriated Bernie's points, utilizing them in a lengthy build-up to a climactic crescendo wherein Bernie was bidden to rid himself of the cadaver pronto. This would be accomplished simply. The coroner would issue a John Doe certificate. There would be a small fee for this service. Bernie would next present the certificate, accompanied by the corpse, to a decent funeral home. The funeral home would give the deceased a Christian burial. All of this, of course, at another fee. And everything, naturally, at Bernie's expense.

Affairs having finally netted the functionary a cash profit, he now relaxed to the point of allowing himself a small pleasantry. "In the future, young man, don't accept any more cadavers from priests or anyone else!"

Bernie didn't.

The incident of the cadaver was long past when I saw Bernie again. Burrowing through the fetid and crowded aisles of Ace Books on Pine Street one afternoon, I noticed a dark-haired owl-eyed young man enter, smoking a pipe and sporting a heavy tweed jacket. Winking at Ace he waved the pipe in the air, hooshed the tails of the jacket, and started to burrow through stacks of photographic magazines. He found what he was looking for at the same moment that I concluded my search, whatever it was, and we stood before Ace holding our finds but staring mutely at each other while Ace, unshaven and gross as usual, great gut starting in gelatinous horror over his unbelted waist, stared mutely at us, breaking the silence finally with a muttered obscenity, upon which we started, stirred restlessly and mewed at each other . . . "My God! Aren't you . . . ?"

"Yes . . . at Irene's cottage!"

"1939!"

"The war!"

"It's you . . . now let me recall your name . . . your name . . . your name is . . . just let me see. . . ."

And in just such an idiotic way we were reunited. We left

arm-in-arm. It took us five minutes to walk to Swedish Hospital, where Bernie had his medical photographic business in the Tumor Institute. We walked in, greeted the teenager working at his desk, sat down for a while, jumped up and walked around, he displaying all his cameras and lenses and various bits of arcane equipment to me, lovingly describing the history and usage of each thing, displaying slides of carcinogenic cells, passionately piling books in my lap, rare volumes on anatomy or photography or reproductions of master drawings.

At the time I was on a disability grant from the state, trying to remodel myself into a commercial artist at the Burnley School, teaching figure drawing for Ed Burnley in order to fluff out my slender grant. I was blacklisted during the entire McCarthy Era, and had sunken into such a slough of despond that I could not envision being able to earn anything near a decent living through my work. The extreme right rode high during the fifties, total ignorance was enthroned, and the arts stayed clear of controversy rather than draw the fire of obscurantism and philistinism.

Bernie's anatomy texts fascinated me, and I told him how Johnny Davis and I were dissatisfied with our skimpy understanding of the body and how we had begun working with the classic Gray's Anatomy in an effort to comprehend the working of the body more clearly.

Bernie chortled in delight. Stooping over in front of a counter, he pulled two dilapidated cardboard boxes out from under and presented them to me. I sat there with one in my lap and the other on a table, while he pried them open. There lay a complete skeleton, disarticulated, greasy, but whole, and, in light of Bernie's past experience with the cadaver, happily supplied with a document of provenance informing all and sundry that the former occupant of the dried bones had been dissociated from his mortal envelope in a dissection class at the University of Michigan in 1905.

But this was not all. From a shelf, Bernie pulled down a thick volume and shoved it in my hands. "Here! Take it! It's yours!" he muttered. "I always wondered why I'd picked it up!" It was a one-volume edition of *Gynecology* by Kelly of Johns Hopkins, one of the

blacklist

great classics of medical literature by one of the greatest of surgeons. What made the volume so extremely valuable were the illustrations, pen-and-ink drawings by Max Broedel and August Horn, the virtual fathers of medical illustration in this country. They were Germans, brought to Johns Hopkins by Kelly early in his career. Their illustrations, many of morbid pathology, rose to unbelievable beauty by the sheer creative energy of the two artists.

Bernie showed me their illustrations eagerly, and suggested that I could free-lance medical illustration through his photographic service, which would add another string to my bow. Within the week I returned with my first trial renderings and Bernie and I enjoyed a long association and a longer friendship. Later I picked up the rare four-volume edition of Kelly's *Gynecology* and *Diseases of the Kidneys, Ureter and Bladder,* and these together with Bernie's original gift volume of Kelly, I presented to the University of Washington medical illustration studio a few years ago, long after I had lost interest and justification for doing medical illustration. What made the gift especially gratifying to me was that a couple of my ex life-class students had worked their way onto the staff.

Eventually Bernie came to hide out from the stresses and worries of his job in the Howard Building studio shared by Johnny Davis and me. Our studio under the skylight was just down the hall from the room where he had kept the infamous cadaver during the war years, and this in fact was the inspiration for his telling us that involuted and marvelous story. Here under our skylight, bathed in limpid light filtering down from above, Bernie would sit by the hour, warmed by our illegal wood stove, chatting, laughing, admiring our drawings, ogling our models, his pipe always lit and his smile and chuckle woven into the warmth of the fire. In 1949 we left the studio, I to work at home in Yesler Terrace, Johnny to rent a studio in an old hotel basement off Yesler. Bernie then rented two rooms in front of the Howard Building, and these became his photographic studio, the same room where he would die a few years later. However, even with his own retreat, he continued to spend much time with Johnny and me up in Johnny's studio.

Occasionally I spent a couple of hours talking with Bernie at
the Tumor Institute, reminiscing, speculating on the amorous pro-
clivities of various ladies, discussing films or paintings. One day he
locked the door of his Inner Sanctum and proudly ran for me an
8mm pornographic film he had acquired by dint of much scroung-
ing, this being the time when such works were still illegal, and the
Danish explosion was still in the future. It was one of the classics of
the genre, a soft-focus black and white work featuring a lissome
dark-haired star playing the role of a nun and working with the
drawback of a less than adequate co-star, and Bernie was less struck
by the athletic gyrations of the action than by the fragile beauty of
the star and the erotic effect of the opening scenes where she ap-
peared in full costume as a nun, only to be slowly and tantalizingly
unveiled until she emerged as Venus Imperatrix, her naked beauty
gleaming wickedly and valiantly in the grainy black and white film.

To Bernie the beginning and end of human wisdom was con-
tained within the fragile and transient ambience of women. He saw
and loved that beauty in little girls, in nubile adolescents or in
women in the full flowering of their sensuous life, or in the fragile
fading of old age. He offended the prurient, who had already been
offended somewhere in the past by their discovery of their own
flesh. No matter, his own love burned so intensely that its heat pu-
rified it from within.

He treasured a little oil of mine, a real rarity because I seldom
worked in oil. It was a painting of old Bill Jonnes, who for years was
the caretaker of the Howard Building, and who was famous in Seat-
tle as our pioneer pornographer, often busted by the vice squad,
never discouraged by police harassment, which was often purely en-
gineered as a scam, Bill's negatives being confiscated only to be used
as the basis of a thriving business by members of the department, or
so Bill told me. For all of this, Bill was a true artist, and a talented
draftsman, who had come off a Midwest farm long ago to attend the
Chicago Art Institute before the turn of the century. At this time he
was near ninety, still harassed, still working away. While he was a
talented draftsman, he was a terrible photographer and his best
work in the idiom was in copying classic French pornography from

the late nineteenth century. In my painting, about ten by twelve inches, Bill was focusing his old view-camera on a lithe and nubile young model who stood fresh and rosy like one of Boucher's drawings of Louis XIV's Irish mistress. It was painted in the Maroger reconstruction of Ruben's formula for oil medium, and had a magnificent blooming radiance. Nothing else I ever did gave Bernie such joy as this painting, which I gave him as a birthday present one year, one of the happier inspirations of my life. He later confided to me that he felt the painting was more than a bit symbolic of the artist confronted by life, adjusting his lenses, trying to focus on living beauty, fiddling with light meters and emotion meters and sense meters and trying, just once, dear God, to grab that living flesh and mold it into meaningful pattern of light and dark, fix its life and light and glitter and crunch it into some form that will be beyond decay and erosion and all the other weapons of killer time.

It was quite easy for me to grasp what he meant, and why he loved the painting. After all, it was really a painting of his life.

One evening, my phone rang. Sue answered and called me. It was Dorothy Ditleveson, the charge nurse of Tumor Institute. Her voice was choked and uneven, and when it steadied enough for me to understand her, I realized that she had said, "Bill, Bernie died today"

Bernie had been in his Howard Building studio, which he had furnished with a variety of Victorian antiques, working with a favorite model. Midway in the afternoon, heavy drapes drawn against the afternoon sun, working at his camera, for all the world like the figure of old Jonnes in my little painting which hung on the wall of his studio, in front of that naked woman-flesh which had blazed its light aross his vision all those years, he had paused one moment, stood straight up, eyes dilating in wonder and anguish as a flawed blood-vessel opened in his brain. With the speed of light, on the crest of a cerebral hemorrhage, Bernie was hurled beyond time, beyond space, beyond light and flesh, beyond the last barriers of self.

Some time later, at one of my previews, some dude came up to me, shook my hand and informed me that he was a longtime admirer of mine, and announced in oracular tones, "A friend of mine

just bought an old painting of yours. Oh not from your dealer. He bought it in an estate sale. Some photographer had owned it, and he had died and they were settling the estate for the widow. A little oil painting of a dirty old man taking a picture of a naked girl. And God! you really caught the humor of that scene, the old man just drooling over the pearly girl-flesh, and the girl sort of cringing in front of him and . . ."

But I had already turned away to greet someone else. Not before I had heard the faint sound of Bernie's chuckle, and his hilarious murmur, "Oh Lord! Some dirty old man! Bill, isn't that rich, just priceless!"

Johnny Davis

I met Johnny Davis after the war. I had seen his paintings in the Northwest Annual and heard of him from people on the Art Project, where he was employed teaching in the free art classes. Somewhere around 1940 a large painting of his won a major award in the Annual. I remember it as a spectacular nude in Bonnard colors, but Johnny always claimed that my memory was faulty, that it wasn't a nude. Whatever, the color was spectacular.

Shortly after the war he came to Seattle in order to use his G.I. Bill at the School of Art of the University of Washington. I met him shortly after at some gathering of leftwing artists and writers, a collection of rather mediocre people for the most part, who were stuck on the position that art was a weapon in the class struggle or various variations of that song. Most were good people, people who really wanted to make a difference in the world, but their artistic merits were slight and were obstructed from expanding by silly ideological wrappings and radical phrasemongering.

In any case, there we were, myself thin and ill-at-ease, Johnny a smiling, middle-size, curly-haired outgoing type who immedi-

ately began a laughing goodnatured putdown of the University's School of Art, which he saw as a hidebound bureaucracy of academic myopia. Irony indeed! Johnny was a favorite student of Walter Isaacs, head of the school, who was urging him to stay on to take a master's degree under Isaacs' personal patronage, a course which would have eventually led to a comfortable sinecure and security for life.

But at the time, John was of no mind to follow the sirens of academe. Like Lubin, he preferred to prowl the night with me, sketchbook in hand, through the taverns and greasy spoons and alleyways of First Avenue and the Skidroad, drawing the drunks, the battered, the warped and mutilated, the hookers and the punch-drunk former state lightweight or welterweight or heavyweight champions weaving out of their lost corners, left jab circling in futile bewilderment in the air before their near-sightless eyes, as John and I traced their neon profiles into our books. A kind of life that has little if any connection with acadame.

In 1948 we discovered a great studio in the Howard Building on Pioneer Square. It was a photographer's studio with a skylight and with the floor and wall covered by glossy white cardboard which, combined with the light from the skylight, created an unbelieveable brightness, like living in a goldfish bowl. Johnny and I were at this time experimenting with techniques and mediums. Our text was the classic *Materials of the Artist and Their Use in Painting* by Max Doerner. We were immersed in the Florentine egg-tempera technique, a tedious and counterproductive method of mangling linear time by using it up in an endless ritual starting with the slow and painstaking building up of an ivory-smooth gesso-surface which could only be considered finished after thirteen or fourteen coats, all sanded and polished, after which a transparent veil or imprimatura was laid over the gesso, on which you had carefully drawn the image you wished to paint, leading then to an endless and insane hatching and cross-hatching of tiny strokes of a small watercolor brush, applying dry pigment mixed with a froth of egg yolk and water, strokes which multiplied through hundreds to thousands to hundreds of thousands, like making a pen-and-ink

drawing with a crow-quill pen, until you had finally finished and were able to stand back and admire the static, stiff and clumsy, unliving figure you had managed to nail together over a period which might stretch to months or even years, but which was bound to impress by virtue of the vast amount of labor which had obviously gone into it. I never finished a painting in this method, but Johnny loved it and worked enthusiastically, never stopping until he had finished it in one great charge, standing back to admire it, admiring it for a few minutes, then, consternation beginning to break over his face, turning to me in alarm, his greatest triumph and defeat being a painting of a girl standing on a windy street corner in a light silk dress which blew out in the wind in a series of ripples and whip-folds, all rendered with absolute care and precision, cigarette butts in the gutter rendered down even to the tiny blue letters of the brand name, and Oh shit! he mumbled in despair as triumph turned into disaster and he saw what I had seen all along, that the poor girl looked as if she'd been dipped in starch and her dress had blown out and set there, no vibration, no movement, none of the magic he'd picked up when he saw the real girl standing there on the corner. By that time, I would have long-abandoned my own half-hearted attempt, knowing that I was no Florentine, lacking their cool intellect and barren sensuality, and I'd draw my friend away, down the stairs we would stumble out into Pioneer Square where life was shimmering, shaking, rattling and rolling and he'd shoot up out of the depths of despond, forgetting his defeated vision.

But all the same, he once said to our friend Earl Carpenter, a sign painter who did miraculous landscapes of the mountain country, "You know I know more about the techniques and methods of painting than you and Bill put together, and you guys can both paint better than me." It was a sadness and one to which you could only return mute agreement because it was true, and the doing isn't in the knowledge or the techniques, they are just the sign that a god has passed, just tracks in the sand.

Both of us had drawn the figure extensively. I had never really drawn anything else. Yet we became dissatisfied with our lack of

knowledge, solid knowledge, of how the body worked, how it functioned. So we acquired numerous anatomical texts to guide us. Over the bones of the limbs after we had articulated them with wire, we modeled the individual muscles and tendons in modeling clay and cord. At other times we worked out ingenious devices of rubber and cord to simulate the action of the muscles in activating the bony structure. Our figure drawings began to take on the sleek contours and the finished rendering of old masters. Unfortunately, they also began to take on the embalmed air of the museums in which the old masters had been buried for centuries.

Through the fifties, Johnny and I were thoroughly blacklisted. These were the years when a vulgar drunk from Wisconsin held the whole country hostage in his squirrel-cage of hysteria, sadism and McCarthy deceit. Very few artists in the Northwest had gotten themselves out on the political limb, an oddity since artists in other parts of the country had made themselves rather conspicuous by their short-sighted, naive and generous-hearted support of leftwing, liberal and humanitarian causes. Johnny and I did crawl out on our limb, and we hung there to the end of the venomous period.

The irony was that we had long lost our illusions, loathed the cheap ward-heeling thugs who mouthed idiotic phrases about Changing The World through the Heroic Efforts of the Vanguard of the Proletariat. So we hung tough for something we hated because we wouldn't turn against the honest rank-and-file friends who had been suckered like us by their own rosy hopes for a better world. Indeed on the night before the Korean War started, I awoke from a nightmare in which I got clearly and definitively that the claims of the critics of Stalinism were right, that the Moscow trials of the thirties and the East European show trials of the fifties were murderous frameups, that old Bolsheviks could look forward to retirement to the Gulag or to a friendly bullet behind the ear as a reward for service to a fantasized proletariat, and I woke up from this startling dream soaked in sweat, tottered queasily downstairs to brew a cup of coffee, turned on the radio and heard the first reports of the North Koreans pouring south over the parallel, to sit there in a daze knowing that now I couldn't quit, couldn't get out, because there would

blacklist

be nowhere to go except to become a pigeon against the innocent and naive rank-and-file as well as the liberals and so- called progressives and sympathizers and fellow-travelers, so that John and I had to stand and be blacklisted for five or six years for something in which we no longer believed.

Our disillusion centered on art. Increasingly we resented the damnfool blather of all leftwingers when art became the subject. Neither Marx nor Engels had more than a thin veneer of expertise in art, but the Marxists who had succeeded them had become more ignorant and troglodytical by the year, and the most ignorant of all were the Stalinist functionaries of the fifties. When John and I shared our Skidroad studio, we often were visited by the District Org-Sec (jargon for organizational secretary) who fancied himself a sort of Mao-Tse-Tung, sitting with a cup of coffee in his hand and a foolish smirk on his face, commenting on our painting and guiding us in the direction of politically-enlightened art.

Johnny had painted an image of one of the Saturday night poker-orgies and fish-fries of his gang. It was a sort of George Caleb Bingham genre painting without Bingham's rude vigor, for which it substituted faithful adherence to tedious detail. But it was of its sort a good painting, the portraits of the players were lovingly delineated, each card and poker chip rendered, the players gesturing and grimacing each in his characteristic dance, and in the background Tom Patrick, glossily black, wreathed in a benign smile, frying fish at the stove.

This painting offended the functionary.

After staring in muddled resentment for some minutes, he turned to Johnny. "What is interesting to me is that out of seven figures the only Negro is standing at the stove waiting on his white friends, who are playing cards and getting drunk."

Johnny smiled. "But it's his house! He's the host, and he enjoys frying fish, and he was just as drunk as the rest of us! And actually one of those so-called whites is black except he's only light brown."

None of it mattered. John in the first place shouldn't choose to paint a bunch of bums to represent the progressive masses of man-

blacklist

kind, he should have chosen to spotlight the earnest and heroic efforts of enlightened workers and peasants who spurned such pursuits as boozing and card playing.

By the late fifties, we were tired of being blacklisted by the Right, tired of being bored by the Left, tired of egocentric ravings of all politicans, tired of just about everything except painting, and drinking, and girls. The witch hunts on both sides of the world had run out of steam. McCarthy fell because he became a pain-in-the-ass to the masters of power in our country. Kruschev announced that Stalin was a bad guy and that a lot of people had been persecuted, and that interrupted the witch hunt over there. Now we could get out.

John's father was a powerful Republican in Idaho. He made it possible for Johnny to teach at Idaho State, where he eventually became head of the School of Art. I was living in an apartment-studio near Garfield High School. Johnny came by. The sun shone through bamboo blinds onto my green enameled floor, inherited from some high flying hooker. Drawings and paintings sprawled all over. We talked cooly without emotion. He was glad to be going to a teaching position in a protected atmosphere, far from the ridiculous rhetoric of political juvenilia. We agreed on one thing, that all politics, left, right, and middle, were beneath notice of intelligent humans, that they meant only one thing, the erosion of all integrity into a gummy square of evasion, half-truth and outright dishonesty. Even at its highest level, politics can only meet art in a straight commercial deal.

We were burnt out.

It came time for him to go. We stood in the door. Our hands clasped and he turned, dropped down the steps and bounded into his car, loaded down with his gear. He turned the key, hit the gas, and was gone.

I didn't see him again.

In the sixties I met Paul Havas, a really good painter who had studied with Johnny at Pocatello. He told me Johnny had married one of his students, spoke of me when Paul said he was moving to Seattle, and spent most of his leisure time on his quarterhorse. I

wrote to Johnny and he replied with a long letter. He was relaxed and open and happy. In a week he would go out on a two-week long cattle drive with a friend's outfit in eastern Montana. Later he arranged for a show of my work at the college. We talked of getting together.

One day I found Havas in the office of the Woodside Gallery talking to Gordon Woodside. We exchanged pleasantries for a few minutes, bits of shop talk, personal minutiae. I hadn't heard from Johnny since my last letter and I asked him if he had heard from him lately.

Paul stared at me, stammered slightly, and said, "Didn't you know? Johnny's dead!"

Johnny had headed the art department for some time. While it was a small unimportant department no one really cared. But as the campus expanded, the State College becoming a State University, the job of department head became a prize worth going for. Johnny had no stomach for campus politics. He spent much of his time riding around the nearby Nez Perce reservation, doing paintings and bronzes of the inhabitants.

Gradually he realized that he was under attack from his assistant department head. Rather than fight, he drank harder. One day he came home, went to his studio, sat there working on a portrait of a Nez Perce, his glass sitting on the ledge of the easel where it had sat every day for countless years.

Later his wife went in to call him to dinner. He was sitting before the easel, drink spilling from his hand, tipped slightly out of plumb in his chair, and he was quite dead of a coronary.

So died one of my best friends.

In the mid-seventies, some years after his death as reported by Havas, the phone in our barn at Shiloh Horse Farm rang. One of Sue's student riders answered. I was down at the other end of the barn, repairing an antique and failing water system. I heard the phone ring and looked up to see the girl hang it up and walk down to me.

"It was a call for you," she said. "I told him you were tied up fixing the waterline and he said he'd call back."

"Thanks. Did he leave his name?"

"Yes. He said to tell you Johnny Davis called!"

I stiffened and a cold wave surged down my back. In my whole life I had only one friend called Johnny Davis. His true name was John B. Davis, but he was never called anything but Johnny.

"He said to tell you Johnny Davis called!"

It was one of those things.

He never called back.

Betty Bowen

Thousands of words have been written about Betty Bowen, and they are for the most part flatulent, irrelevant, empty and meaningless. Except for one thing. They are a barometer of her impact on people in our region. They measure the difference she made in our lives. So viewed, they validate themselves as meaningful.

I met her around 1960, when I began to impinge on the consciousness of art lovers and such. Somebody brought her around to my studio and introduced us, and I didn't catch on to the fact that being introduced to her was a sort of manhood rite, a sign that I had been spotted on the radar and was being given an escort to bring me in.

Some escort! She was the most abrasive person I met in my life and I loved her. Since it didn't occur to me at the time of our meeting that she was there to help and support me, to introduce me to people, and to wake people up to the fact of my art, it didn't occur to me to hold her in the sort of self-serving gratitude reserved for those who we hope to use. So I simply responded to her as to an annoying boon bestowed absentmindedly by an incompetent god in a moment of benign carelessness. In short, I looked on her as a friend.

In any case she was a friend who made things happen, and I

would be hard-pressed to even guess at how many people heard of my work initially from her and were brought around to meet me and to buy something out of the studio and to sit and talk and drink a little something and share a few kind and not-so-kind words.

Somewhere along the line she brought Joanna Eckstein over, and when Betty and Joanna and Roxanne and I were seated in a coy circle with the shadow of the Freeway Bridge looming through the studio windows it would be hard to say who was the most abrasive, so expert were each of us at exacerbating nerves. The result of putting the four of us together was the inevitable. Instead of a grand tour of abrasiveness, all that happened was a milkbath of soporific sweetness. The jumble of four abrasives cancelled out into slickly smooth converse.

Most of the time it went differently. Betty early on picked up the annoying habit of bounding into my studio and loudly greeting me with the ritual salute, "Well dear, are you still married to the same girl or have you thrown her out?" a myth she assiduously cultivated all over town. The fact that like everyone's my marriages had beginnings, middles and ends, became one of the favorite items of after-dinner conversation among the cultivated, the cultured and the elite. And, in spite of my own knowledge of my innocence, I winced each time she whacked me with it.

Around 1968 she inveigled me into writing a short memoir of the Federal Art Project period for the Junior League monthly, *Puget Soundings.* It duly appeared and caused a run on the magazine, meshing neatly into the complex conspiracy in which she was engaged, which was no less than to maneuver me into a spot where I would be forced to write a book on the subject. Sometime in 1964 I found myself seated in a Mexican restaurant with Roxanne, Betty and Don Ellegood, chief editor of the University of Washington Press. He had read the memoir and was impressed, and before the last margarita had been tossed off, I had agreed to write the book, agreed on its general content and been assured that we would have a best seller.

Time passed.

No book appeared.

I became increasingly reluctant to share my memories, became even more reluctant to even admit that I possessed memories. Worse yet, I found as time passed that I couldn't remember what my memories were.

On top of which, I had to admit that I hate to write.

So a tedious parlor-game ensued. Don or Betty or some innocent bystander would meet me, greet me, and eventually ask, "How is the book coming?" to be met with a blank stare, a muttered imprecation and eventual defiant silence.

Numerous stratagems developed. The most common was to provide me with a tape recorder. Roxanne came home from Frederick and Nelson one evening with an immense recorder, the kind that takes tapes about eight inches across. I was invited to sit down with it and breath on it with memory. I sat down with it and became mute, bereft of memory.

Eventually it was used to record a lengthy interview between Tom Robbins and me which was notable mainly for the fact that we were stoned into total oblivion, the interview eventually melded by Tom into print as a rather incoherent, somewhat dull exchange of density.

Later Sue provided me with minirecorders, which actually did churn up a bit of memory that found its way into typescript. But no decisive change. The book was still over the next rise.

At times, when I became enraged with some enemy, I would vow to write the book for the sole purpose of pillorying the miscreant. And this failed because I am not capable of using my creative gifts for hostility, which I have tended to save for private conversation under the odd illusion that it is sort of neat, endowing me with a toughness that is really just an act totally out of register with my self.

The most aggravating of suggestions was the frequent volunteering of ghost writers to "help" me, arousing my annoyance in the extreme. The thought that someone else should write my book was too horrendous to contemplate, and I replied to one offer of assistance, "If only I can *not* write my book, then it's obvious that only I can write it!"

Time continued to create the illusion of passing, or perhaps I should say that people continued to create the illusion of time passing. Sue and I moved to the Pine Lake Plateau and went through the experience of Shiloh Horse Farm, bought four acres in Upper Preston, built a log house, moved there in 1980 and began a new life in a mountain valley, shadowed by Tiger Mountain, serenaded by the Raging River. One day in May of 1982 I said to her as she prepared to leave with my daughter Karen for a three-day horse show, "I'm just going to sit down and write that damned book, just like that from beginning to end!"

She simply said, "Hmmm?"

After all, she'd heard it before.

Once she simply responded to my threat to write the book as a giant indictment of various enemies conjured up by my imagination by saying, "You're never going to write that book, so why don't you just forget it?"

Stung, I nursed invisible wounds silently.

Now I just laughed and said, "Well, when you get back it will be on its way."

We kissed goodbye and she took off and came back late Sunday night after her kids had murdered the opposition and won all the silver and the pretty blue ribbons. She got up late Monday morning to the sound of the typewriter. When she came down she found that I'd finished three or four chapters.

In six weeks I had written the first 80,000 words. At that point I forgot it for awhile.

I felt good about getting so far.

But the good feeling was a little out of sync.

In the shuffle of moving away from town and getting involved in the farm I had lost much touch with the world of Seattle. People lived, moved away, moved back, went through the motions of life, and when all else failed, died. Often without my knowledge.

Sometime along there I heard that Betty had suffered a stroke.

Sometime along there I heard that she was dead.

I can't recall the relationship between the news of her death and the progress of the book.

Time doesn't really exist except as a relationship.

I do know she never saw the book she brought into being.

She was an audience of one, who conceived the book, bruised me into gestating it, harassed me, suffered my bad-tempered growls, put together the publisher and the writer, made it possible for it to happen.

That audience never got to see it happen.

Betty Bowen was my friend. She rasped my nerves to insanity with her sandpapered aura of abrasive japery. She talked brightly of art, of Mark and Morris, of people. She sang like a sparrow. She danced soft-shoe across the stages of mist and clouded pale sunshine.

And she never let on who she was.

A farm girl out of the Skagit, a flack and a publicist, a lover of something vaguely called "art," a constant chatterer, a bright and witty and volatile child.

Like many of us she danced to a different drummer.

But who was her drummer? What was the rhythm that moved her feet into the intricate and asymmetrical steps that kept her moving swiftly, always a few paces ahead? You followed after, hearing her voice from somewhere up ahead, trumpeting discovery of a rare bird nest, shrilling advent of some apocalyptic view.

She shared everything except her self, which sat on a shelf in plain view, obscured in intricate wrappings of silver and gold paper, stickers with strange devices, badges and buttons, ribbons and lace and autographs of clouds scrawled hastily in the midst of squalls and rain flurries.

Walks now perhaps the pastures of Gilkey's Skagit where she spent her girlhood, where the matrix was formed for the woman she became.

Walks now in her old firm step, prints left neatly behind in the soft loam, girl eyes fixed on the undulant mountains to the east, close-packed under soggy clouds, hands fiddling in jacket pockets softly jingling change.

And it was when? Sometime gone away, she walks dream into a past that only exists because we create it, will it to be out of noth-

ing, put it together out of Indian artifacts, road maps and Dick's dour paintings.

It is in past and it is in dream, and if we want to know what she was really like, that's where we have to go to see her.

The Artist

The Artist

In 1921 or 1922 or 1923 my family lives in Portland on an unpaved street near Foster Road. Every three or four days a horse-drawn ice wagon rolls down the street to pull up in front of our house, the houses across the street, all the houses in the block. Driver clumps clumsily down, walks to horse's head, fastens a leather thong to its halter, opposite end fastened to iron weight which is dropped to pavement. Horse thus secured, cold-blood descendant of arctic bog-ponies, innocent of desire to curvet and stomp, having received no hot blood of Arab. Iceman ties canvas bag of oats over coarse-contoured muzzle, horse in dappled stolidity munches slackly, gelid eye fastened moist two thousand twenty miles away on glacial icefield across which moves herd of blocky ponies, coarse-maned, brush-tailed, slack underlips flapping in nervous apprehension.

Iceman walks to rear of wagon, pushes aside heavy canvas curtain, pulls impatiently at icy monolith out of which he hacks and chips smaller blocks, individually hoisting them onto his back, cubes gripped in metal tongs, shoulder protected from melting ice by leather shoulder apron, size of cubes dictated after quick smirk at cardboard rectangle stuck in housewife's front window, red 50 or blue 25, ritual by which happy housewives assure continuity of cool moist air in zinc-lined walnut iceboxes standing ubiquitous in each kitchen.

Cube hoisted to shoulder, he turns his ill-shaven face toward our house, mutters rough affection into my upturned stare, thrusts sliver of ice into my hand, stumbles over the curb with stuttered and casual curse as he retrieves his threatened balance and totters up the walk and around the house, ducking beneath the clutching arms of wisteria at the end of the porch, lurches up the back steps breathing hoarse alcoholic breath onto the warm air of summer, slides sudden into the dark maw of kitchen, hidden now to my blinken eyes.

Moments later hear the sound of icebox lid raised, clatter and crack of frozen cube dropping into box and lid slapping sharply back into place with zish of extruded air.

On reverse side of block in a brown house covered with shingles lives my friend Joseph with his brother Melvin and his parents. His parents are grownups and are invisible. Joseph is four, red-haired, freckled, quick-moving and electric. Melvin is two, squat, rounded at all protrusive points, round apple cheeks, round button-nose, round ball of chin, a prototypical Campbell's Soup Kid. Over his sweat-tousled head hovers the Dark Angel who interrupts our play occasionally with sardonic chuckle as he reads from a galactic duty-roster which reveals that Melvin, apple cheeks and all, will be neatly stitched by machine gun bullets or blown by bomb blast loose from his various terminal limbs on December 7, 1941. We pay no attention to the Angel since we do not speak his language.

Having watched iceman's descent from our kitchen, careless repartee tossed back over his shoulder to my mother hovering in the screen door's translucent haze, his elliptical circumvent around side of house and back out to ice wagon, losing interest in his rhetorical dance even as sound of horse's hooves clock off into distance, I slide through the backyard fence of vertical boards into Joseph's yard, slipping a sideward glance at our landlord, Mr. Tomassini, as he grubs in his garden.

Joseph and I take up our play where we left off yesterday. Each day we repeat our ritual, crouching over our tin trucks as they haul endless loads of redundant pebbles over dried-mud hills shaded by roses bushes. Suddenly I look up, heart squeezing in apprehension. My eyes lock hastily over Joseph's shoulder onto the distant intersection. A shadow moves. I stare, brow knitted in frown. Into the intersection and out moves a woman.

I drop my truck, load spilling over cardboard-box town nestled in petty bourgeois comfort in the dirt.

I yelp, "Missy!" Missy is our Southernism for mother. I yelp more loudly, "MISSY!"

My mother is running away from me!

Stumbling over Joseph in panic, I run clumsily out of the yard and down the street, bellowing in rage.

Barely able now to see floating away on far peripheries of tear-clouded vision the image of Goddess as she floats, blows, skims away, hovers in sluggish breeze, drifts off into the muggy stupor of noon-seeking sun.

Joseph retrieves self from the dirt where I knocked him in my precipitate flight, fastidiously dusts off short woolen pants, adjusts petty officers' insignia on sailor-collared blouse, moves into hasty trot through the yards, stumbles awkward up our back steps, bursts into our kitchen to stand breathless, socks drooping over thin ankles.

My mother stands scrubbing noon vegetables in sink.

"Mrs. Cumming!" he lisps over his long-nibbed upper lip. "Billy's running away again!"

Cold squeeze of fear becomes pain as she drops scrub-brush, knocking over colander of potatoes which drop, some in sink, some on floor there to lie in bruised neglect as she wrenches off apron, speeds out door and down steps, pausing to snatch long switch from a bush at foot of steps.

Hurrying up hot concrete sidewalk she tries to blot out question, "Why does he run away?"

This son whose birth cost so much pain and terror, torn violently from womb, wrenched into world by head clamped in forceps, why does he reject her, why does he run away? She feels once more the paralyzing cramps fracturing her pelvic surety, feels the load of turgid child-flesh wedged into birth canal, stuck! blocking the conduits of life. Once more she stifles scream she needs to allow if she is to breathe freely, if she is to live, if she is not to die!

The unknown woman drifts goddess up the sun-drowned street, oblivious, and I after her, legs going soft and uncertain, steps turned to stumbled stutter, leaking animal cries of hopeless rage and fear.

After me, my mother, switch now raised to fall, and it falls! stinging pain across scrawny calves, small mouth expelling shriek of dismay as she wrenches me around so that in an instant the image of the unknown woman is ripped away, lost into nothingness and silence, and I never see her face.

This Mobius-filmstrip of dream fear and anxious despair re-

peats itself long after I have abandoned the sweat-pocked body of childhood, long after my mother has stepped out and away through the rotted cabbage-leaves of her lungs away from the strictures and unctions of life.

If not my mother, then who floats away from my gaze down summer streets of light and cast-shadow, light fractured, light fragmented, light scattered in prodigal glory, light leaking out of the sky to drip, run, and dribble over visioned landscape?

Under the lewd cling of silk dress and summer jacket what goddess moves her warm-fleshed thighs, hot maternal flesh congealing toward what assignation in the declining morning? Who did she pursue, who flee?

The years turn, the vision remains, programmed into the tension and release of my drawing hand. Terror is transmuted to irony and we are distanced from the sources of pain, it only visits us now because we re-create it over and over. Eventually I transform the sources into images and they become validation for my pencil or brush, become figures seen from behind as they disappear down sunny streets, body's gesture repeated and variationed in cast shadow so that one figure becomes two, body parents shadow, shadow choruses body.

And the faces are never seen.

The drama of my birth was bonded into the family mythology. Forever I would be the strange one, the wayward one, the marked child, lad touched by the finger of Faery, touched by the wee ones. Lad marked for greatness, marked for strangeness.

Of all this my grandfather was certain. It came with our blood.

* * *

During the long rainy season of Portland our unpaved street was more mudpuddle than street, and there we played all winter. With astonishing regularity I fell in. I rush into the house, wet and miserable, stand steaming in front of the Round Oak heater and

wail, "Joseph pushed me!" Investigation proves the falsity of my claim, which is made less out of slyness than desperation.

My mother is bearing my sister. Pregnancy renders her desperate. In our family a lie is the worst of crimes. Gentle, but never able to forget that this strange one damn near killed her at birth, she pronounces anathema. "One more lie and we cut your tongue out!"

Within twenty-four hours I fall in.

Without hesitation I bawl, "Joseph pushed me!"

My brother is sent to investigate. He returns smirking with self-righteousness.

"Jimmy!" says my mother. "Get the butcher knife!"

I am gone before God can blink an eye.

One of my brother's friends stands transfixed with amazement in the corridors of my memory, frozen with his lawn mower as I fly by bellowing with fear, my brother in hot and giggling pursuit, running me down, snatching me up in remorseful affection, nuzzling his face into my chest, carrying me home.

The memory shuts off abruptly as we enter the house.

What does my mother say?

What do I do?

What happens?

And my mother, glaring that night in the bedroom mirror . . . what does she see?

* * *

I have another friend down the street. Cadmus Van Vliet. Magical name. Does he grow up to sow dragon's teeth?

I stand behind him one day as he raises a hatchet to slay a dragon. His back swing is energetic but unwise. It cracks open my scalp. Blood pours into my startled eyes. His grandmother's hands, cool and soft, wash and bandage. She puts the therapeutic water in a gray enamel pan in which she keeps grain for her chickens, and I wonder if any of the loose grain has gotten into my scalp. Will I sprout wheat from my head?

Two weeks later Cadmus' grandmother descends from the

steps of the scarlet and gold streetcar, takes two soft steps toward the sidewalk and is run down by an amok Pierce-Arrow in the hands of a grease-sideburned gangster.

The wheat never sprouts, but I do remember her soft touch. And I remember my friend's name, how it reverberates with ancient glory.

* * *

My Grandfather Cumming is tall and dour, descendant of Covenanters. He works as a janitor in a small Presbyterian church, lives with us. I am the apple of his eye. He walks to work and back with my small hand clasped in his big one.

In 1923 he visits my Aunt Anna in Seattle. It's spring. She lives across from Madison Park, near the studio where I write this. He dies there. Five years later I visit her and stand in that street one afternoon with a friend and a red roadster will whip down Madison and up the hill, a blonde with streaming hair and a streaming silk scarf at the wheel throwing a lewd exciting kiss to two small boys. I remember the roadster and the blonde girl and the fact that it was outside the apartment where my grandfather died in the spring of 1923.

My mother tells me that my grandfather won't be coming back. He's passed away. I asked about his death. My grandfather has talked of this one and that one in Nova Scotia where he was a lad ". . . and he died!" ". . . and she died!" Sitting in my high chair one night I join in the refrain, waving my silver spoon as a baton, and my grandfather laughs. He has planted the mystery of death in my imagination.

* * *

My Grandmother Edmiston was born in Cairo, Illinois, across the big river from Kentucky. Her people were Aikens, Mackays, Edmistons. They staggered through the Gap with old Boone, settled and fought on the bloody ground of the Kentuck, owned slaves

to add a hand here and there, eventually slipped stealthily west across the tip of Illinois to old Missouri, where the war found them. Jayhawk militia burnt my great-grandmother out when they found my great-grandfather not at home since he was off fighting with Earl van Dorn or the hooligan Quantrill or perhaps prodding gently upwards borne on the roots of black-eyed susans in the peach orchard near Shiloh Church.

My gramma was a little lady with a soft Kentucky lisp, different from the alien twang of Mississippi and the Deep South, a gray-haired smile wafting over long skirts and high-button shoes, a pair of thin horn-rimmed glasses peering smilingly into your blue eyes, her own smiling eyes, now cataracted, having gazed as a small girl at the sight of Yankee louts looting, firing the house of her childhood and the barns and outhouses, driving off our blooded horses to be straddled by fat-assed Kansas hayseeds masquerading as cavalrymen, liberating the two or three slaves to wander the roads of want together with the women of the family, who loved their land and hated slavery, as did many Southern women.

This dear soul becomes one of the great loves of my life, dying one day in 1929 while I am in school. Tessie Henke intercepts me before I can get home and feeds me milk and cookies while she comforts me.

Much earlier, when we had just come to Portland from Denver, I sit on our white wicker clothes hamper. I am about two. I scream incesssantly. My mother hovers nervously with a pair of toenail scissors. I don't want her to cut my nails. I want my grandmother, who isn't there.

* * *

In the summer of 1924 my grandmother and I visit my Uncle John and Aunt Florence in Gold Hill near Medford in the valley of the Rogue River. Aunt Florence is a frustrated novelist given to wild exaggeration. My cousin Jim will be a writer. Cousin Mary will become a welder. Cousin Helen will sport forever a lithe catlike body, will play Portia at Ashland and will inspire in me an incestuous erection whenever I think of her body.

We hunt rattlers in the crick-bottoms, dig up arrowheads, pick pears during season. I have to undergo crude knifeblade surgery to remove two blood-gorged ticks from my scalp before they burrow through my skull and destroy my brain. I trudge barefoot through the thick powder of hot dust in the roads, squinching my toes. We ride endless miles down tree-arched roads and trails, backs taut with expectation of cougar dropping sudden from trees. We swim in the Rogue.

On July Fourth we go into Medford for a parade. The National Guard marches, legs wrapped in puttees, rifles sloped. I sit goggle-eyed and open-mouthed. One boy sees my rapt face, unslings his rifle and reaches it out to me in mock offering.

* * *

When my grandmother and I leave Gold Hill at summer's end we don't return to Portland. We go on through to Seattle, where my father isn't present due to faulty communication, and my grandmother leads me hollering through the lobby of the New Richmond Hotel in charge of a bellboy who smilingly soothes me before he leaves us in our room and vanishes forever.

* * *

We live now in Tukwila, fifteen miles south of Seattle. It is strictly country. The Duwamish Valley is a patchwork of farms which will magically turn into warehouses and blacktop in the postwar.

My mother has a friend, who is an unofficial aunt to us kids. She works in Washington, D.C. I collect stamps and as she works in a bureau with overseas correspondence she sends me stamps and we begin a correspondence. At seven I have chosen art. She buys me a correspondence course in the old International Correspondence Schools. I learn one thing, to draw the naked human body. Through my textbooks I discover names. I discover Mucha, Art Nouveau master of poster.

I never get beyond *Drawing the Human Figure* in the course, and that is all I need. I sit here now in confusion and chagrin, unable to recall her name. Women have been what my life was about, and this woman who played such a germinal role in my life remains nameless, and there is no one left who can recall her name. Like the mysterious woman fleeing from me down the sunlit street in Portland, she will never reveal her face.

* * *

Across the street from us lives an old scene-painter and decorator. His name is Tommy Schure. He paints laborious copies of old masters. He loves art above everything. I spend hours in the evenings, listening to his stories of working on ceiling decorations of great theaters, listening to his advice, his memories. A few years later, after I have discovered modern painting, I return home on a visit. We live further away. I think of walking over to visit him. He's really old. He's been unwell. I realize that I've gone far beyond the naive primitivism of his ideas. I don't visit him. It's too far. Soon it's too late, and shame dribbles through my brain.

* * *

I learn art history at the Seattle Public Library. In the late 20s and early 30s I labor on the lawn of an ancient pair of public stenographers in return for a weekly trip to town.

Mr. Green was thin, diffident, wore pince-nez with a long black ribbon disappearing into a vest pocket where it attached to a gold watch. Under his pale blue eyes drooped edematous pouches in multiple folds to the corners of his close-cropped moustache. His hands were heavily-veined, the fingers terminating in square blunt nails. At times his hands quavered slightly.

Mrs. Green looked like a grandmother, except she had no children, hence no grandchildren. Small, frail, energetic, she addressed her husband as "Mister Green," sat silent in the shotgun seat

wrapped in heavy swaddlings of vintage clothing, her collar wrapped around her ears. She greeted me when we met without seeming to see me.

Mr. Green drove sitting bolt upright, clutching the wheel, glaring myopically at the traffic threatening disaster on all sides, as he charged through gaps in the stream of cars and trucks, depositing us eventually, breathless, at the foot of Madison Street.

As he drove off to park, Mrs. Green would frostily admonish me to be in front of the Lowman Building, where they maintained their office, at precisely 5:30 P.M. And at precisely 5:30 I would be there, my arms full of opera scores, books of poetry, novels, biographies, histories, books on paintings, histories of art. At approximately 5:32, the pair would march through the gold and glass doors of the Lowman Building and we would silently ascend into the great chariot, a 1923 Dodge. Mr. Green would sniff, adjust his pince-nez and we would roll provocatively out into the stream of First Avenue traffic, nosing our way onward to the south, over the Duwamish Bridge and past the truck farms of the Italians and Japanese at Riverton, past Baker's kitchen under Quarry Hill, Bakers the only family of color between Seattle and Renton until Mrs. Brown moved in on the flats at Tukwila, past the Foster Golf Links and turning at the Tukwila Grocery and Post Office to labor up the hill, dropping me at our house. After another quarter-mile, they turned in at their Victorian house set in the middle of a vast flat lawn cropped to brilliant evenness by my grudging labor.

Car parked in the garage, the two marched primly up the steps to the high porch and disappeared into the shadows. Dim lights at night signed that the Greens were home. No music ever issued, no sound of radio or victrola. Life dissolved into the gray anonymity of work. Life itself to all intents and purposes was produced without effort, passion or stress. I watched them, struck by the colorless poignancy of their lives. Their faces never betrayed signs of whatever emotion had led them to splice themselves together. Their hands never touched, they addressed each other as "Mister Green" and "Missus Green." In all the years of our weekly trips to town we didn't exchange the makings of a single evening's conversation. I

watched them, and sometimes I found myself caught up in a great depth of sadness, an inchoate rage that ended with a frustrated shake of my head. Like a wild animal.

* * *

I wrote a fan letter to Stuart Morris, head of the *Times'* art department. He replied and invited me in to see his domain. We became friends. He gave me an original editorial cartoon, which was my treasure for a few years until I realized it wasn't that important and lost it with casual ingratitude. His daughter married Stefan Balogh, head of the Cornish Music Department. In later years Stuart became confused and tended to wander. A friend described a visit from Stuart and his daughter. "Daddy, it's time to go," Patty said to him. Smiling, Stuart reached for his hat and placed it on his head. Except that what he placed on his head was his teacup. He had long forgotten giving me a drawing and he never knew that I eventually lost it, unthinking and uncaring.

Stuart gave me a letter of introduction to George Hager at the Strang and Prosser Advertising Agency in the Smith Tower. George did tidy pen-and-ink illustrations for the light company, and also did a cartoon strip "Waddles The Duck" in the *Christian Science Monitor*. He played cello in an amateur string quartet, which also included Billy Bobbit, who occupied the desk next to George's at the agency.

He introduced me to Debussy. I did a piano transcription of the Debussy quartet. I sometimes sight-read piano parts with his quartet. He loved Renoir. He took me to countless lunches. He shared his frustrated dreams with me, how he had always wanted to be a painter, how he had studied with Robert Henri in New York.

After I made new friends I saw him less. He was too slow and I was moving rapidly. He died of a heart attack without my knowing. When I learned, I felt again that twinge of shame. How easily I shed friendships as I moved on toward my own destiny.

* * *

In 1937 I met Morris, and through him was bonded into the circle of friends who were to nurture me and support me out of childhood. Behind me I left friends like George and Stuart and Tommy Schure and my nameless benefactor who bought me the correspondence course. And my family who I visited increasingly rarely. I was on the way to fame, and I was scarcely conscious of the friends who were dropping behind into the dark waters of Forget.

Sometime in 1935 I made an appointment to talk with Nellie Cornish in hopes of receiving some kind of scholarship to study. I walked from the bus terminal with a large portfolio of work, including sketchbooks of figures drawn in action. Miss Nellie sat benign behind her desk, sunlight dribbling gouts of golden treacle over her hair and bosom. She leafed through my drawings abstractly, uttering vague commentary in a honeyed monotone. On the floor lay her dog, an overweight terrier of varied color. The dog uttered a continual counterpoint of ominous growls and complaints behind our vague piffle. To the dog's growls Miss Nellie replied with ambiguous reproofs.

When she at last finished with my portfolio, she sat, a vacant smile on her round face. Our conversation reduced itself to, "What did you have in mind?" to which I replied, "Oh, I just thought maybe you . . . ?" eliciting from her a distressed, "Oh dear! I just don't know if we . . . !" on which I rose, thanked her absently, walked to the door, stumbling over the dog as it escorted me, and set off on my return to the bus depot. She remained sitting like an oversize Raggedy Ann doll, scrutinizing her appointment book to discover what other arcane ceremonies dotted her day. The dog slumped to the floor to dream.

Nothing came of it. I was happy. Ideas for new drawings circled my head. I was safe from the danger of getting a scholarship to Cornish, which would have faced me with all sorts of problems, chief of which would be to become a student. I was not burdened with the humility appropriate to studenthood. I would never be burdened with any sort of humility. I would not go to Cornish or to any other school except for an abortive attempt at becoming a commercially usable commodity at Burnley some years later.

It's tempting to speculate on what might have been if I had gone to Cornish or to the University School of Art or to Chicago Art Institute. But I didn't. And I never really wanted to. I had been programmed by the wee dark people to go my own way, and that was the way I went.

* * *

Two years later I met Morris and Kenneth and Margaret and Lubin and Guy and Mark. They treated my adolescent efforts with kindly solicitude, overlooking my smalltown romanticism with its grotesque excesses and its garish color. For a time they overlooked my obvious derivations from French modernism.

They praised extravagantly my drawing, in which they saw the roots of my borning style. Margaret particularly loved my sketchbooks, marveling at the facility with which I transcribed bodies in the midst of movement. These pages fascinated her, and she finally in exasperation kicked over my silly plagiarisms of Pascin and Modigliani and practically ordered me to focus my vision on my sketchbooks, where I was busily inventing a race of human beings uniquely and energetically gestured.

Years earlier, when I was about twelve, I had read the polemics of Delacroix against the sterile classicism of Ingres. The followers of Ingres hooted at Delacroix's nervous and incisive multiple lines by which he sought to capture the shifting contours of animals and humans in rapid movement. Delacroix, friend of Chopin and George Sand, regarded Ingres with distaste.

Delacroix, the leonine pleb.

Ingres, the icy bourgeois.

I didn't think twice. I regarded as revelation Delacroix's statement, "If you can't draw a man falling from a fifth-story window before he hits the pavement, you'll never be an artist!" When I was nine and ten, I had spent tedious hours with charcoal, stomps and tortillons, sitting in front of plaster casts furnished by the Correspondence School, sanding, rubbing, toning, lifting out with kneaded rubber, and I hated it. Here was Delacroix, whose paint-

ings reverberated with sonorous power, damning to hell the very fountainhead of classical academic drawing. Out of Delacroix's nervous dynamism I would forge a kinetic style of drawing, which would oddly eschew Delacroix's nervous multiple lines for a self-confident single contour which owed less to any of the French masters than to the incorrigible Japanese master, Hokusai.

Movement, the human body in movement, fascinated me. In my drawings I would achieve the athleticism which on the football field and basketball court escaped me.

I sat on the bench while my classmates won their letters, and in the pages of my sketchbooks the daring young men flung themselves blindly at darting runners, lumbered heavily over prostrate bodies guarding a goal line, stretched desperately for the elusive rebound. Today the daring young men are scattered, daring other challenges, flinging themselves through other air, some nailed to wheelchairs, some lying recumbent under spring grass. And in my old sketchbooks, wherever they are, they still tumble and roll.

Misunderstanding the advice of Auguste Rodin, who advised picking poses out of a sequence of moving gestures rather than making up isolated poses, I undertook to draw sequences of moving gestures while the movement was still in progress. Naked models were rare in Tukwila, but there were always people moving, and my books were soon filled with athletes, children, workers, old people, all in the continuity of gesture out of which their lives were defined.

* * *

One day I brought home from the library a biography of James McNeill Whistler by Joseph and Josephine Pennell. Heady wine! I was intoxicated not only by Whistler's delicate nuances of color, but by his aggressive cockiness. Today few remember that it was Whistler, a painter with a talent for polemical scribbling, who fought the first great battles for an art which invents and creates its own reason for being, independent of the silly illusions of institutions, political or religious or social.

More important to my drawing was the occasion of being in-

troduced through Whistler to the Japanese woodblock masters, to the ukiyo-e prints of Hokusai, Utamaro and Sharaku. The Floating World (Ukiyo-e) was exactly the world I was drawing, world of illusion, world of gesture and transience, world that vanishes as it appears.

Even more important was the essential lesson of Japanese art to the industrial West. Forget the illusion of deep space! Abandon the intoxication of centrolinear perspective! Honor the working surface and its two dimensions, by disturbing it as little as possible. This was the main lesson taught French painters by the Japanese prints which infiltrated Paris in the middle years of the nineteenth century, and ever since the appearance of Manet it has been the major influence in the painting of Europe and America.

After seeing Hokusai, no painter of integrity has been able to abide in the temples of Renaissance space-projection.

* * *

In 1936 I met Eustace Ziegler, whose heavily-impastoed oils of mountains, fishing boats, Indian villages and pack trains had earned him a lucrative audience. Although he worked within the tradition of pictorialism, Zieg was a key figure in bringing to the Northwest a real sense of sophistication in use of paint, being rather a parallel to Tobey in that they both introduced us to high standards of craft, one as traditionalist, one as iconoclast.

I remember vividly my first visit to his studio in the White-Henry-Stuart Building. I went there on his invitation, having been introduced to him by Herbert Malloy, a well-known teacher of piano who happened as well to be a patron of painting. In a large studio-room a model dressed in Indian robes occupied the stand, while fifteen to twenty students drew and painted. Within a few minutes Zieg called a coffee break and the model got down, walked over to a chair and sat down, never letting on to me that his name was Guy Anderson, that he would become my friend, and that he and I would share with each other, as well as with Jim Fitzgerald, an admiration of Zieg's painting regardless of its traditional cast.

Zieg called me to bring my work over to the model stand, where he had seated himself, while his top student Chuck Stanford and other students stood by. Zieg poured through my work, admiring my figure studies, dropping noncommittal remarks about my Parisian-inspired attempts at painting. Then he opened my sketchbooks, turning over the pages with sharpening interest as page after page of moving figures stumbled in front of his gaze. Athletes in action, athletes resting, children playing, walkers, runners, jumpers, stumblers, staggerers, lying-downers, sitters, standers, fallers, rollers. Zieg was accustomed to wasting little rhetoric on young artists. Halfway through the book, studying some pages of football sketches, he glanced up, a suspicious glint in his cold blue eye, and rasped at me, "Boy! tell me the truth! Did you do these drawings?"

Chaos and confusion, touched with dismay! How bad must they be to draw forth such a glare! Worse, did they resemble some artist unknown to me to the point of throwing a suspicion of plagiarism on me?

All I could do was tell the truth.

"Yes," I stammered.

Definitive, definite and defiant, albeit delivered in a voice rendered obscure by the threat of fainting from chagrin.

"Yes! I did 'em!"

Long hum of contemplation, pages turning, little sounds of wind sucked through teeth. I glanced at Chuck and a tall pretty girl lounging beside him, his fiancee it turned out. No help there. To them I was just a homeless wanderer off the streets, a ne'er-do-well. Go home Enoch Arden, back to your wife and bairns, take your rotten drawings and your beardless chin back to the heath that bred you and quit pretending you're an artist!

At this juncture Zieg's tight little face broke into a bemused smile and he spit out, "These are damned good! Where'd you learn to do this? At home! All by yourself!" Disbelieving. "Nobody taught you? I'll be damned! Well boy, keep it up!" And he bundled them all together, jammed them into my arms, called back the model and got the class moving. Feeling dismissed, I pulled my

forces together, tottered to the door without a visible goodbye and fell straight down fifteen stories, cushioned by the fact that I was in the elevator.

<p style="text-align:center">* * *</p>

I graduated from Foster High School in June 1934, around the time that Morris had emerged into prominence as a young painter.

Without prospect of a job, lacking money for college or the daring to join the thousands riding the rods, I stayed at home. Painting, drawing, reading, listening to music, plucking at blemishes in front of the bathroom mirror, reading the French decadent poets and spawning vivid dreams of a studio in Paris with a skylight and a mistress, somehow blushing in scarlet confusion when confronted with a living nubile female.

In late 1934 I won a scholarship to a soon-sunk art school in town, the Northwest Academy of Art in the Textile Tower, where I studied little beyond figure drawing, that being taught by Ernest Norling, who paid little attention to teaching me since I already drew the figure with more authority than he did. I worked as a kitchen drudge in a boarding house in Wallingford in order to be able to live and study in town. The house was owned by a bent and weary employee of the business office of the *Times,* a graying man who sold advertising space, who one night reminisced for me about his youth, how he once traveled by train down the coast regaled by stories told by a chance companion, how in later years he realized that his companion was Ambrose Bierce.

By early 1935 I left school and returned home to live, taking out the remainder of my scholarship in weekly life-drawing sessions. The city fascinated me and depressed me. On the occasion of my first life-class in September 1934, my first-ever opportunity to draw from the nude, the model, a thin, pale girl, collapsed from hunger after five minutes. Not much later I returned to a weekend at home to find my brother dying.

By 1936 I was doing artwork for my high school under the auspices of the National Youth Administration, mostly signs and

1 7th + Olive Bldg, with "El Gaucho" Restaurant, an Art Deco building

drawings for the school paper, cut with a stylus into the oleaginous blue film of mimeograph stencils. A few months later I transferred into the NYA Photographic Project in town.

Meantime, my friend George Hager introduced me to Lancaster Pollard, publisher and editor of the *Town Crier,* who asked me to write art and music reviews. Payment was the sensual pleasure of seeing my adolescent yawps in print. And one of these reviews, taking up the cudgels for Morris and Ken and Guy, introduced my name to my future friends some while before we met.

And so, in 1937 we met.

And the years from 1937 to 1942 seem almost to be my life, even though they are only four short years. So much of the rest, if not all of it, seems an echo or a spinoff of that time, those friendships, those feelings, and ideas and impulses.

None of us knows for sure just what happened, what it was or what it meant. The authorities and experts try to tell us what it meant, and what I get from all that is simply that the attempt to impart meaning to truth merely demeans, literally de-means, truth. So I'm unimpressed by talk about the Northwest School or the Northwest idiom. And I acknowledge that something began more or less in that slice of time between 1930 and the midforties within that space known as the Northwest.

It didn't last very long and it was gone before someone named it.

But it did exist, whatever it was.

* * *

So I met Morris and I got on the Art Project.

I exhibited in the Northwest Annual, and in 1939 or thereabouts won the watercolor prize for a large tempera. That same year Mark won the big prize, and Hilda Deutsch won in sculpture. Controversy broke out, and it became the year of the big But Is It Art? hassle, that being the headline over an article by Doug Welch in the *PI.* We were the avant-garde, but what we looked like is hard to say. Certainly not like a school.

I resembled certain stylistic segments of the others in my dull color, my use of tempera and my reliance on draftsmanship. Their alleged mysticism touched me not, nor does it today. From the beginning my work has faced to the material world. How I have held that world in my private life has shifted back and forth, as if I was having trouble focusing. But the object in my painting has always been recognizable as a surrogate of an object in the world outside me. Which has resulted in being called a realist, a silly term. Almost as silly as abstractionist.

My color has changed radically.

I started with my focus firmly set on the value spectrum, the range of dark to light. This made my painting relatively colorless.

At the same time I was passionately aware of the ambience of Northwest color, how the moist air creates a field of grayed color in which pure colors are allowed to shine out brilliantly. What I didn't know was how to paint this effect. I refused to turn to study in a school or in someone's class. I did it my way, and eventually I worked it out by mortising pure color with activating colors (generally called complementaries) to sour the color. Today my color excites me.

My color is radically different from the rest of the Circle, and it represents to me my response to the region. And it reflects as well my delight in film color (what Tom Robbins calls the technicolor effect in my painting), particularly in the abstract orchestration of color in porn films where the great amount of rampant human flesh works miracles of nuance, transition and juxtaposition in color as well as anatomy.

My drawing is programmed into an effortless glissade and bears no resemblance to good drawing, governed by the academic sense. That form of drawing called objective drawing, governed by standards of realism or photographic realism, represents for me the furthest extreme of abstraction away from direct comprehension of reality. It is a triumph of skill, which has little or nothing to do with creation.

The space between alleged objects is the space which defines or creates the objects. Miscalled negative space, it is the space of rela-

tionship, whether in a painting or in people's lives. That is where living shows up, and that is the decisive space in my paintings. It is often defined with a colored aura.

The auras serve so many functions that there is no use in talking about them. I put them there because I put them there.

The subject of my paintings is paint. The object is the figure and the space between figures.

I am a good painter, and I wish that I could have a private showing sometime for my brother, for Margaret, for all the ones who went away.

How I paint is related directly to two other things in my life, my teaching and my journey into politics. The journey into politics was a masterpiece of slapstick, and it threw me into contact with many people from whom I learned a great deal, little of it pertaining to politics. It spanned roughly from 1937 to 1944, a period in which I existed naively sympathizing with the suffering masses, and from 1944 to 1959, in which I was an activist.

A news item from Paris announced that the writer Louise Bryant, widow of John Reed, had died. Wherever bohemians gathered it stirred memories. Not long after, I read Jack Reed's *Ten Days That Shook the World*. It put the banner into my hand. It shook up my life. I became aware of the world outside the parameters of art.

And it created for me a concept of revolutionary change, of transformation of the world. This concept was unfortunately nearly twenty years out of focus. Like a child born with a fatal disease, the Russian Revolution had already staggered down from its first days to its ultimate end.

Eyes fixed happily on the past I lolloped along in the grandeur of phrase-mongering nincompoop. I became for a short time a full-time functionary of the party, which meant that I collected dues and tried to raise funds, or gave half-hearted support to the election of liberal politicals, usually New Deal Democrats.

I was married to an activist. Eventually we had three children. My health collapsed regularly, usually in a welter of pulmonary blood. I slid further into nightmare. My painting stood still. I so-

laced myself by becoming a Trotsky-baiter, harrying anyone who displayed Trotskyist tendencies or connections. At odd moments I realized that my anti-Trotskyism was an act to hide from myself my fear that I was a congenital Trotskyist-type.

In 1952 I awoke one morning from a real nightmare, in which I got that Trotsky's charges were true, the Stalinists had murdered the revolution, had destroyed what there was of transformation and humanity in the upheaval of October 1917. I had to get out. I staggered down the stairs and sat there in the early light, while my family slept. I fiddled with the radio, craving music. I got special news reports. North Korean troops were flooding over the 39th Parallel.

War had come.

Repression would follow. There would be no easy way out. The only way out would be to cooperate with the architects of McCarthyism, and that was impossible. So I would have to stand like the Spartans at Thermopylae, stand and die if necessary for a cause not my own.

So I did.

Repression brought a new name to prominence, Joe McCarthy. The alcoholic, semiliterate senator from an obscure Midwestern state would drive thousands from their jobs, send some to death, and whip the American people into obscene silence in the face of a saturnalia of ignorance and brutality.

For six years I was blacklisted. For six years I lived with the possibility of a prison sentence for violating the Smith Act. For six years I stood firm in a cause for which I felt no love, in which I increasingly saw another form of earth-is-flat idiocy, in which I saw only naive rank-and-filers like myself misrepresented and used by shallow, self-serving ward-heelers, self-styled leaders of the proletariat.

Finally I jumped the fence, put in two years with the Trotskyists to repay them for the many slanders I had spread about them, endured their piquant and tedious mixture of courage and dogmatism, and in the end said goodbye to them after I had paid off my debt to them.

In 1982 when Warren Beatty made *Reds* I had been gone from the pastures of ideological rhetoric for twenty-five years. The story of Jack Reed and Louise Bryant brought back the physical ebb and flow of the living reality on which ideological rhetoric simply placed a veneer.

In the thirties, Jack and Louise were better known as artists and bohemians than politicals. The reality of their love was real to every insurgent poet, novelist and painter, how Jack died of cholera in the early years of the Revolution, how Louise died eventually of Jack's death. How they struggled like confused children against their love, how they loved in the middle of a vast cataclysm of millions of humans battering hopelessly at the walls of despair.

Radicals of the thirties saw human destiny from the vantage point of the thirties. They saw mass starvation leading to gigantic upheavals of millions of people. They saw these upheavals answered by terrible repression, and in the first place by the naked terror of fascism. They sought answers, and generally found plausible answers for their time and place in the nostrums of radical parties.

Looking back, it's easy to see that we were locked into a set of circumstances called the Great Depression, from which we created a determinism in which economic factors became the base out of which options would grow.

The depression existed, fascism existed. It became a determining circumstance in which we were helpless to do anything except react. We were at the mercy of what happens to us.

The drama of lives like Jack Reed and Louise Bryant lies in their commitment to exceed the limits of the possible. They lived this commitment in their public lives and also in their private lives. Louise struggled for selfhood as a woman when she could have easily given herself over to indolent comfort as did millions of women. Jack put his life at risk in a cause larger than himself because a life not at risk isn't any kind of life at all. And they were simply individuals out of a whole generation, a generation of artists and writers who gave themselves the opportunity of enlarging the parameters of human possibility without consideration or reservation, aware that the transformation of the lives of millions hinged on the transforma-

tion of the lives of individuals. It was the loss of this self-awareness that eventually sapped the idealism and spirit of later generations of radicals.

For myself, radicalism meant a chance to bury my bohemian individuality, submerge myself in something oceanic. It allowed me to abandon myself as an artist, give up all my privileges, make myself a victim of forces too great to overcome or even comprehend, even to the constant ripping open of my body by cooperative bacilli, who when all else failed could be counted on to create crisis by eating holes in the pulmonary vessels so that I could spout great hemmorhagic blurtings of bright arterial blood, spurting blind defiance at Father and Mother, at God and Universe.

I had been bewitched by flesh, I had dozed through Mary Baker Eddy's renunciations of that flesh, sleepily protesting to myself, "Disease and Death may not be real but I sure hope that Sin is!" Turned caress of sun on bare flesh into something called art, woke at ten staring into mirror at blue eyes surrounded by freckles and realized, "I am an artist!".

Committed forever to draw, to paint, to commit to his materials the erotic energy of family, the demanding lust of Shiva, of Pan and Dionysus, the wee dark gods of Scots' earth.

And all of this put at risk by the cold Appollonian mind, by its demand that he be a good soldier in the cause of humanity, so that he literally threw away the years from the early forties to the late fifties.

Walking away from self-imposed exile in 1959, reclaiming all that he had put at risk, retrieving his genius for line, battering at the densities of color, rocketing through studios near Garfield, on upper Yesler, under University Bridge, nuzzling flesh that would shortly sprawl across sketchbooks, freedom informing his nubile hand in resilient contour, apocalyptic counterpoint of dark and light, beginner always reborning. *PAINTING CAREER*

And looking back at the years of the locust, wondering, "Why did I do that?" Knowing, I did it because I did it.

Remembering with affection the bodies, all the bodies, of the people he'd seen, flesh invented human by itself.

APPOLLO VS. DIONYSUS

Musing, "Bloom, bodies pregnant with living. Pump, blood, through vessels. Breathe, air, through ribwalled lungs. Love, flesh, through the fingers of sensing. Curse, voice, and praise your life and leave moping and glooming and lamentation and aging and dying to the worshippers of concensus and demos."

Getting it yet once more, I did it because I did it.

In 1957 I did a lot of things. I experienced what is called fortieth birthday. I broke with Stalinism and began my passage out of politics through Trotskyism. I committed myself to quit having hemorrhages and being sick and having to be whittled on. I decided that the only way I could make a living was by becoming a famous painter, so I did. Since I was already teaching a bit, I committed myself to teach a lot, and to make my classes something more than classes. So I did.

For the most part my teaching has been in what is shallowly called commercial art, largely at the Burnley School of Professional Art which has now been succeeded by the Art Institute of Seattle. The invidious distinction of commercial art and fine art is poppycock. There is only art. Every single human being is born containing an artist, and this being invents art for itself at around the age of three when, without any teaching or coaching or indoctrination, it invents shape, invents three-sided shapes and four-sided shapes and omni-sided shapes.

This being appears a few years later in an art school, having suffered at least twelve years of primitive superstition based on the idea that education is the imparting of knowledge by those who know best to masses of those who know least. They have also suffered indoctrination in the idea that art is divided between commercial art and fine art, that the first is vulgar and the second is creative.

At this point the job is to share with this being that he or she is now empowered to get back into contact with the artist they left behind when they were forcibly sat down in a schoolroom and told, "Sit there and don't chew gum!"

Creativity is a space created by the artist, regardless of the domain in which he works.

Fame is the spur, as Milton says. Fame is acknowledgement, and if you create without desire for acknowledgement you will create shit. Fame is the artist's right.

You have a right to make money out of art.

To make money out of art, you have to create art which someone wants to buy.

Very simple.

Don't ask, "What is art?" Ask, "Who am I?"

Don't adapt yourself to art. Adapt art to yourself.

Be here now. That is the power in what people call the Northwest School. What I call the Margaret Callahan Circle. Margaret empowered me to be here, be now, and create my art out of that power of being.

There are skills and knowledge that can be passed on in a teaching process. The essence can't be taught, it can only be shared. Sharing calls for a sensei, one-who-was-here-first, not one-who-knows-better. A sensei shares some things with their students, allows for them to share some things with him or her.

The sources of art do not lie in the domain of rational thought. The sources of art lie in the pelvic chakras, they come from the domain of Merlin's cave. From Merlin we learn that creation is causing-to-appear, a process not of work or explanation or analysis or thought but of evocation. To evoke something, you have to get it. So get it!

My painting is what it is because it is.

The most common question about my painting is, "Why aren't there any faces?" And my most common answer is, "Why aren't there any faces?"

Nothing is true, and everything is possible.

Folklore it is; definitive art tome it's not

**Sketchbook: A Memoir of the
1930s and the Northwest School**
By William Cumming
University of Washington Press
239 pages. $16.95

One of the remarkable things about Seattle's history is, curiously, its history books. There have been tomes, of course; some, like Roger Sales' *Seattle Past and Present*, have been well-written as well as scholarly.

But for the most part, scholars have not taught us about our past. We've learned our history through briefer accounts that touch gently on the sad facts, memorable eras and bizarre events.

Few cities can boast a book of the quality of Murray Morgan's *Skid Road*, which took us from the founding of Seattle on Alki Beach to rathouses and Hoovervilles, the great general strike and the World's Fair. A few years ago Emmett Watson's episodic and nostalgic *Digressions of a Native Son* told us about a lot of wonderful people and a lot of absurdity that came along after publication of *Skid Road* — Jack Hurley, Leo Lassen and Garfield High School, to name a few.

Still, there is a period in Seattle's past that even Morgan and Watson overlooked. It's the '30s, when a fantastic group of artists — Mark Tobey, Morris Graves, Kenneth Callahan and Guy Anderson — called Seattle their home en route to becoming recognized internationally for their work.

Those looking for a definitive historical memoir of the artists who were members of the Northwest School in the '30s won't find it in William Cumming's *Sketchbook: A Memoir of the 1930s and the Northwest School*.

However, those willing to go with Cumming down his personal memory lane will very likely find the trip worth taking.

The author writes in bursts of enthusiasm. People stride, stagger or even erupt into rooms; they gleam, smolder, shriek and sob wildly, instead of simply looking at each other and talking. When painter Mark Tobey took out his sketchbook, the pen "leaped into his hand." The weather is also conspiratorially melodramatic, amplifying whatever heightened emotional state Cumming happened to find himself in.

Cumming, who is having a a solo show at Woodside/Braseth Gallery opening Thursday, is well-known in this region as a painter. Those interested in his painting will find the book particularly fascinating because of the relation the writing bears to the painting style.

Just as the writing concentrates on significant moments, each painting concentrates on a highly colored, frozen instant of time. Figures typically stand or turn in pools of radiating light. For Cumming, life is a series of moments lit with alternatively rosy or ominous glows, the universal radiance of what is.

He is the first to admit that his book isn't intended to be prescriptive, balanced or definitive of the period.

"Seeing is an act of design not given to us by our retinas," he said in a phone interview this week. "We each invent what we see." We invent what we remember, as well.

As a young painter in his early 20s, he fell into the charmed circle of Kenneth Callahan and his late wife, Margaret, Guy Anderson, Morris Graves and Mark Tobey. These are the people his account focuses on at its best. He was there when they were young or vigorously middle-aged painters.

They comprise the stars of Cumming's Northwest School, and his account is a personal view of them. We learn what they looked like to him, what they ate, talked about, where they lived, their sexual preferences and drinking habits, their view of life and art as Cumming understood it.

His understanding of their art has serious limitations. He offers the stand── ──' calligraphy, while Callahan's art grew in large part from the Mexican mural painters, and his own from French painters of the last century, principally Bonnard. These notions, while accurate, are only part of the picture.

He makes no attempt to relate Tobey, Graves, Callahan and Anderson, or anyone else for that matter, to contemporary artists elsewhere in the country, such as the artists who eventually created Abstract Expressionism in New York City. He doesn't deal with the influence of Northwest Coast Indian art on artists of that period, an influence that is particularly strong for Anderson.

Cumming also devotes a lot of space to painters who were minor at best, such as Lubin Petric, and ignores or brushes off with a phrase or two Seattle artists who made significant contributions, such as Ambrose Patterson, Ray Hill, Alden Mason and George Tsutakawa.

Artists whose work is crucial to a history of the time but who were working in Portland instead of Seattle aren't included either, not even Louis Bunce, Carl and Hilda Morris, Clayton S. Price or Charles Heaney. Those who showed up after the '30s don't figure at all, even though the book takes us to the present.

"Well," he said with a chuckle, "as Tom Robbins once said, my strength lies precisly in that I don't really know what's going on in the art world. I'm still a farm boy."

Part of the appeal of the book is Cumming's modesty. He paints himself as an eager bumpkin schooled by the wise Callahans, or as the ignorantly dogmatic Marxist unable to appreciate Tobey's greater understanding.

Sketchbook is best at describing the human relations, the late-night drinking with Petric, the madcap, theatrical antics of Graves as he sabotaged a Dadist performance by his friend John Cage at Cornish Institute. Cumming is very good at making the reader feel present at the dinner table with Margaret Callahan, whom he calls "a natural observer with a gift for being with you."

His book charts his own coming of age, and he describes his own maturity as slow in coming. One of his central gifts, however, is a gift for friendship.

This book is a gift to those he loved. For Cumming, the Northwest School is nothing more or less than the people he happened to know. He can make the reader care about the people he cares about, not only Graves, Anderson, Tobey and the Callahans, but Betty Bowen, Dr. Richard E. Fuller, Bernard Flageolle, Faye Chong and Johnny Davis.

When Cumming stacks the deck against those he doesn't care for, such as Walter Isaacs, it doesn't seem malicious as much as simply human. Cumming isn't a saint, but he is a writer with flair and authority. He was there during a high point in Seattle's art history, and he got his memories down on paper.

As painter Wesley Wehr said, "The book is a rich addition to the folklore of the area."

Regina Hackett